SARASOTA
MODERN

SARASOTA
MODERN

Andrew Weaving

RIZZOLI
NEW YORK

First published in the United States of America in 2006 by

RIZZOLI INTERNATIONAL PUBLICATIONS, INC.

300 Park Avenue South, New York, NY 10010

www.rizzoliusa.com

ISBN-10: 0-8478-2872-7

ISBN-13: 978-08478-2872-2

Library of Congress Control Number: 2006904380

Designed by Aldo Sampieri

Printed and bound in China

2006 2007 2008 2009 2010/ 10 9 8 7 6 5 4 3 2 1

CONTENTS

Foreword

The west coast of Florida has attracted visitors to her native shores since prehistoric times. From the time Paleoindians arrived here twelve thousand years ago to today, Sarasota has enjoyed steady growth through successive land booms while rarely experiencing serious economic downturns.

The Florida land boom of the mid-1920s attracted architects from around the country who sought to create a Florida identity loosely derived from the architecture of the Mediterranean basin. The style was borne out of the fantastical longings of developers to market the state as a remote and mysterious tropical oasis. And yet the Mediterranean Revival Style of architecture, ill adapted to Florida's moist and warm climate (thick walls, narrow roof overhangs and small windows), was the antithesis of all that was to come with Sarasota's modern movement twenty years later. Such is the difference between an architecture that is purposefully created to fit a region and one that is reinterpreted from another time and place to provide a backdrop to an imagined land.

Sarasota in the 1950s was a small community graced with alluring natural beauty. What set it apart from so many other Florida beachfront communities was the concentration of artists, writers, and architects who gathered here. According to a 1952 edition of the Sarasota Herald Tribune, Sarasota had more artists per capita than any other city in the United States. Among them were American impressionist Helen Sawyer, portraitist Jerry Farnsworth, and abstract artist Syd Soloman. A synergism existed there, produced by the intermingling of these artists with award-winning authors like MacKinley Kantor and Walter Farley—and a group of young architects just emerging from the some of the finest architectural schools in the country, influenced by European masters of Modernism such as Walter Gropius, Mies van der Rohe, and Le Corbusier. This was the confluence of art and architecture that laid the groundwork for the Sarasota School of Architecture.

Sarasota is fortunate to have its own regional modern movement—adapted to our unique subtropical climate through innovative site planning and the use of indigenous materials. Few other such movements exist around the country. Named the Sarasota School of Architecture by Gene Leedy at an AIA Design conference in the 1980s, architects around the world knew there was something special happening in this small gulf coast town long before then.

Historical preservation in Sarasota presents unique challenges. Traditional threats to historic buildings result from forces of nature or aging. Yet the greatest threat is the tear-down trend that has taken hold recently in response to skyrocketing property values, a phenomenon most evident on highly coveted waterfront lots, where unique historic homes from all eras have been lost to the bulldozer, replaced mostly by monotonous, oversized, Mediterranean Revival–style knockoffs that lack the fine detailing, scale, and materials of their 1920s predecessors.

Resources from the Sarasota School are highly threatened because so many are located on our desirable barrier islands. Built originally as second homes, their small size and modest scale lack amenities necessary to the Sarasota lifestyle of the twenty-first century.

Further hampering their preservation is their relative "youth" and the requirement that a structure be fifty years old or older to qualify for historic designation on the national level and in most locales.

In Sarasota innovative techniques are being employed to help save these important buildings. Some efforts have been made by local government and some by impassioned homeowners, developers, architects, and realtors. One of the earliest preservation success stories occurred in 1985, when the Sarasota City Commission conferred local historic designation on Twitchell and Rudolph's severely deteriorated Healy Guest House (Cocoon House). Historic designation halted the condemnation process and allowed the owner to sensitively rehabilitate the structure.

In 1994, residents of Sarasota's Sanderling Club nominated Paul Rudolph's Clubhouse and Cabanas to the National Register of Historic Places, in part to allow them an exemption from Federal Emergency Management Agency (FEMA) regulations that limit reinvestment in non-conforming structures. With this exemption the cabanas were rehabilitated without having to meet requirements for wind load and elevation, restrictions that would have ruined their delicate design. Both nominations were based upon special criteria for underage resources that demonstrated the exceptional importance of the buildings.

In 2001 the Fine Arts Society of Sarasota sponsored a five-day symposium, entitled An American Legacy: The Sarasota School of Architecture, which brought together architects, academics, enthusiasts, and government officials to talk about the defining elements of the movement, what resources remain, and what barriers exist to their continued preservation. The symposium was a great success that attracted more than a thousand participants and energized the local community for the continued preservation of these resources.

A year later, in 2002, the Sarasota Board of County Commissioners granted a coastal setback variance for land located on Sarasota's Big Pass—in part to ensure the preservation of Tollyn Twitchell's 1956 Carousel House. The approved plan featured the small historic house relocated on site to accommodate a new home designed in the modern spirit. The Carousel House will serve as a pool house.

More recently, the owners of two important modern homes located on Siesta Key took preservation matters into their own hands in the hopes of saving their important structures after resale. In order to combat the tear-down trend, both commissioned modernist architects to design large master-suite additions that would bring the size and amenities of their modest homes up to a level more commensurate with the value of the land. Well received, both projects have earned design awards from the American Institute of Architects and approval by local historic preservation boards.

Another interesting project strives to instruct home buyers on the merits of the Sarasota School of Architecture by building new homes in the spirit of the movement. The Houses of Indian Beach project, by architect Guy Peterson's Office for Architecture, will draw its roots from a synthesis of the regional modernism of the Sarasota School of Architecture and today's technologies, materials, and resources.

Once heralded as "the most exciting new architecture in the world" by noted architectural historian Henry Russell Hitchcock, in an Architectural Review article of 1952, the modernist structures of Sarasota once again excite and challenge the innovative thinking of local architects, developers, preservationists, and aficionados as they seek fifty years later to preserve Sarasota County's unique architectural legacy.

Lorrie Muldowney
Historic Preservation Specialist
Sarasota County History Center

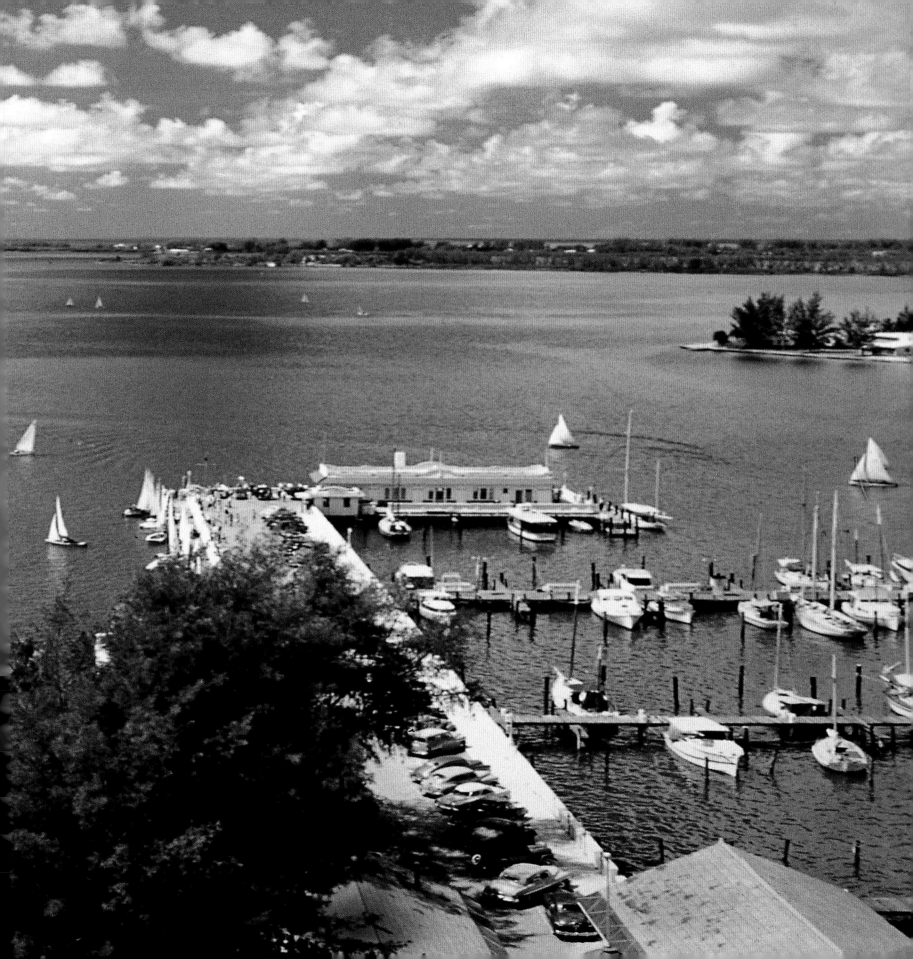

One of the first speculative houses built on Lido Shores by Philip Hiss; recently demolished to make way for two McMansions.

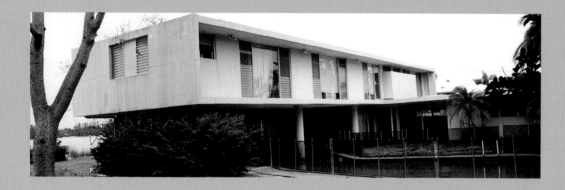

Sarasota, ideal vacation destination and arts capital of Florida, is also home to a unique collection of mid-twentieth-century American architecture built by a group of architects whose movement recently came to be known as the Sarasota School of Architecture. Initiated in the late 1940s, the Sarasota movement was not a critical success on the level of its contemporary, the famous Case Study program in California. But Ralph Twitchell, Paul Rudolph, and Philip Hiss, among others, working in harmony with the climate, lifestyle, construction techniques, and materials of the Sarasota region, managed to build houses and public buildings of international importance.

Presently, Sarasota is witnessing a total reassessment of the houses and other buildings within the city (and elsewhere in Florida) built from the late 1940s onwards. New architecture developed around existing landmarks has enabled many gems to be retained within the original building plots. Moreover, some developers are now slowly moving away from the Mediterranean Revival–style McMansions built within the last decade in the demolished imprints of many important

examples of the Sarasota School. New modern subdivisions that cater to the demand for more affordable modern homes have enabled more Sarasota School classics to be preserved. Yet only within the last few years have some important examples been demolished—the most striking loss was that of the Hiss residence on Lido Shores, the first of many speculative houses built there by Philip Hiss and others, including Tim Seibert and Paul Rudolph.

The name "Sarasota" first appears on government maps of Florida issued in the early to mid-1800s, some years after the U.S. took control of the area previously owned by Spain and Britain. (Florida achieved statehood in 1845.) Where the name Sarasota came from is disputed. Some say the city's name is based on the conquistador Hernando de Soto's daughter, Sara. Some say it comes from the language of the region's prevailing tribe, the Calusa, whose word "sara-se-cota" means "an area of land easily observed." In early maps the area is labeled "Porte Sarasote" or "Sarazota"; it is said that there was also a fishing camp and trading post on Longboat Key that was named "Saraxota."

Many years earlier the native Indians had begun to take advantage of the area's bounteous game and its lush crops of wild fruits. It wasn't until the middle of the nineteenth century that the first full-time white settler moved there. William Whitaker owned over one hundred acres of land on Sarasota Bay, where he built a cabin that was soon burned down by Seminoles. He and his company eventually moved further inland to escape the blockade runners and other naval hazards of the Civil War.

It was John Webb who first realized that the area was an ideal place to invite northerners to take advantage of the warm climate in the winter months. He built the first vacation resort, widely advertised in the national press as "Webb's Winter Resort at Little Sarasota Bay." This area was soon named Osprey, which is south of Sarasota and includes Casey Key.

As the nineteenth century neared its end, more and more communities settled in the area, mostly on the mainland. The citrus farming industry expanded also, as speculators bought up some 700,000 acres of deeded land that had been made available at very low prices.

Introduction

Ca d'Zan, the Ringling Mansion.

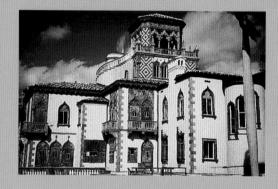

Immigrants from as far as Scotland were pouring in, but various problems caused some to move on soon after arriving, and the Homestead and Swampland acts put a stop to the development of central areas. The arrival of new settlers soon slowed to a trickle.

John Gillespie, who owned a mortgage company, soon got things moving again. He helped forge a shipping connection with Tampa, he built the DeSota Hotel, and he is said to have introduced the first practice golf course in the United States.

Just before the turn of the century Ralph Caple, the railroad entrepreneur, announced that he would build a railway line from Tampa to Sarasota. By the early 1900s the town had a yacht club, a new school, a theater, its own water and electric plants, and two newspapers.

What was Sarasota Key was soon renamed as Siesta Key (the bridge that connects it to the mainland wasn't opened until at least ten years later). Wealthy Americans were immediately attracted to the place. Mrs. Potter Palmer, a Chicago developer's widow, arrived in about 1910 and built a winter estate at Osprey, which is now called Spanish Pointe.

Charles and John Ringling, the ambitious Ringling brothers of circus fame, arrived in Sarasota in the early 1910s and purchased neighboring typical cottages on a waterfront location. Pumping more and more money into their empire, they soon owned beachfront properties, hotels, and extensive art collections and they managed to buy almost all of the islands fronting Sarasota Bay. In the early 1920s they started to dredge the islands—most of which were mangrove flats or swamps—and turn them into solid land. New canals divided the rows of real estate lots created by the dredging, and the excess from these trenches raised the elevations of the surrounding land. The Ringlings even used elephants from the circus to help with the construction. A new bridge connected the islands to the mainland. The islands included were Bird Key, Lido, St. Armand's Key, and Longboat Key. An area at the end of the bridge from the mainland was developed to create a circular complex of shops and restaurants. Called St. Armand's circle, it was extensively landscaped with Italian statues and palm-lined streets.

At this time a bit of sibling rivalry developed. Since Charles and John Ringling already owned their own banks, hotels, and property companies, the brothers decided to build their own mansions. On the lots they initially bought ten years earlier they tore down their cottages to build their palaces. While Charles built a Georgian-inspired mansion, John outdid him with an immense Venetian Palazzo called Ca d'Zan, where a reinforced concrete structure of three floors was topped with a soaring tower and embellished with stucco and tile with Venetian glass windows and Spanish terracotta roof tiles. John Ringling brought works of art from Europe, as well as architectural features such as doorways, arches, columns, and statuary, to be included in the construction of the house and other projects. The house had balconies, a huge terrace overlooking the bay, and a viewing tower. Inside there were at least thirty rooms, some with painted ceilings and some with skylights.

The architect was New York–based Dwight James Baum. At this time Ralph Twitchell was brought in to oversee the final completion of the work for Baum,

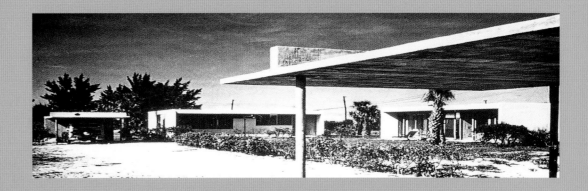

and with Twitchell's organizational skills the house was completed by the end of 1926. This impressed Ringling and they remained friends for some time.

At this time the boom was starting to dwindle. There were several natural disasters, including a hurricane that caused damage exceeding $75 million in 1926, a fruit-fly epidemic that destroyed the citrus crop the following year, and a year later another hurricane that killed almost two thousand people. The railroad did not proceed as expected, lack of materials halted construction and the real estate market was hit by an influx of confidence tricksters. The Depression that was soon to effect the entire country came early to Florida. While the city of Sarasota was ready to move forward, the Depression put a stop to this. The Ringlings carried on with their projects in Sarasota, where the Circus now wintered. They continued construction of the art museum and school. But the city soon received some federal assistance. The WPA started various roads and parks projects, and soon developed the Bayfront area and a municipal airport. The Ringling causeway, which united the islands and the mainland, was also repaired.

The effects of the Depression came late to the Ringlings, though. Their banks failed, and after the deaths of both brother Charlie and wife Mable, John Ringling carried on alone. He died in 1936, at the age of 70, unable to refinance the circus and save Ca d'Zan from the IRS. The Ringlings left behind a foundation for the arts and the circus development that was soon to follow.

Ralph Twitchell arrived in Sarasota in the 1920s. He received a Florida architecture license in 1926 after successfully working on the Ringling mansion and carried on working with Baum on various Mediterrannean Revival–style projects in the area—buildings with thick stucco-finished walls, tiled roofs, and tile-and-ironwork decoration. Due to a decline in Sarasota construction and property speculation, however, he returned to Connecticut for other projects, working in the north with the local natural stone, sawn timber, and wood decking. Yet he and his family still wintered in Sarasota.

Twitchell had always been drawn to the tropical environment, the white sandy beaches, the sea, and the islands so close to the mainland. Still, he knew that given Sarasota's seasonal population, it would take a while for there to be enough work for an architect based there full-time.

Ten years after his first visit, Twitchell returned and set up a new firm, Associated Builders Inc., to build his designs and enable him to receive both architect's and contractor's fees. The firm's first commission was for the writer McKinley Kantor, a prominent job that established him immediately within the Sarasota art community. The somewhat traditional-looking house on Siesta Key that resulted included local materials such as cypress for the siding. Twitchell again introduced new ideas for construction and the methods involved, here using a poured concrete monolithic slab that had a thickness to the edges to create the footings. This method allowed for any type of construction above. He went on to work with John Lambie, who was developing concrete construction, and used the Lamolithic system, consisting of a poured concrete roof suspended on steel columns bedded into a concrete slab. This allowed for large open spaces within. Using this method he built house No. 1 for his bookkeeper, Lu Andrews, who carried on to live in various experimental and speculative houses that Twitchell built.

Lido Casino by Ralph Twitchell.

Florida Southern College in Lakeland, Florida, by Frank Lloyd Wright.

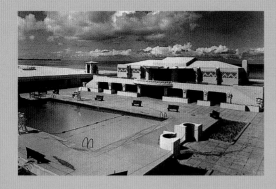
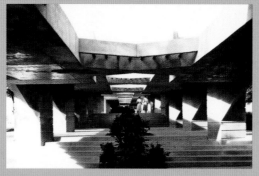

In 1938 the WPA Lido Casino Project was put into full swing. It is believed that Twitchell used the sway of his local connections to get the project. The scheme included a poured concrete structure with glass block window details. Oversized seahorses guarded the building, which included an Olympic-sized swimming pool, restaurants, and dancing areas—a complete entertainment and recreational facility. In 1940, he built a house of concrete stacked block, made from local Ocala sand. This house was framed with cypress panels and had a flat roof. It was another move forward; every project came nearer to the modernist ideals.

Frank Lloyd Wright was making an impact with his work now being constructed in Florida. He was commissioned by the president of Florida Southern College to design a complete new campus in Lakeland. While the project took many decades to complete, it was an inspiration for local architects and brought about international interest in new Florida architecture. The twelve-building campus was built mainly of poured concrete, with rendered and painted masonry and

detailing and relief work. This brought many other architects and student architects to see what he was building there. William Rupp recalls a field trip while studying at the University of Florida, visiting both the college campus and then Sarasota to see the works of Rudolph and Twitchell. On visiting the firm's office they found both architects were out of town, so it fell to a young Mark Hampton to show them around.

Frank Lloyd Wright's influence was just one of the factors that drew Paul Rudolph to Sarasota; he was captivated by Wright's work at Lakeland as well as the critical praise he was reading, and the tropical climate and landscape drew him closer. He had initially worked for Twitchell between leaving school in Alabama and joining Harvard. There he was taught by Walter Gropius and studied alongside Philip Johnson. His first year at Harvard included many trips to Manhattan to observe the architecture, go to museums, and watch plays on Broadway. He soon learned that architecture was closely related to the arts, and at Harvard, with Gropius as leader, he socialized with artists.

When the war began Rudolph joined the Naval Reserve. There, based in Brooklyn, he learned "the understanding that comes from seeing how 75,000 workers were organized and the importance of respecting each man's role." Twitchell also joined the forces and was stationed in Charleston, South Carolina. Many of the future Sarasota School group were to experience the armed forces. Jack West joined the Navy while Mark Hampton and Victor Lundy went into the Army.

Rudolph and Twitchell's relationship carried on. They corresponded often, and Twitchell offered Rudolph a position in his firm after the war. He accepted, and between terms he was at the office in Sarasota working on the latest projects. He worked on several schemes while away, producing many pen-and-ink drawings that were often published.

During this time, however, the level of Rudolph's input into each project is unclear. He did most of the drawings for each project, but as Twitchell realized, Rudolph had a great design ability and Twitchell took advantage of it.

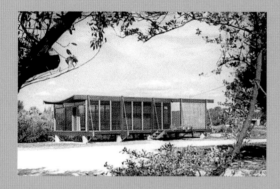

Healy guesthouse, Cocoon House.

Laura Hampton house by Mark Hampton.

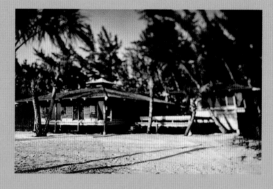

The Zimmerman's South Seas–style house.

Rudolph graduated in 1947 and won a scholarship to travel Europe. He visited many cities that were under reconstruction after the war and realized the importance of urban design and planning. Returning from Europe a year later, he was offered a full partnership in Twitchell's firm. With Rudolph conceiving the design ideas and Twitchell working on construction, client relations, and any problems that arose from their often experimental methods of construction, they made a great team. During their partnership some twenty or so houses were built, including Twitchell's own house, the Denman, Miller, Russell, Deeds, Burnette, Bennett, Haskins, Coward, and Wheelan residences, the Miller and Healy guest houses, and the Revere Quality House. Several others were built further from Sarasota. Among these projects were those for friends and family, in which more experimental and speculative ideas appeared.

Their partnership lasted until the early 1950s. Though Rudolph eventually realized that he needed to work on his own, he appreciated the chances Twitchell gave him. Their partnership, however, grew more and more difficult over time. Twitchell was twenty years or so older than Rudolph. And while Twitchell was content to carry on building houses for Sarasotans who contracted for them, Rudolph sought national recognition and larger projects further afield. The partnership had several projects published both domestically and internationally, and Rudolph desired more. So he left Twitchell and set up his own office in 1952. After the split of Twitchell and Rudolph, Jack West joined Ralph Twitchell. But the partnership did not last and they built only a couple of houses. West formed his own firm in 1954 and went on to design two schools in Sarasota as well as the City Hall.

Also at this time Mark Hampton, who was the partners' first employee, set up his own office. A native Floridian, Hampton returned to Tampa, his hometown, where he started his own firm. One of his first buildings was a house for his mother, Laura. This project led to further commissions elsewhere in Florida. Hampton's use of alternative building materials, the regular brick, added another element to the work of the group and the Laura Hampton residence was published and brought about many commissions. Hampton is now based in Miami, where he still works. Philip Hiss had arrived in Sarasota a few years earlier, in the late 1940s, working with the Zimmermans, who translated his ideas from his travels in the South Seas into houses for the tropical Florida climate (they had also traveled heavily and so had some idea of what Hiss wanted).

Gene Leedy, the first employee of Rudolph's own firm, had previously worked with the Zimmermans. They called him in to help move their ideas forward. He designed a more modern speculative house with ideas from the new direction of architecture happening in Florida. During this time Leedy also designed and built a house under the firm he set up, Contemporary Builders. Perhaps due to its expense, Leedy's speculative house did not sell very quickly. It was a simple rectangular structure with ten-foot-long sliding doors and matching full-height and length screens which, at the roof's edge, transformed the house into a screened porch with an interior cooled by cross breezes. The house was published in *House and Home* and *Arts and Architecture* magazines and brought

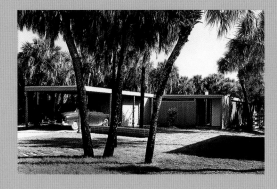

Gene Leedy house for speculation.

Umbrella House by Paul Rudolph.

about further commissions that were also published. He moved away from Sarasota and set up his office in Winter Haven, where he still works.

Hiss had been buying up and developing waterfront properties in Sarasota for some time when he hired Rudoph to design a house on a very visible lot among his speculative developments on Lido Shores, close to the main road that led to the mainland. The result was the Umbrella House, the well published speculative house so named for the two-story-high parasol that extended from the main house and screened the pool area from the overhead sun. (Unfortunately, the "umbrella" was lost in a storm soon after construction.) A few other houses along Lido Shores were designed by Hiss himself with Tim Seibert—the Hiss Studio, for example. This building on concrete pillars was the first fully air-conditioned building in Sarasota. Hiss's own house, built in 1951, was made of reinforced concrete; the building swept on columns over an abstract pool, while the main living area was a breezeway underneath the bedroom quarters. Sadly this house has recently been torn down to

make way for two large McMansions towering over the few surrounding examples of the Sarasota School that remain.

Tim Seibert returned home to Sarasota in 1954 after graduating from the University of Florida. Rudolph was now in his own office on Main Street and Seibert worked for him now and again as a draftsman. It was Rudolph who introduced Seibert to Philip Hiss. At Hiss Associates, Seibert became staff architect specifically for the Lido Shores developments. Paul Rudolph would often visit Hiss as the office was just opposite his house. Rudolph would leave comments on Seibert's drawings. "His critiques were often devastating, but always true and to the point," Seibert remembers. "I had the best possible training as a designer."

Seibert built his own house, which impressed Rudolph, who often drove by and gave his comments. Rudolph was a great ideas man, his friends would say, but the principles of achieving the desired results bored him, so many details had to be tried out in the field. Seibert opened his own office in 1955 and worked on several one-off houses as well as several speculative and affordable housing designs, and, later on, condominiums on the Sarasota Bay mainland.

Now working on his own, Paul Rudolph received one of his first commissions from Mary Hook. A qualified architect herself, Hook had travelled Europe and the Far East. She had faced great hostility as a female student in Paris at the turn of the century. When she completed her examinations in 1906 at L'Ecole des Beaux Arts, the male students threw buckets of water at her as she left the school courtyard. She had previously studied architecture at the Chicago Art Institute as the only woman in her class. After some initial trouble finding employment she got a job at a firm in Kansas City, where her family had recently moved. She went on to build many houses there, including some of the first houses with an integral garage or a swimming pool. She is also noted for being the first architect in Kansas City to incorporate the natural landscape into her schemes, and also the first to use poured concrete.

She married Ingraham Hook while in her forties and formed her own firm soon after. She was very much inspired by her travels—her Kansas City houses were Italianate in style, using stone brick and older architectural

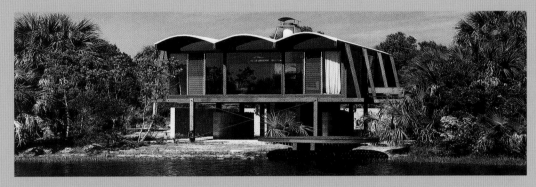

Hook Residence by Paul Rudolph.

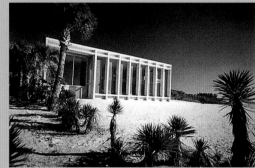

Below
Deering House by Paul Rudolph.

Page 18-19
Brentwood Elementary School by Gene Leedy
with William Rupp.

features, some with painted murals, colored and leaded-glass windows, and both floor and wall tiling. Her own, self-designed house there has become something of a landmark. She relocated to Sarasota in the mid-1930s, she bought some fifty acres of gulf-front property on Siesta Key. One part was developed as Whispering Sands, a haven for artists and writers, while the other area was named Sandy Hook and included an enclave of individual houses by the Sarasota School architects. Mary Hook built many of Sandy Hook's houses herself, but there was plenty of room for others. Twitchell, Seibert, Lundy, and Rudolph all built houses there, as did the following generation of architects. The house Hook commissioned Rudolph to build, the Hook Guest House, was not to be one of those "Twitchell Houses" that she knew from Siesta Key. She wanted a case study development of architect-designed houses on her property, buildings that represented the latest thinking in domestic design. While her grander dream was never accomplished, Hook's commission for Rudolph spurred him forward from his days with Twitchell. Here he used a plywood vaulted roof

system and raised the living areas above the landscape. The simple timber post-and-beam frame of the house was enclosed with typical materials—plywood sliding with fixed, sliding, and jalousie glass windows.

In Rudolph's first few years on his own many projects were developed, but not so many were built. The Hook and Walker guest houses were the first, followed by the Umbrella house for Hiss Associates. A house built for the Cohens, again on Siesta Key, followed a series of ideas and concepts. One of the schemes received awards from *Progressive Architecture* magazine. Planned for some two years, the end result was a compromise of the two main ideas proposed. On Casey Key, south of Sarasota, two larger houses were commissioned. The Burkhardt residence took Rudolph away from the work he was doing in the more middle-class development areas to a ritzier location that better suited the seasonal Sarasota resident. The Burkhardt house appeared to be a return to Rudolph's earlier work with Twitchell, with heavy cypress beams and ocala block. With the Deering house, however, further south

on the same Key, Rudolph moved much further forward. This templelike house stands on the white sands of Casey Key like a relic of the past. Embellishing the usual concrete block with cypress wood facings, the Deering house is slicker and more sophisticated than its predecessors. Simple slabs of stone mark the entrance approach, which opens onto a terrazzo-floored lobby leading to a lower level living area and then the massive screened patio. The Deering house's varying levels make it the forerunner of Rudolph houses that followed elsewhere, the Milam residence in Jacksonville, the Bass residence in Fort Worth, Texas, and his own house in New York, to name but a few.

Victor Lundy also made his mark on Sarasota. He and Rudolph were at Harvard together, and Lundy's later establishment in Sarasota seemed to resume somewhat the competition they'd initiated as students. Here the tension between them yielded positive results; many say that it was this that pushed each of them to a new level of achievement they may not have reached alone.

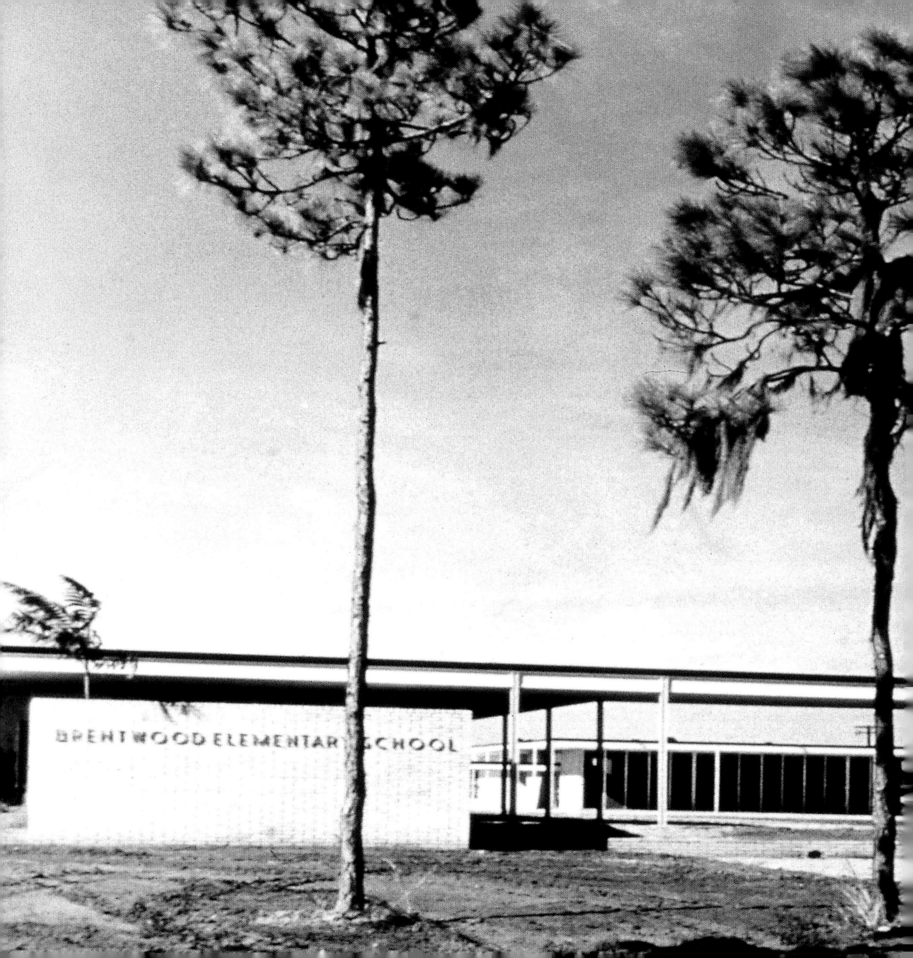

Presbyterian Church in Venice by Victor Lundy. *Warm Mineral Springs Motel by Victor Lundy.*

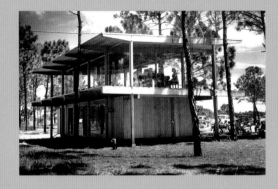
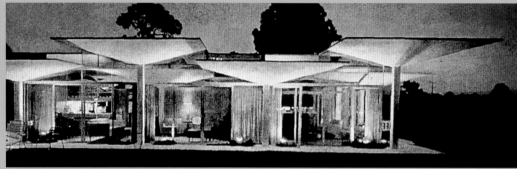

Like Rudolph, Lundy studied under Walter Gropius. He worked in various New York architectural offices before setting up his own firm in Sarasota in 1954. His first architectural project was the Drive-In Sanctuary at the Presbyterian Church in Venice, south of Sarasota. This glass box was prominently featured in *Life* magazine and the Architectural Forum, after its completion, including a photo of Lundy and his family experiencing the drive-in. In *Life* magazine the title of the article, "Drive-In Church; Florida Worships in Cars!" sums it up. The Presbyterian congregation wanted a church of its own but had no money. The Home Mission office bought them a tranquil eight-acre site of land that was heavily covered with pine trees. Victor Lundy designed a simple, handsome, modular structure of wood and glass, with the pulpit elevated above the level of the site.

The building was set among the pines so that no tree needed to be removed, and the parking places were set accordingly. From this Lundy went on to design and build many churches throughout the country as well as in Sarasota, where in 1958 he was commissioned to

build St Paul's Lutheran church. Lundy's design called for laminated wooden beams supported by concrete columns, which was to become a signature of his work. Lundy's Chamber of Commerce building in Sarasota, completed in 1956, included his characteristic curved wooden beams, this time supporting a blue tiled roof above. On the domestic side he designed a house for the Herron family in Venice. A series of curved beams created the main visual structure of the house, while the garage was a circular brick-built structure. This house was featured in *Architectural Houses* of 1958 and lauded with an Honor award in *House and Home* magazine. "Of all the houses we've seen today, this one adds up the most memorable image because of its laminated shell structure," read its citation. "This concept—of enclosing living spaces under a roof novelly contrived—is valid and exciting. The house explores in the direction of plasticity, which now interests so many architects so much." In 1958, near Venice and the renowned health spa the Warm Mineral Springs, Lundy built a hotel on the busy Tamiami Trail. The hotel was a U-shaped complex of concrete-built units

united by a mushroomlike structure that was glazed with plexiglass, creating different ceiling levels that would define the uses within. The concrete hyperbolic paraboloids in two heights symbolize the Fountain of Youth. A year later, in Sarasota, he built a new showroom for Galloway's, the modern furniture store. Here a circular building of a laminated wood central core grew into a circular roof. The external walls were fully glazed. Lundy moved from Sarasota in the late 1950s and set up office in New York in 1960. He went on to build many religious buildings and the U.S. embassy in Sri Lanka, and his work was included in the 1964 New York World's Fair and at the exposition in Osaka, Japan, in 1976.

Lundy also built a school while in Sarasota, one school among many in the schools program that Philip Hiss initiated. Lundy's Alta Vista elementary school was the program's smallest and featured his signature construction of laminated wooden beams. But it also included forward-thinking elements such as solar heating for the hot water. Philip Hiss was elected onto the board of the County School Program in 1954. His commitment

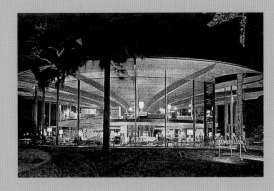

Galloway's furniture store in Sarasota by Victor Lundy.

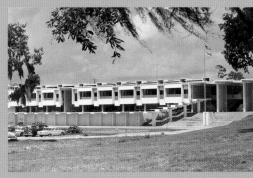

Sarasota High School by Paul Rudolph.

to modern design included the view that new thinking from young architects was necessary to revitalize school design. According to Hiss, schools were badly designed and outdated, and since they were not built to suit the climate or environment the schools were too cold in the winter and too hot in the summer. Each successive rebuilt school in the program was based on the first project. The Zimmermans, with whom Hiss had worked before, were the first architects to be given a commission. Brookside Junior High was built in 1956. Its simple structure of a steel frame with timber decks included jalousies for ventilation and large glass openings for natural light. Typical of the Sarasota School ideas it also had ample overhangs to create shade.

Most of the Sarasota School architects drew up schools for the program. Mark Hampton designed Venice Junior High and Amaryllis elementary while Gene Leedy, with William Rupp, designed Brentwood elementary. It was a natural association considering that both men had worked for Rudolph. Brentwood elementary was a low-level, steel-framed building with individual brick-built courtyards for each classroom. It had ample jalousies for ventilation. The elements of the entire complex were very similar in appearance to the residential projects of Leedy.

Of course it was Rudolph's designs for two schools that really got all the publicity. His first, Riverview High, built from exposed columns and beams that were painted black, reflected the dark bark of the surrounding pine trees. Bert Brosmith was working for Rudolph at the time. As the only two-story school within the program, its construction was considered dubious at the time because the use of the masonry infill within the steel frame did not appear to consider the thermal expansion and corrosion problems engendered by the Florida climate. Yet it may be the most well-survived example of all the schools built in the program (though there have been many alterations and additions). With Rudolph away so much in his New Haven office, as he was now head of the architecture department at Yale, Brosmith was in control of the Sarasota office and much of his input was included in the detailing of the school.

By 1958 Rudolph was coming to Sarasota only for very short visits. His addition to Sarasota High was really the icing on the cake. This project alongside the Deering house of the same date marked a change in Rudolph's work whereby he now privileged the importance of understanding a building from a great distance rather than focusing on the linear organization as in earlier buildings. The Sarasota High addition is composed of glass-fronted classrooms on different floors on either side of the corridors. As Sibyl Moholy-Nagy says in her book on Rudolph: "This building is intended to suggest the uniqueness of the Florida climate through carefully arranged sun shields and interior ventilating and lighting scopes. Its concrete structural frame is bent in such a way as to create hollow boxes at every bay, thereby accommodating an integral mechanical system." Even though the Milams were already aware of Rudolph's work, they came to see this school and the commission for their house soon followed.

On the whole, the group of schools built within the program garnered severe criticism from the general

Plymouth Harbor by Frank Folsom Smith. *St. Thomas More Church by Carl Abbott.* *The Summerhouse Restaurant by Carl Abbott.*

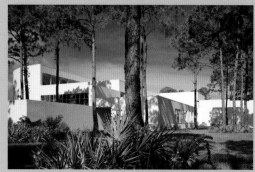

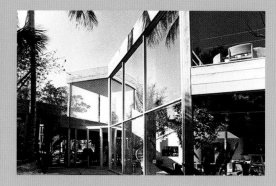

public, politicians, and local press, many of whom turned away from the group. While the schools earned national recognition and influenced school design throughout the country, their architects were not encouraged or commissioned to build many other large projects locally.

With Rudolph and Lundy now working away from Sarasota, a new generation of architects was coming into its own. Bert Brosmith opened his own office after Rudolph's closed in 1960. He was given the commission to build an addition to Sarasota Junior High, going on to add the ground-floor addition to the earlier building the Hiss studio. Hiss went on to develop an idea to build a college in Sarasota. The new college soon had a board of trustees, but referring back to the reaction of the school program the locals demanded that a more nationally known architect be selected rather than one from the school group. Whereas Hiss had retained control of the school program, such was not the case here. The board selected I. M. Pei as architect of this project and Bert Brosmith was chosen to be the local representative.

During the 1960s most of the work built in Sarasota was by the new generation of architects. One of

Frank Folsom Smith's first commissions was a high-rise building, Plymouth Harbor, built to house the elderly. A great success, the building included internal courtyards every few floors which themselves created smaller communities within. Smith also built a small enclave of condominiums on Siesta Key called Sandy Cove. Having previously worked with the Zimmermans and Victor Lundy, he experienced a wide range of projects.

Carl Abbott had worked with Bert Brosmith on some of the fittings and details within the Hiss Studio addition. He received his architectural degree under Rudolph at Yale. After a short stint with Norman Foster and Richard Rogers in the U.K. and with I. M. Pei in New York, he returned to Florida and set up an office in Sarasota in 1966. He built many individual houses and public buildings there, including the St. Thomas More Church complex. His first house was the Weld beach house at Boca Grande. Abbott's Summerhouse Restaurant on Siesta Key, built in 1976, was recently saved from demolition. The Sarasota Architectural Foundation and the outcries of the local community combined to form one

of the most successful preservation campaigns in Sarasota history—residents worked with the developer to save this significant building of the Sarasota School. Simply it is very much hidden amongst the lush greenery. Its upper level appears to float in the treetops, a haven away from the hustle of Siesta Key beach nearby.

Even though the Sarasota School had somewhat disbanded, many projects by members of the group were getting publicity and awards. In the mid-1960s, *Architectural Forum* picked Bert Brosmith as one of fourteen U.S. architects featured in its article "New talent for the Sixties." Abbott's Weld house was *Architectural Record*'s pick as the house of 1972. Hampton's concrete and brick house in Tampa got first place in the *Horizon Homes* program. Siebert's Field Club additions and residences on Siesta Key were featured in *Architectural Record* in 1961 and Jack West got a Homes for Better Living award for his Courtyard house for the Arvida corporation in 1964.

Further afield Gene Leedy was designing many buildings in Winter Haven, in central Florida. Working

Lake Region Yacht Club by Paul Rudolph with Gene Leedy.

Dorman Residence by Gene Leedy.

Syd Solomon Residence by Gene Leedy.

Perry House in Lakeland, Florida by Mark Hampton.

Perry House in Lakeland, Florida by Mark Hampton.

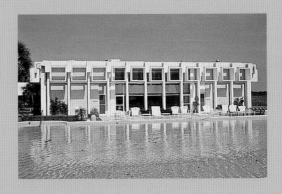

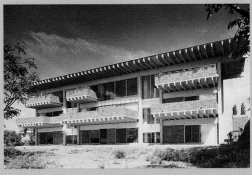

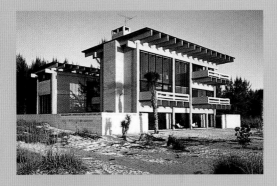

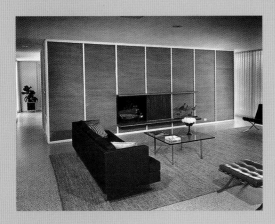

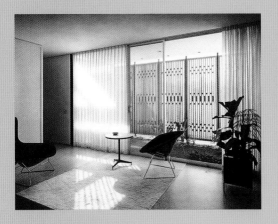

with Rudolph there a little earlier, he designed the Lake Region Yacht and Country Club, built on the banks of Lake Hamilton. This concrete-framed building features a series of sunshades on all sides, similar to the Sarasota high addition. Using his prestressed concrete T-beams, Leedy's office was the first to be built with this method. The beams were supported by tall concrete columns, and he developed a double T-beam, which became a characteristic element of many of his future buildings, both domestic and public.

The Dorman house in Winter Haven showed the potential of Leedy's new method. With this new construction method he managed to build a 10,000-square-foot house for $50,000—about twenty-five percent of the cost of a traditionally built house of that size. In Sarasota he built a house for the artist Syd Solomon in 1970. Yet his house, built at the southern end of Siesta Key, has recently been lost due to irreparable damage caused by the intruding sea.

While one cannot stop the elements from damaging structures, one can prevent the encroachment of unfeeling developers. In Sarasota things are changing. More eyes are open and watching what is going on. The new developer is one who takes into consideration what is existing and seeks to add to or improve on what exists. Projects are being developed now in Sarasota that intend to preserve the important landmarks that make the area what it is today. One of the largest collections of individual modern houses in the world is waiting to be rediscovered, restored, and appreciated once more.

There is perhaps more chance of finding and saving a masterpiece in areas just outside of Sarasota. I was recently lucky enough to buy the Perry house, designed and built by Mark Hampton in 1957. It is located in Lakeland, the home of Frank Lloyd Wright's Florida Southern College. The Perry house had been in the same family since construction and was totally unaltered, with no additions or updates. I was also able to retain some of the original furnishings. If this house was in Sarasota it would have most probably had four or five owners by now and been extensively altered. If it was on a waterfront lot it would have been torn down by now. Instead, one more house has been saved.

Lucienne Twitchell House

Big Pass, Siesta Key

Ralph Twitchell, 1941–42

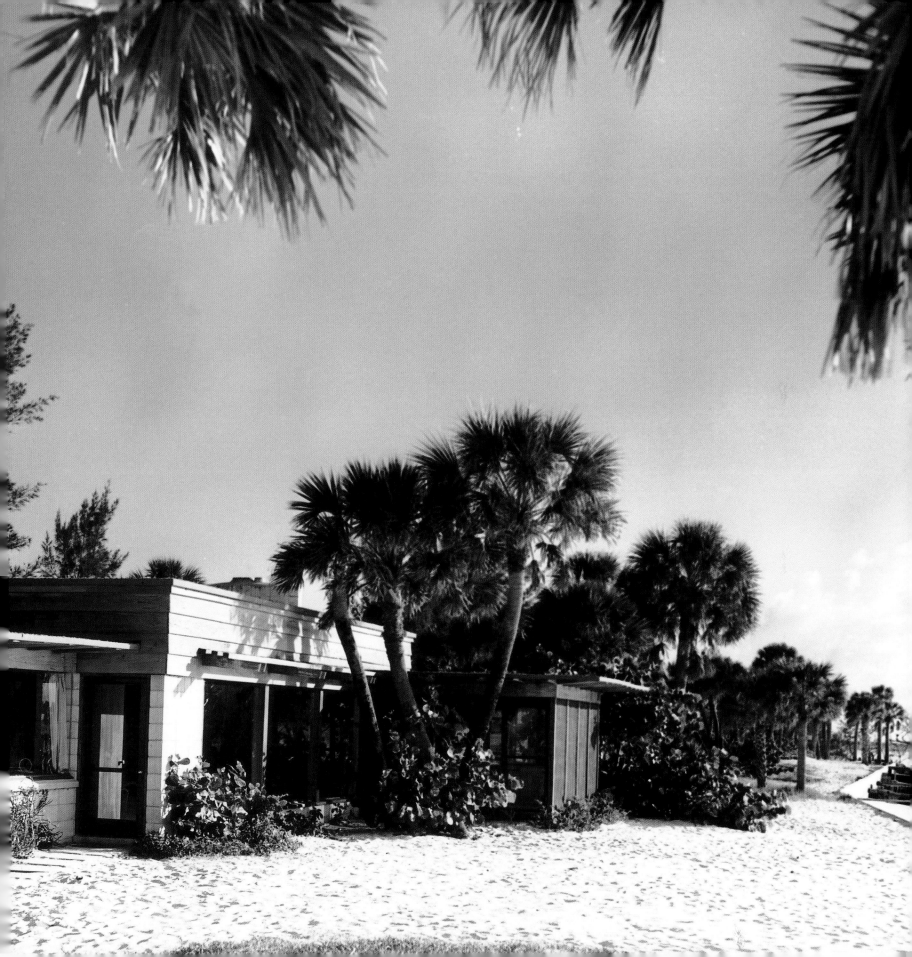

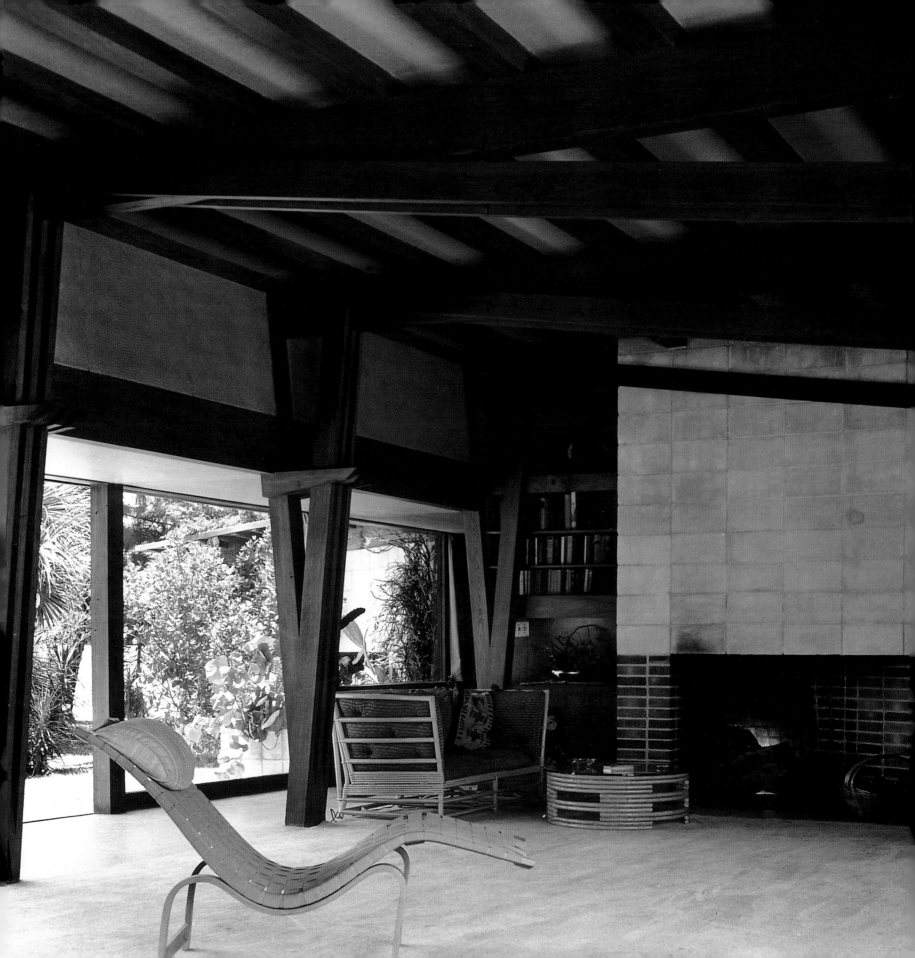

Page 24-25
Overlooking the Gulf of Mexico, the cedar and
Ocala block house gels into the local landscape.

Left
Typical of Twitchell, the massive exposed cedar
beams make a visual impact as does the stacked
ocala block chimney wall. A Bruno Mathsson
lounger brings the outside in.

Ralph Twitchell had been building in Sarasota for many years before Rudolph arrived from Birmingham, Alabama, in early 1941. Rudolph had worked at a local architectural firm in Birmingham since his graduation the previous year from Alabama Polytechnic Institute. He was drawn to Florida by Frank Lloyd Wright's Florida Southern College in Lakeland, Central Florida, by what he had read about Sarasota and, of course, by the lure of the tropical climate. Twitchell invited Rudolph to Sarasota to work. (He had worked for Twitchell via correspondence one summer while at Harvard. One of Rudolph's classmates had worked for Twitchell previously and put him forward for the position.)

Completed late in 1941, Twitchell's own house rested on Siesta key overlooking Big Pass with views of the gulf. William Rupp, one of Rudolph's employees, recalled in a term paper that Rudolph, in response to a question about whether Twitchell had designed the house, said, "Of course not, I did it when I was down one summer. Do you know it's all based upon dynamic asymmetry?" Oddly, in other writings about Rudolph no claims were made on the building.

Twitchell had used local materials for construction in earlier projects, most notably the "Glorieux" residence for his wife's parents. It was a small, flat-roofed house with exposed ocala block construction and exposed cypress timbers.

The Big Pass residence was Twitchell's first family home, where his children were to grow up with his first wife, Lucienne. The couple divorced in the mid-1940s, after which he lived in the Revere House with future wife Roberta Finney. They lived together for many years at the Revere house, unmarried and without scandal; this was Sarasota, after all. So the Big Pass house came to be known as the Lucienne Twitchell residence.

The house at Big Pass was the first to be developed while Rudolph was working at Twitchell's office. Although it is clearly not a Rudolph design, the house's plan does appear to be a move forward from Twitchell's previous work and, due to the help of Rudolph, it complements the gulf views. The differing ceiling heights were useful in dividing the spaces and the house employed high-level strip windows. Though these innovations derive from Frank Lloyd Wright's work, they clearly represent Rudolph's input in view of future projects of his then in development. So while Rudolph's assertion to Rupp about his responsibility for the Lucienne Twitchell house's design is questionable in particular, the collaborations of the two men are often controversial in terms of how much input from each went into their end products.

A studio building with some living accommodation was soon built alongside the main house. Rudolph lived there for much of the duration of the partnership, which was formed in 1948. Again, there are questions as to who designed this building. The studio has obvious Rudolph elements, but John Howey, in his book *The Sarasota School of Architecture*, mentions in an interview with the Twitchell family, ". . . this project appears to have been totally designed by Twitchell."

At this time Lucienne Twitchell, moving often between Florida and New York, asked Rudolph to design a house for her at Martha's Vineyard, which he worked on just after finishing at Harvard in 1947, but did not see to completion until the early 1950s. Unfortunately it was destroyed by fire.

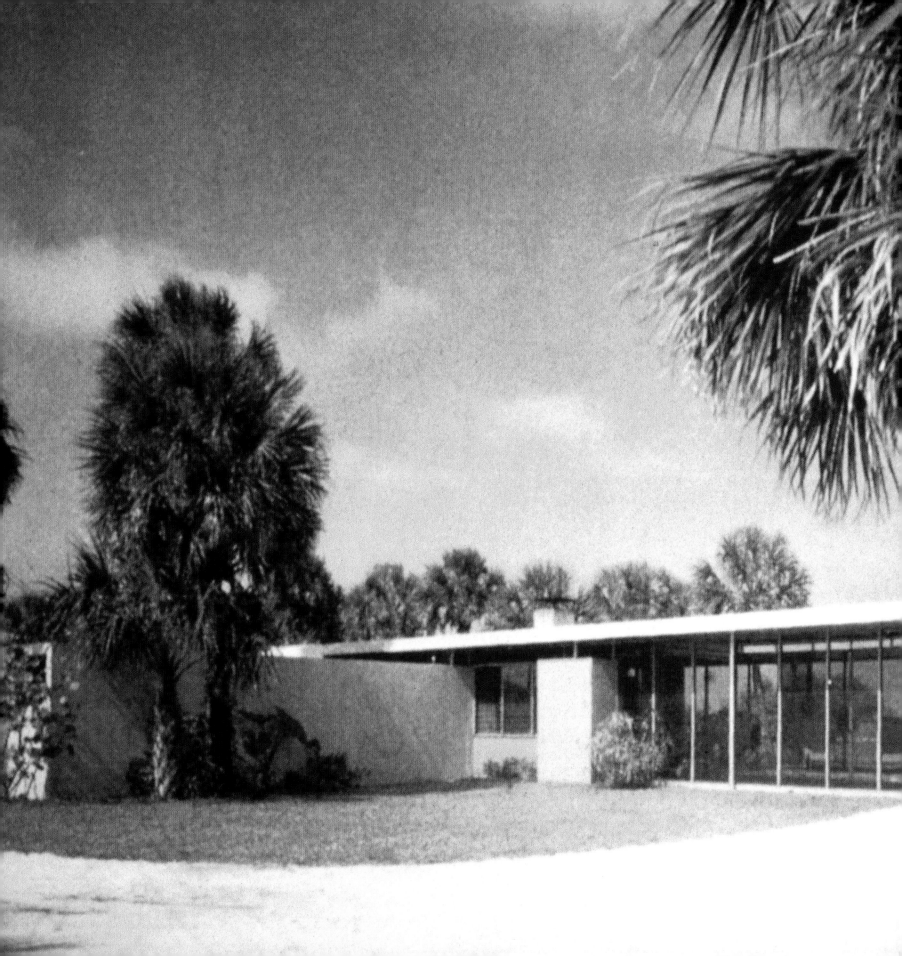

Revere Quality House

Siesta Key

Ralph Twitchell and Paul Rudolph,
associate, 1948

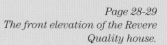

Page 28-29
The front elevation of the Revere
Quality house.

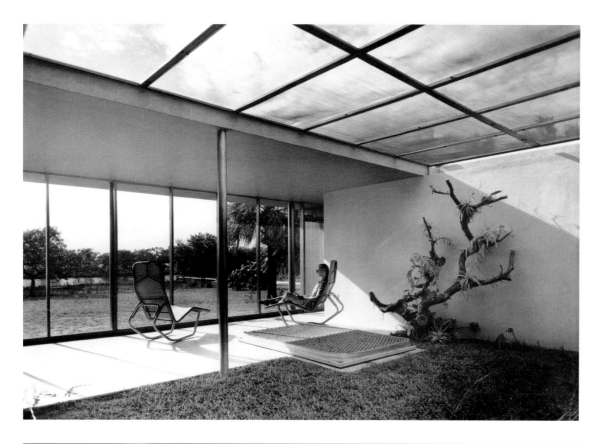

Left Above
The interior courtyard, open to the
elements from above, was screened in
to allow bug-free leisure time.

Left Below
The original enclosed living room
had timber-frame sliding glass doors
facing the internal courtyard.

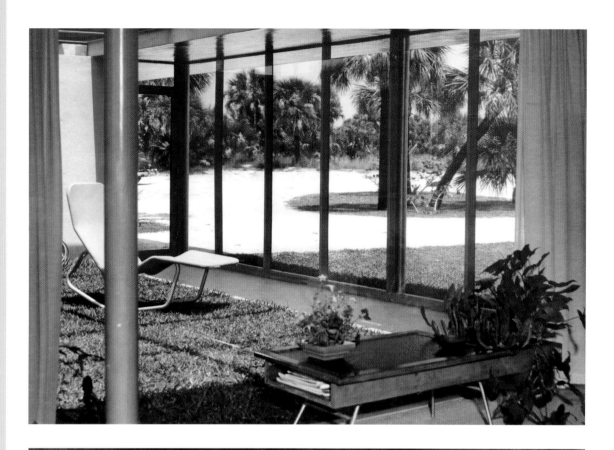

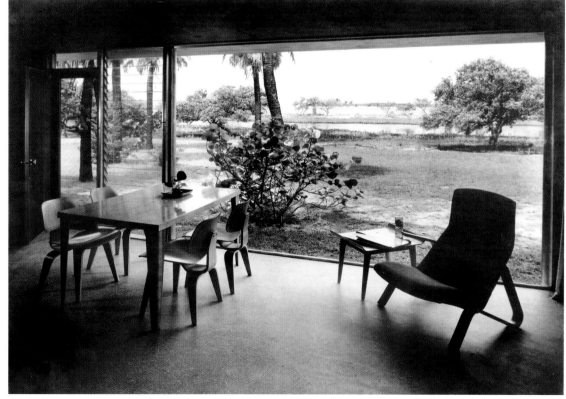

Right Above
Looking out to the front of the house.
The Barwa lounger in the courtyard
area brings the outside in. A table by
George Nelson is in the foreground.

Right Below
The fully glazed back of the house
looks out over the bayou and beyond.
The steel structure allows for large,
frameless openings. A Grasshopper
chair by Saarinen sits along side
the Eames dining set.

Bayou Louise is on Siesta Key, a strip of land with the Gulf of Mexico on one side and the bay of Sarasota on the other side. Here you find a few great examples of the early work of Twitchell and Rudolph, including the incomparable Revere house.

Revere Copper Company, founded by Paul Revere, put its name on this house alongside *Architectural Forum* magazine, which endorsed the work of Ralph Twitchell and Paul Rudolph with extensive, nationwide publicity that included the house used in Revere advertising campaigns in 1948. When the Revere house was completed and opened to the public, some 16,000 people passed through its doors within just the first year.

Rudolph had just returned to Sarasota and was Twitchell's associate at this time. He did most of the construction drawings while in New York based on Twitchell's experiences with the Lamolithic concrete system employed for Lu Andrews house No. 1. The system consisted of a poured concrete roof slab set on a series of steel lally columns that allowed for freedom in the placement of any interior walls, as the load was borne by the vertical supports and all the exterior walls were made of poured concrete. Lamolithic construction also allowed for huge expanses of glass.

When first built, the Revere house included an interior open-air courtyard that brought the outside in and wide roof overhangs for shade. The roof was coated with a porous material that intended to absorb water from sprinklers located on the roof and thus reduce the temperature inside the house.

The client for this project was Roberta Finney, who eventually became Twitchell's second wife. Rudolph conceived his visionary design for the project while away from Sarasota. The main house was to be joined to a small guest cottage by a wooden walkway over the water. The two-bedroom house—with a large enclosed living area, walls of glass, and easily accessed screened outdoor areas—was to become a typical plan for many houses of this time. It had all the necessary elements for housing in this tropical environment: glass jalousie windows to catch the cooling cross breezes, terrazzo floors, and wide roof overhangs to create shade. The Revere house also had copper elements, especially the chimney and the cooker hood, which funneled out cooking fumes and worked as a radiant heater when a wood fire was burning. Interior walls of storage divide the areas and are

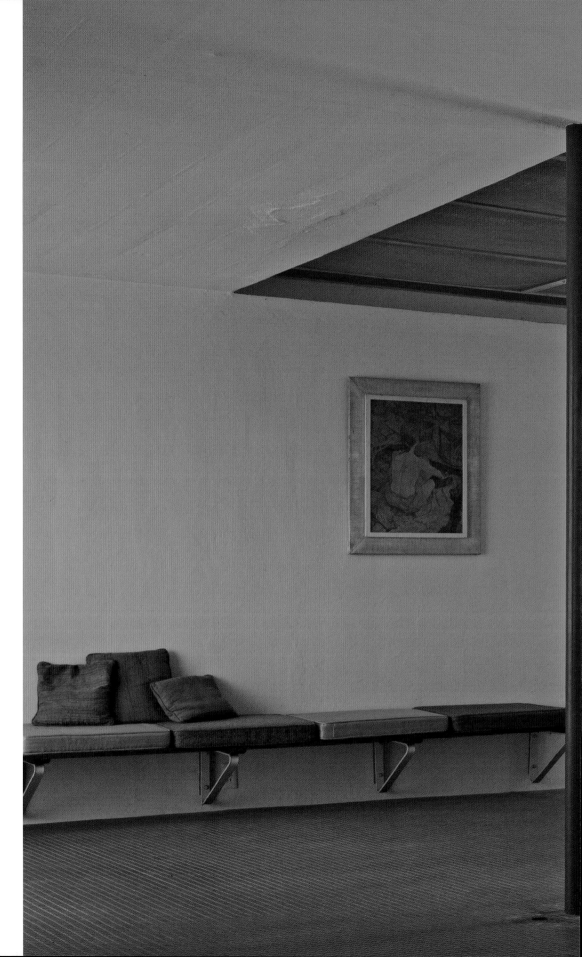

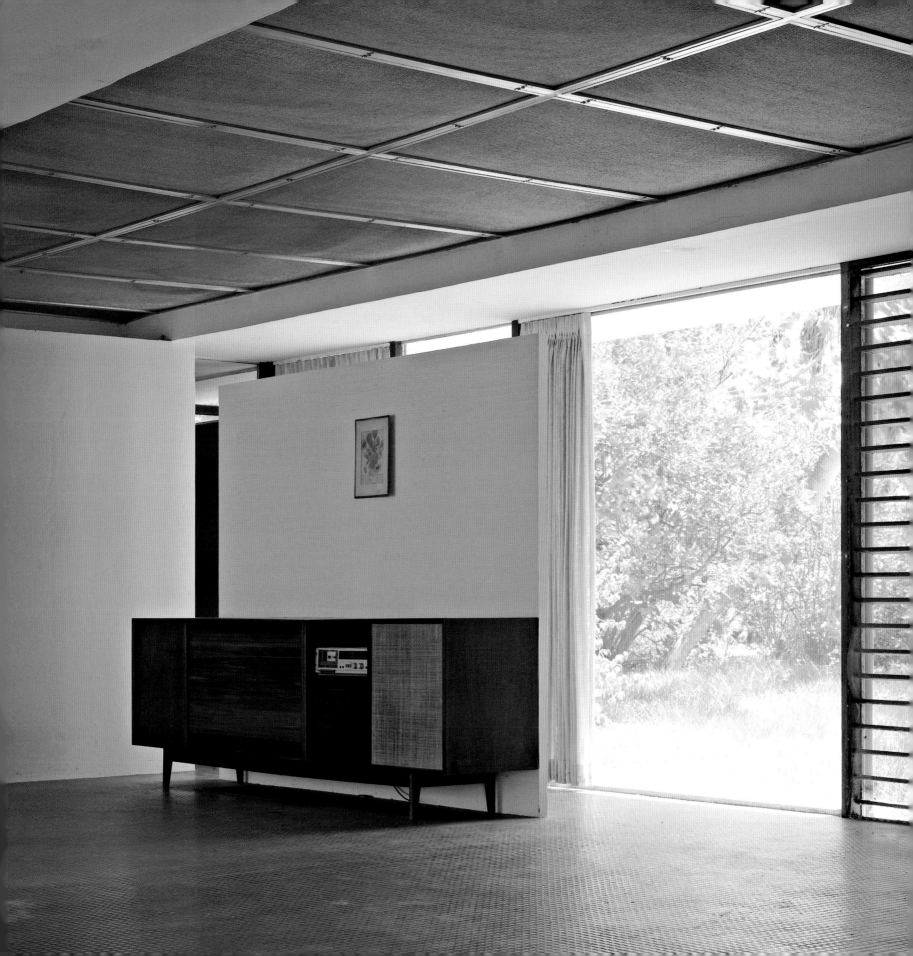

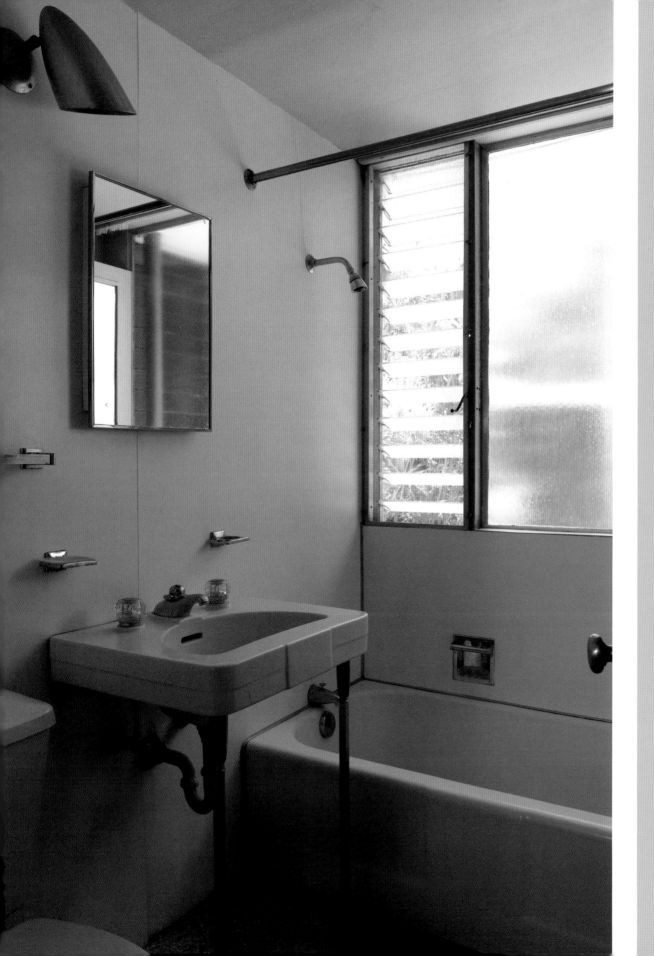

Page 32-33
The once open-roofed interior garden with timber jalousies that enable the benefit of the cooling crosswinds. The wall-mounted seating and the radiogram are all original to the house.

Left
The original bathroom still intact with its Twitchell blue ceiling, and the jalousies for ventilation.

faced with striated ply, which is plywood with a milled finish that resembles various thicknesses of groove with folded leather pulls.

In an early, unbuilt design by Rudolph, a group of six interlocking houses was proposed. A series of lamolithic houses were built though also on Siesta Key. This was Rudolph's first and perhaps only chance to experiment with multiple housing where termites and hurricanes were the only enemy.

The house was soon enlarged with the once carport becoming another bedroom and the indoor/outdoor central living space becoming more enclosed with the introduction of glazed walls and wooden jalousies. The open roof filled with a fiberglass material allowed some light to come through. A guest suite and new carport were added to the lot, and followed the same visual elements of the main house, with of course the famous Twitchell blue roof overhangs and ceilings seen in many of his houses.

Twitchell married again after the death of Roberta Finney. He married Paula Bane in 1969 and they lived in this house until his death in 1978. Paula carried on living there until she died when the house was then left to Aaron, son of Ralph and Roberta; his sister; Paula's son; and Sylva, Ralph's daughter with Lucienne. Aaron, who had grown up in the house, carried on living there with the house declining around him, but surprisingly remaining intact. The family hoped that he would buy them out but unfortunately taxes and upkeep prevented it from staying within the extended family, so it was sold.

It is amazing how this house has survived in this ever developing market where many important houses have been lost.

This house and lot has recently been resold to a speculative developer. While the original structure is to be retained and restored, it will be overshadowed by a huge white box, raised off the ground to meet local requirements, installed within the footprint of the original Twitchell addition.

Guy Peterson is working on this architectural assignment. The master plan for this site is a complete restoration of the Revere House back to its original 1948 condition, as well as a design for a new code-conforming, 4,750-square-foot adjacent house to serve as the principal residence. "The relationship and dialogue between the two structures is critical to the success of this project," Peterson says.

The project is explained in more detail here by Guy Peterson: "Because of the Revere House's small size—less than 1,000 square feet—the purchase of this property and its restoration only becomes financially feasible if a larger home is constructed with this house to justify the cost of the waterfront property it sits on. The Revere House is very low in height (eight feet to the top of the roof) and the new house's lowest habitable floor is required at this same level. This relationship coupled with the only buildable footprint to construct the new home as a long linear area directly to the south of the existing house. It makes the design a careful study of the relationship between the two structures. The new house is completely independent of the Revere House and is slightly rotated off a perpendicular axis to create a dynamic relationship between the structures. The area below the new house is carefully left open adjacent to the Revere house to allow for sight lines under the belly of the house to a controlled courtyard in the distance. In the new house, carefully designed walls are placed so that occupants do not look down on the roof of the original house. As the new house emerges seaward of the existing house, the walls become glass and take advantage of the rear garden and pool area, as well as views to the lagoon and glimpses of the Gulf of Mexico. The area of the Revere House defined by the original detached laundry becomes a courtyard defining the entry for the new house and an exterior entertainment area for the old house. A pool is being added on axis with the Revere house covered courtyard. The original house will serve as a pool cabana and guesthouse in the new master plan."

This seems to be the way forward—the original masterpieces of the Sarasota School of Architecture retained and restored alongside the addition of new architecture bringing the lots up to date and new recognition and publicity to the concepts as a whole—opening up the eyes of those who perhaps would not otherwise be aware of the historical importance of these earlier buildings.

Page 36
The built-in desk area and storage define the space within the house. The steel columns support the poured concrete roof above. A steering wheel clock by George Nelson is on the wall. The copper hood above the fireplace acts as a chimney on one side and a cooking extractor on the kitchen side.

Page 37
The original door to the carport is flanked with full-height adjustable louver panels.

Page 38-39
The front elevation, unchanged for many years except for the relocation of the front door. The timber jalousies originally encouraged cooling through cross breezes.

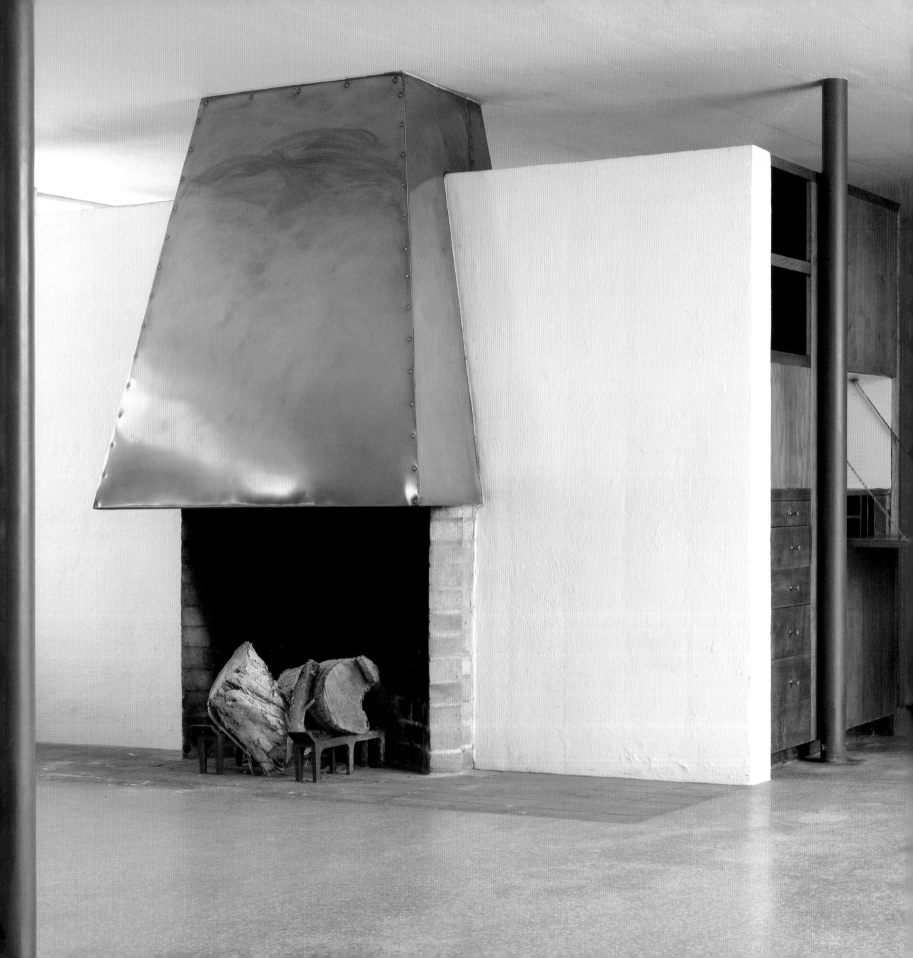

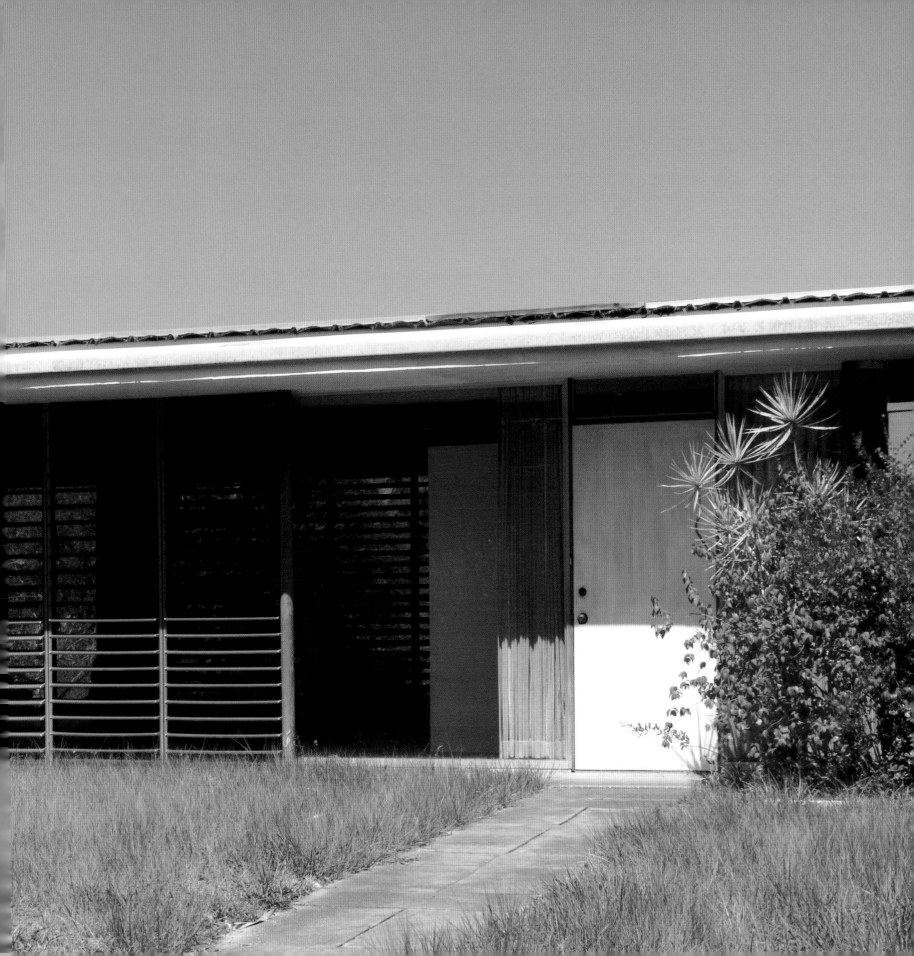

Hiss House

Lido Shores

Philip Hiss with Christopher Robinson, 1951

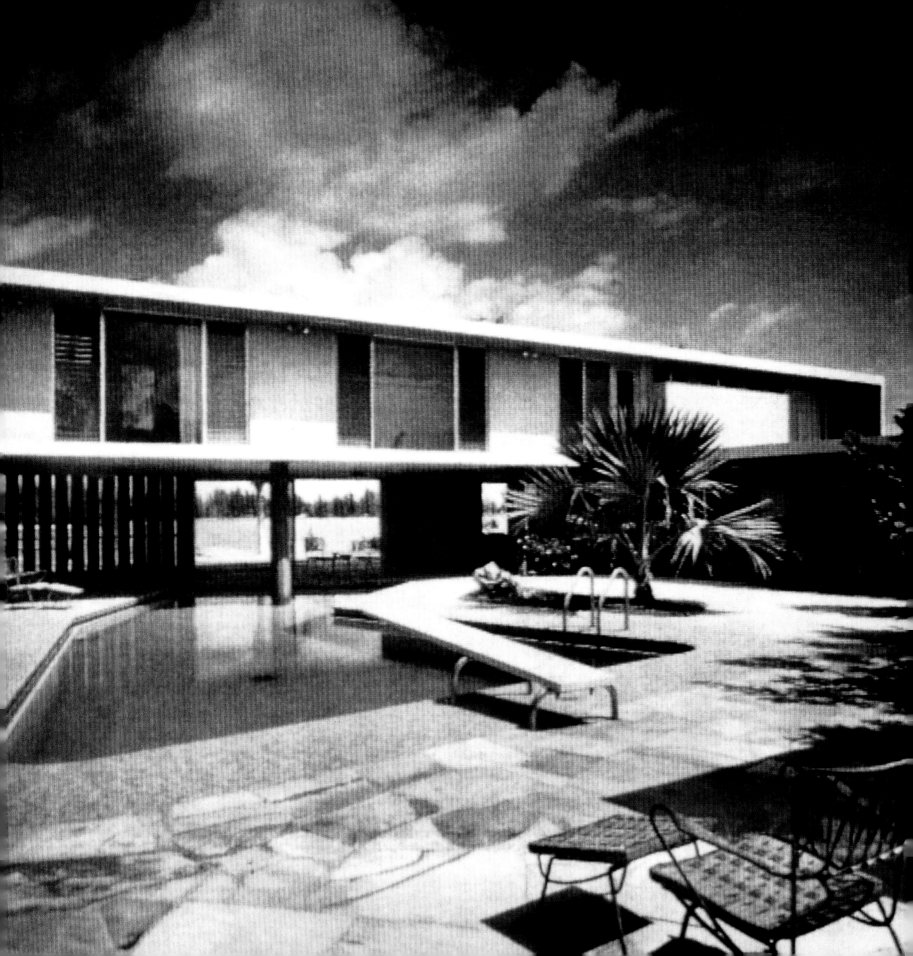

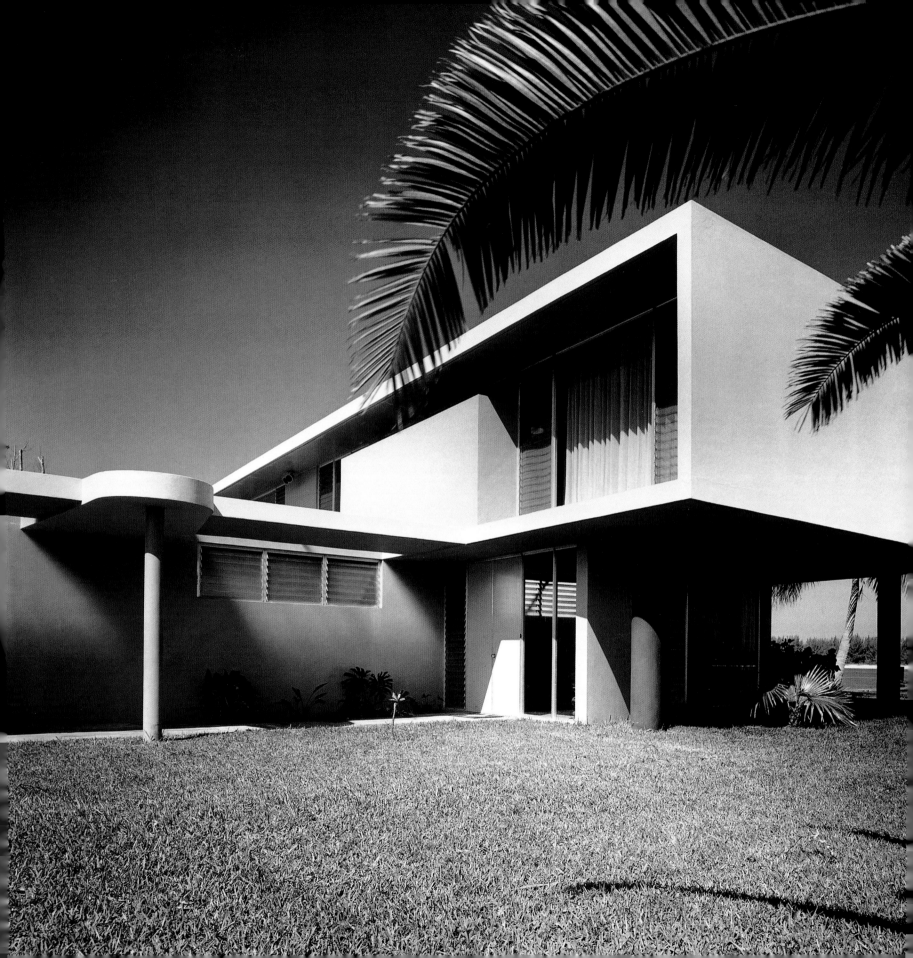

Page 40-41
Luxury and glamour at the original Hiss residence. An angular pool flows under the house.

Left
The service wing of the house juts out from the main building. A white box on stilts, how more modern could it be?

Right
A simple staircase from first to second floors rises upwards on a curved wall. This area, with its telephone shelf, was a busy area of the house.

Philip Hiss built his speculative houses at Lido Shores to invite the cool breezes in and to get shelter from the sun, rain, and bugs. According to a July 1954 article in *House and Home* magazine, "he demonstrated to people everywhere how simple it is to keep cool." In building his own house, Hiss intended to build the right house for the right location, and, moreover, to use good materials, have good layouts, and, above all, make it look good.

Hiss lived a glamorous life, able to go anywhere in the world when he fancied. He toured South America on a Harley Davidson, was involved in the inaugural PanAm flight from Rio to Miami, lived in Bali for a year, and, prior to settling in Sarasota, was a residential developer in New Canaan, Connecticut, before serving in World War II.

Hiss had traveled in the South Seas to explore, take photographs, make notes, and write a few books. Returning to the States with an interest in building, he announced that "the average man's architecture in the tropics doesn't offer any good solution to the problems of heat and humidity. Native architecture is often much better. . . ."

When he arrived in Sarasota, Hiss knew he had to do something about the problems of living in a near-tropical climate. Working with local architects, the Zimmermans, he built several South Seas–type houses in the late 1940s before designing more modern houses himself. He used his experiences in Bali to create the ideal home for those acute conditions. How could the native hut be adapted for modern needs? He knew he had the answer.

On his colony, Lido Shores, Hiss encouraged other architects to build top-rate architecture. His "spec houses" were priced to sell, from around $15,000 to $60,000. The first group to buy included a corporate vice president, a hotel chain magnate, a radio station operator, a newspaper publisher, the president of a major engineering corporation, and an aviation industry official. These high-profile buyers appreciated Hiss's answer to the very simple question: How to keep cool in a hot place?

By 1950, Tim Seibert had returned from his time in the Navy and at Stanford and was working for Hiss as a draughtsman. Even though Hiss took the design credits for this house, he had employed an architect, Christopher Robinson, to work on the architectural side of the development. Robinson was more involved in working out the project rather than the visual architecture of it; for example, he was responsible for the slab concrete calculations.

Seibert recalls that Hiss was very involved in the house, working with Phil Hall, a local decorator, on the interior design. Hall had a store in downtown Sarasota where he carried new work from Knoll and Herman Miller and even imported new Scandinavian designs. The end result was a great example of Sarasota School ideals but totally different in construction from other houses being built at the time by Twitchell, Rudolph, and the Zimmermans. Hiss's house was an important architectural landmark of the time. Unfortunately it was recently demolished to make way for two McMansions constructed by the Vittadini developers.

The two-story concrete house was built on a lot overlooking the Gulf of Mexico; the bedrooms were on the upper level with jalousie windows, while the main living area at the lower level was a breezeway. The main part of the house was built over an abstract-shaped pool that carried on under the building. Built in 1950, it was the start of something big. It would draw great attention to what was happening in Sarasota at the time—Lido Shores was the hub of the incipient architectural movement. Hiss himself took great photographs of the area, using color film, while Ezra Stoller and Joe Steinmetz recorded all that was happening in black and white.

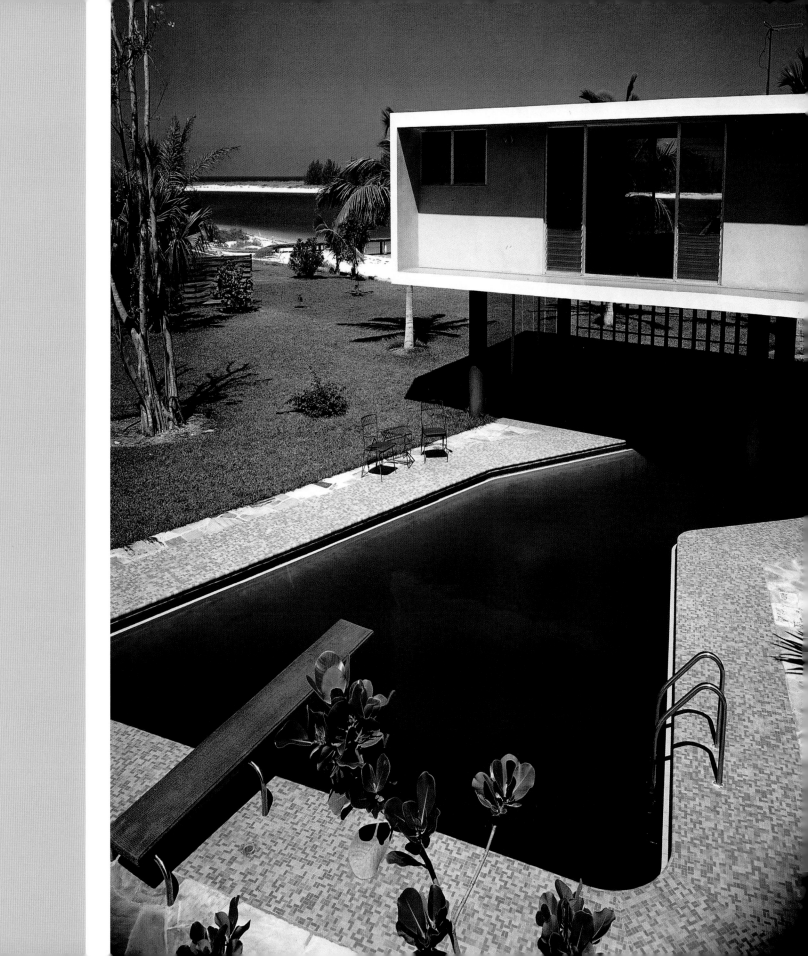

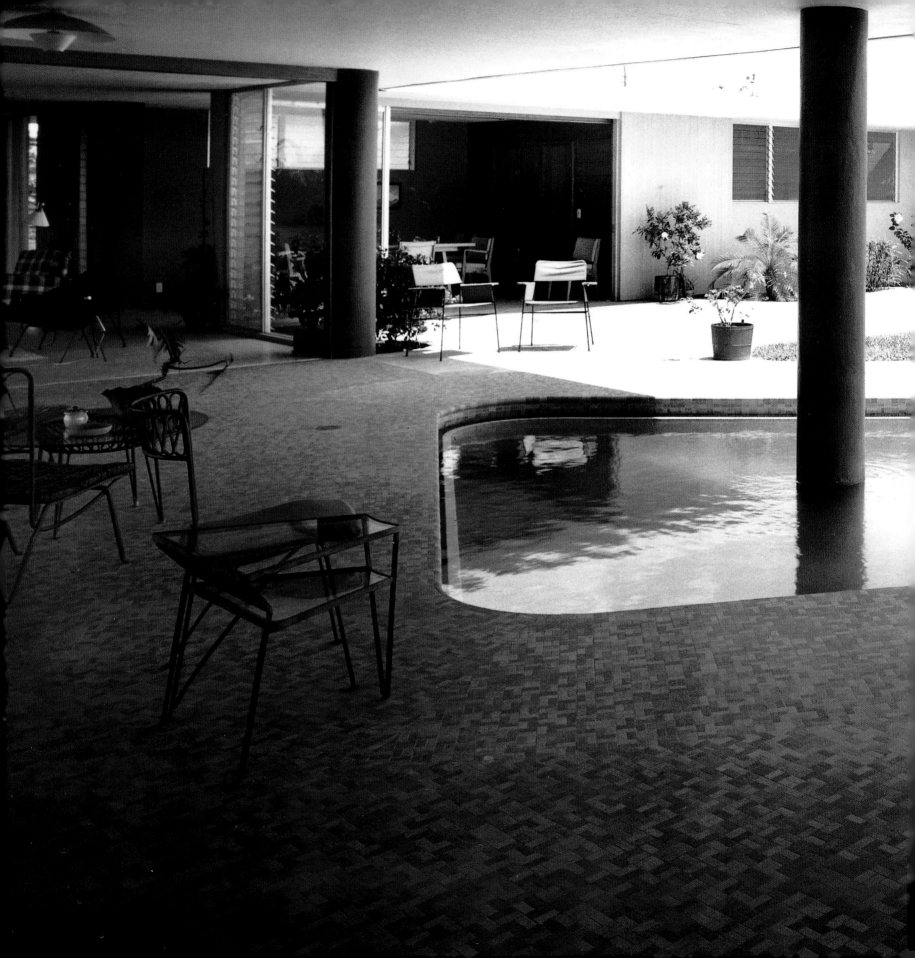

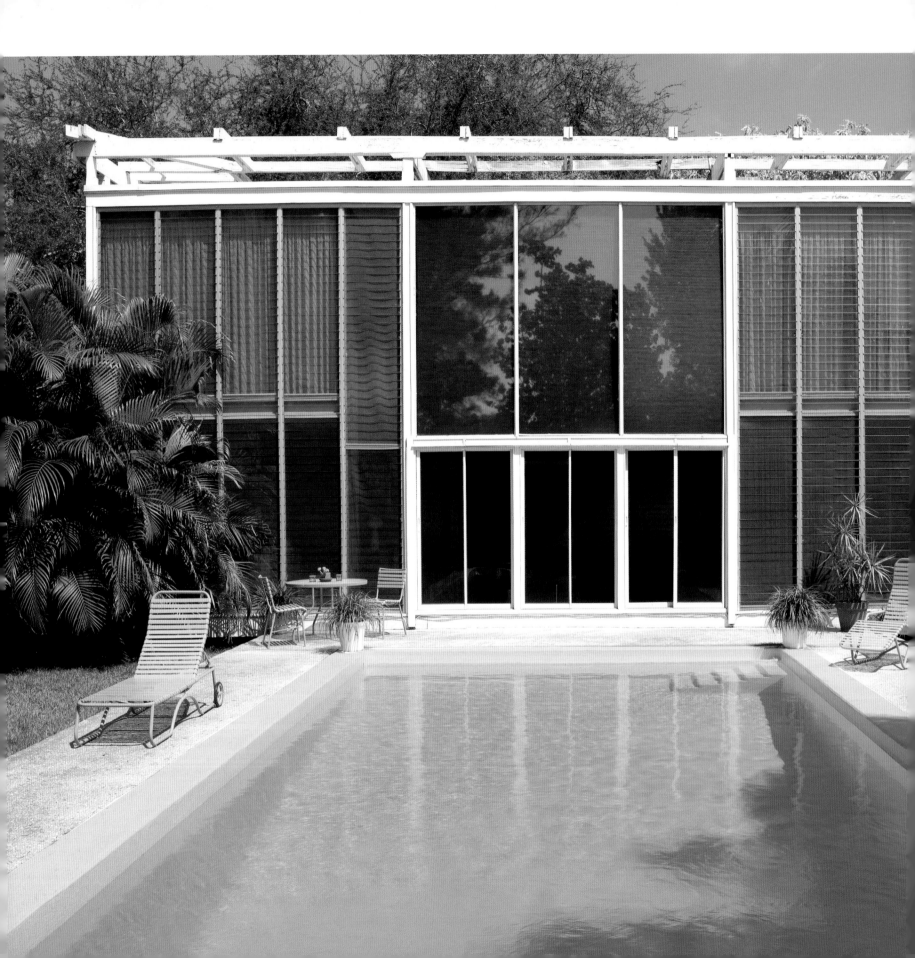

Umbrella House

Lido Shores

Paul Rudolph, 1953

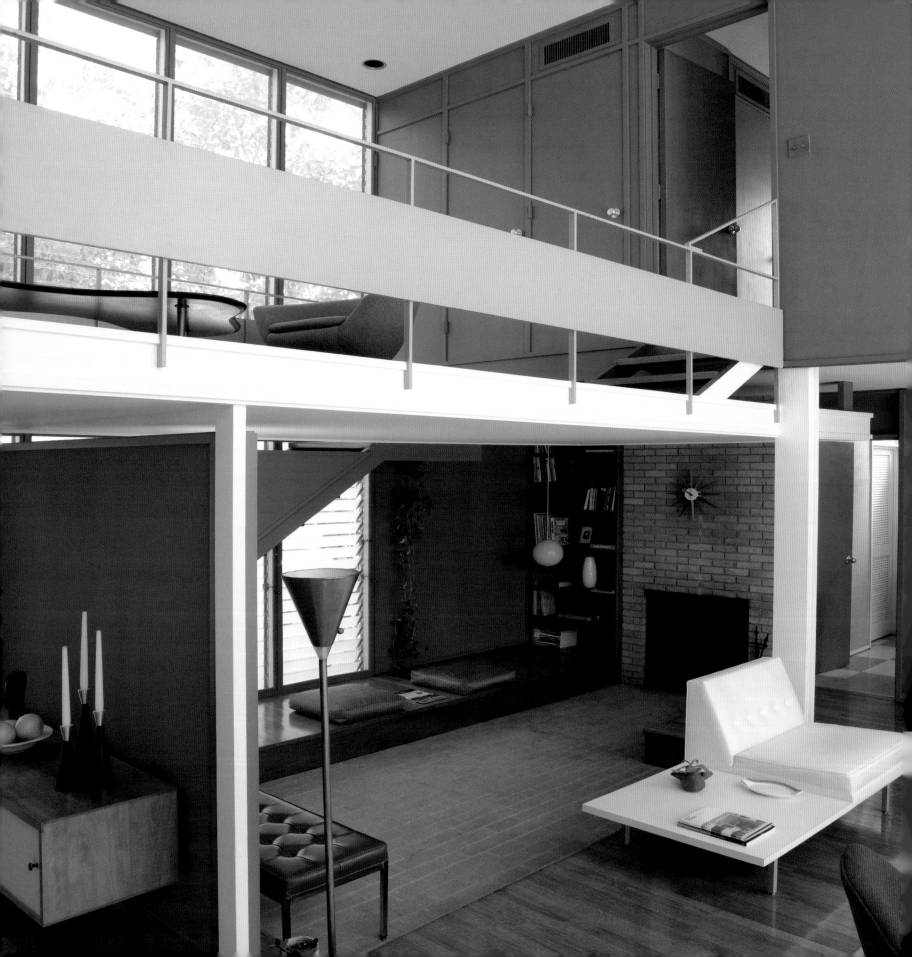

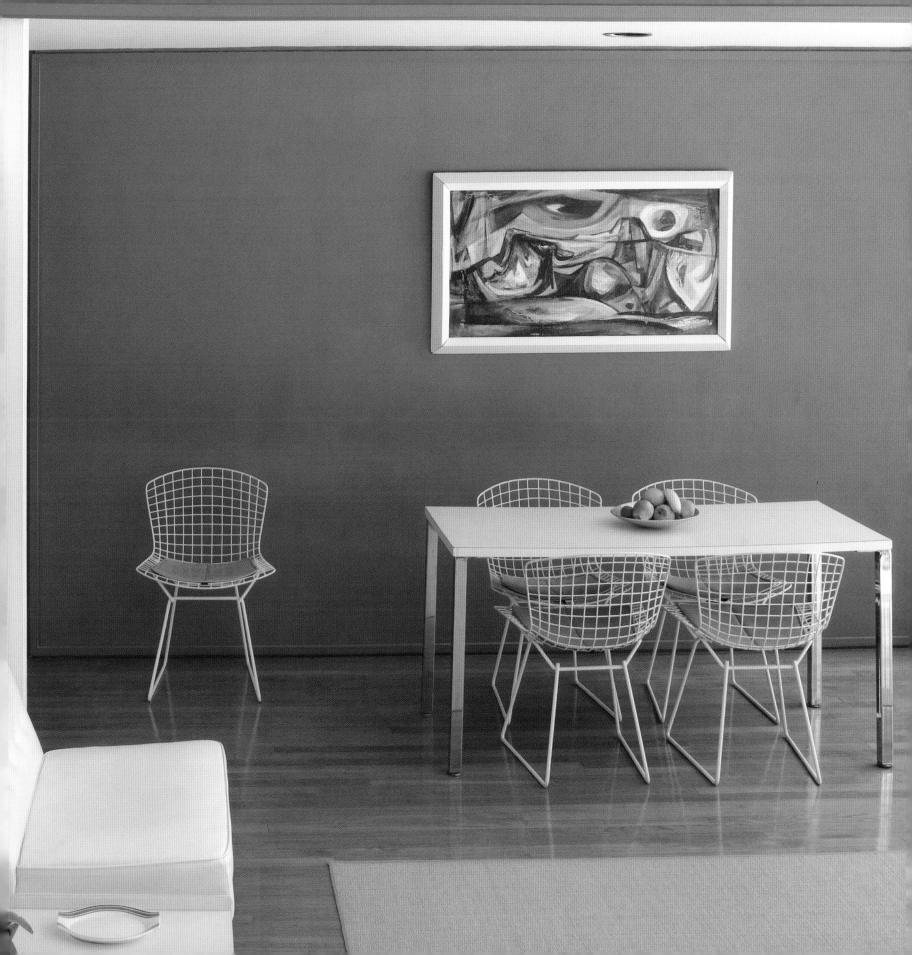

Page 48-49
A spec house for Philip Hiss by
Paul Rudolph stands prominently
on Lido Shores. The pool-facing
elevation shows the vast area of
jalousie windows. On the roof are
traces of the huge "umbrella" that
shaded the pool area.

Page 50
On entering the house,
a screen wall leads you in to the
double-height
main reception area.
A mezzanine area above
leads to the bedroom areas.
Seating by George Nelson
and Florence Knoll works
well in this space.

Page 51
Here a simple dining table flanked
with Bertoia wire chairs gives an air
of space and organization. The walls
are painted to an original color
selected by Rudolph.

Left
The kitchen, with its original
cabinetry, looks out onto the den
area below the mezzanine.

Right
The full double-height reception
area is shown to its best advantage.
Behind the Nelson seating is a unit
that houses office storage in the room
beyond and acts as a well-positioned
display area. Above, the bedroom
has sliding shutters and again the
protruding storage.

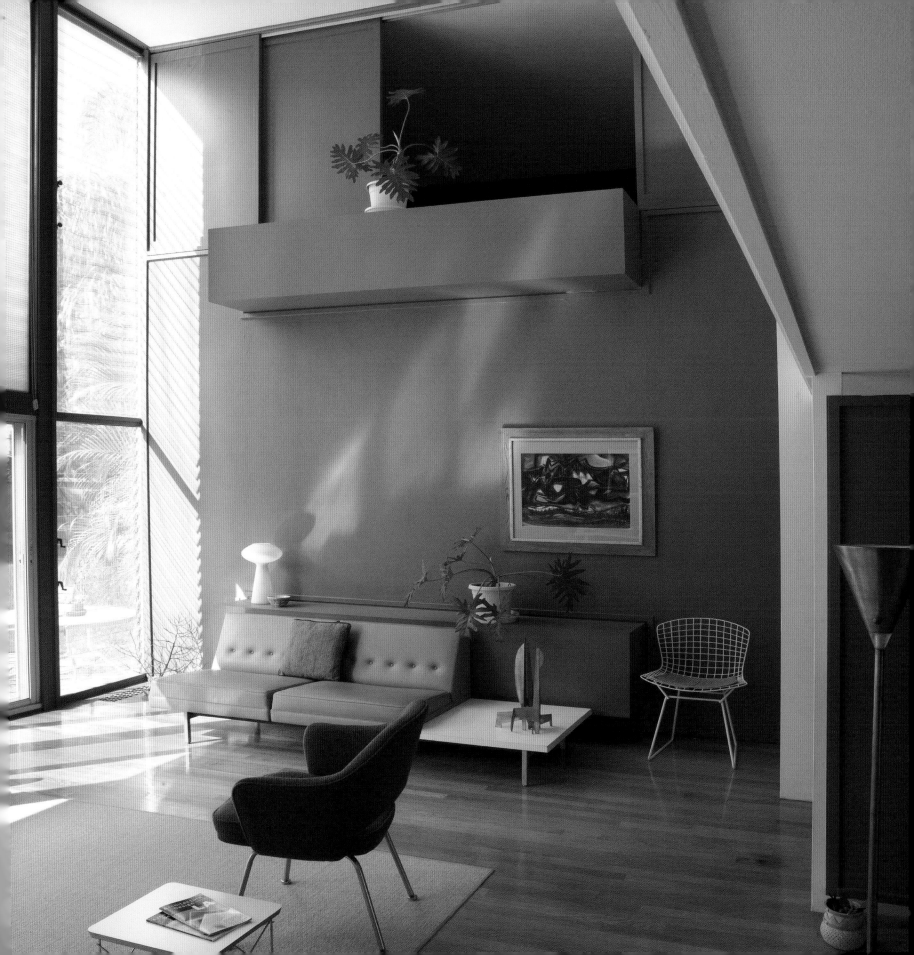

Rudolph, now with his own practice, built the Umbrella house for speculation under the guidance of developer Philip Hiss, in the "colony" of Lido Shores. Following the principles and ideas of Hiss's own house across the street, this house was meant to harmonize with the tropical climate.

Like the Hiss house, the Umbrella house was featured in *House & Home* magazine, July 1954, in the article entitled "Houses for hot climates." Photographs by Lionel Freedman accompanying the article showed the full visual impact of the house on the surroundings. With illustrations of the plan, the magazine described the house: "The house proper is a two-story structure, forty-four feet long and twenty-five feet deep, containing a dramatic two-story living room at its center and a series of balconies and connecting bridges around it. These accommodate three bedrooms, kitchen, baths etc. Front and rear walls are almost entirely of glass jalousies that permit cross ventilation in every room."

Built so that it could be seen from various view points and situated at the curve of the main road leading north to Longboat Key, the Umbrella house could be seen to its best advantage. This prominence on the horizon underscored Rudolph's demand for public awareness of his work. It stood out as a herald of the new development happening on Lido Shores.

One side of the house faced the Gulf of Mexico; the other faced Sarasota Bay. Both sides were glazed over entirely with large fixed planes of glass and banks of jalousies that encouraged the trade winds to cool the house when necessary. The other two sides enclosing the box are faced with wooden siding. Air conditioning was eventually installed, but the jalousies stand as an important visual feature of the elevations.

The three-thousand-square-foot latticework parasol, the "umbrella," was an entirely separate structure supported by twenty-six double columns. A two-foot air space existed between the parasol and the roof of the house. The purpose of the parasol, made from hundreds of tomato stakes, was to shade the roof, the terraces surrounding the pool, and part of the lot. Its pattern against the sky was graceful and charming.

Shortly before the house's completion, William Rupp joined the Rudolph office. Even though the majority of the drawings and construction were already done, Rupp involved himself in the detailing of the umbrella. He also worked on some of the interior features, such as the safety rail along the walkway to the bedrooms in the house. In a letter to Rupp, Rudolph wrote about this area: "I am most disturbed at spacing of supports for railings on Hiss job. Too many vertical supports. I prefer it as sketched. The only thing one really needs is something to catch if you start to fall. If Phil insists on having more then use a vertical support to align with each window mullion, but have it the same height all the way across the balcony (not inclined as one reaches the bed rooms)." Regarding the umbrella, he continues: "The bracing of the sunshade roof is really difficult. I am somewhat leery that this scheme will solve completely the problem. I prefer the tension members in the roof to be above the cypress slats although I realize that this will cause some difficulties in attaching tension members to column and beam." Rudolph added a little sketch to explain his ideas.

Rudolph was often away from Sarasota, either at the University of Pennsylvania, at Harvard, or in New York, and corresponded with Rupp to stay updated. Based on the comments and ideas in his correspondence, one senses that he was perhaps more concerned that the end result look as good as possible rather than that some design elements might function better.

The Umbrella house seems to have changed hands often over its first years and was only really used in the winters. Its most recent stewards bought the house in 1997 from previous owners, who had lived there for thirty years. Amazingly, not a thing had changed. The house retained the two-story breezeway at its core as well as its open bridges and all the bathroom fittings and kitchen cabinetry. All that was missing was the umbrella, lost in a storm just a few years after construction. There is a plan to replace it, however, whether executed by its current or future owners. These present owners have meticulously restored the house to its former glory, reinstating the colors intended by Rudolph and adding sympathetic furniture and furnishings.

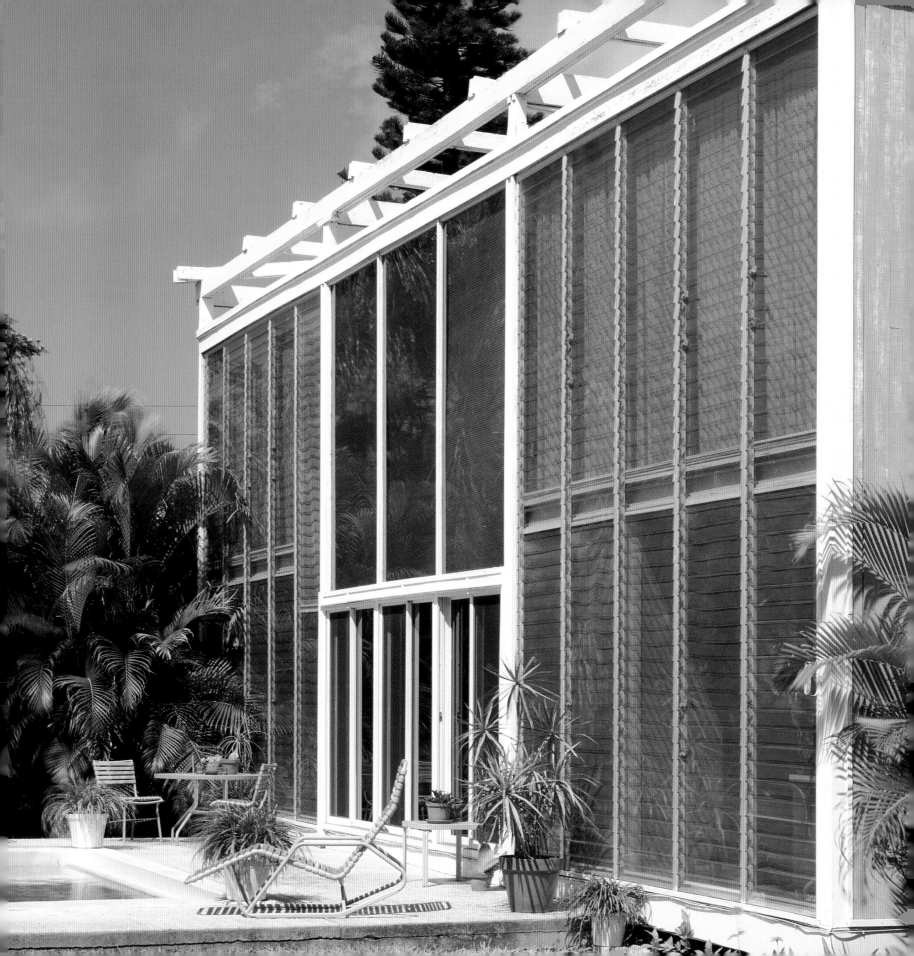

Hiss Studio

Lido Shores

Tim Seibert, 1953

addition by Bert Brosmith, 1962

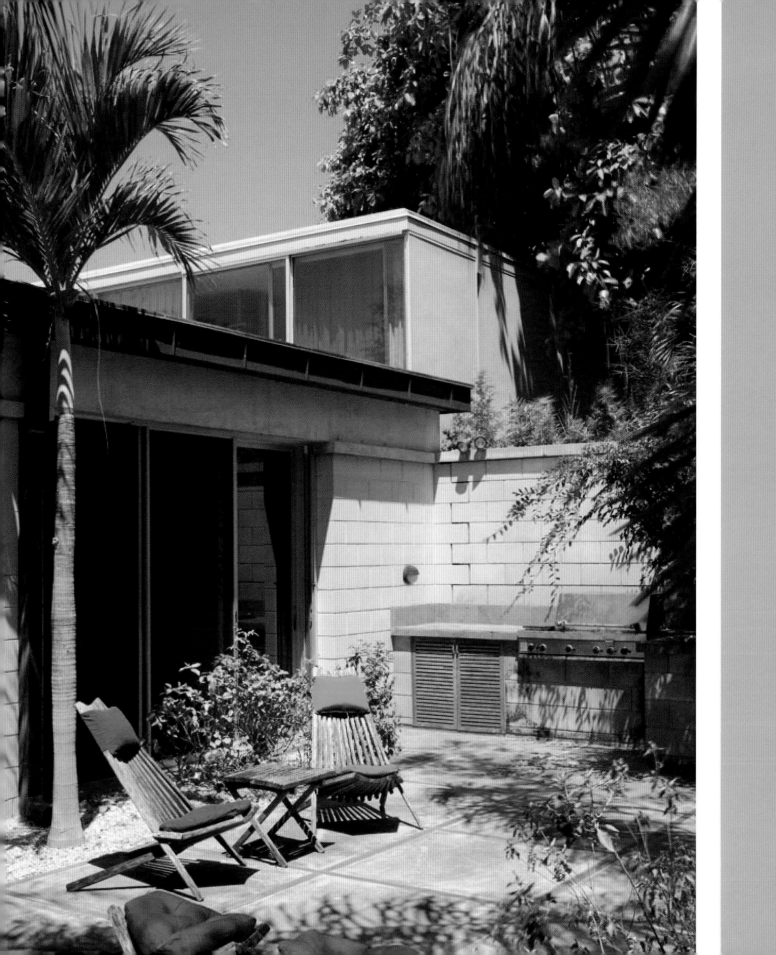

Philip Hiss built a studio designed by Tim Seibert on Lido Shores in 1953. Published in *House and Home* magazine, July 1954, the studio was the first glass building to be completely serviced by central air conditioning. Hiss explained: "A/C is expensive, though when I consider the damage to furniture, draperies, books, clothes, et cetera, due to salt air and moisture, I wonder how expensive it really is." So it was used here to protect his extensive book collection from mildew and fading induced by the humidity of the tropical climate.

The studio was intended as a place of work that also housed Hiss's books. It featured fixed windows and curtains sprayed with aluminum to reflect the heat. Standing on concrete stilts to allow for cooling cross breezes under the house, the house follows many of Hiss's hot-climate construction ideals, including the usual large overhang to create shade, albeit atypically subtle here. The A/C and the insulated drapes were supposed to compensate for the heat and sunlight that pounded the building during the tropical season.

The original studio's layout consisted of an entrance lobby at ground level and a sweeping marble tread staircase leading up to a large library level with adjustable racks for books (conceived by Hiss but drawn up and worked out by Tim Seibert). A small kitchen is hidden behind full-height folding panels. A tiny corridor leads through to the office area and a bathroom. The office includes more bookcases, a desk, and other storage units. Most fittings were built in, with partitions folding to open up or close off certain areas when necessary. Siebert recalls that these fittings were designed by Phil Hall, who had a large and well-stocked shop on Orange Avenue in downtown Sarasota. Hall carried Eames furniture, Mies Barcelona chairs, and even imports from Scandinavia. He supplied most of the furniture for local houses when they were photographed.

Seibert worked in the office of this building during the mid-1950s while the Umbrella house was going up next door. He recalls contacting Rudolph, who was in New York at the time, with concerns about the stability of the structure of that house. "The glass will stiffen it up," Rudolph assured him. And it did.

In 1962 the Hiss family decided to convert the studio into a residence to house his children and their nanny. Bert Brosmith, who had come to Sarasota in 1955 to run Rudolph's office until 1960 when he opened his own office, was called in by Hiss to design the living quarters that would fill in the lot at the rear of the existing studio. This created a courtyarded lower level with living, sleeping, and kitchen areas that are cut off from the studio. The addition feels like it is underground, a cooler space to live in. It benefits from great detailing and space allocation and promotes the inside-outside lifestyle. Carl Abott, who at that time was an eighteen-year-old architecture student, was one of Brosmith's designers. His full-height doors still fit as snugly as when they were first hung. This addition was built from naked concrete block, an often used element in Abbott's work.

In the late 1960s, Hiss and family, disillusioned with what was going on in Sarasota, packed up and moved to England. At this point the Sarna family bought the studio. (At the time of purchase Mr. Sarna ran a restaurant in the Ringling Towers Hotel, since demolished.) Two daughters were brought up here: Shivan Sarna moved in at eight and lived there until the age of thirty-five. She recalls that when her school friends came around they were in awe of the building; to her, it was home and she didn't realize how different it was until she would go to their colonial homes. It was like living in a gallery, she says, especially with the Indian artworks. Yet the intricate wood carvings added a sense of coziness, a good contrast to the hardness of the concrete block, especially at the first-floor level. "I love that house," Shivan explains. "The space was comforting to me. My grandmother thought it looked like a prison, and I understand why. To me, however, it was a safe haven. The courtyards were my own private gardens. When you came home, you were safe and truly away from it all. The contrast of the utter privacy with the access to the outside via the interior atrium and side gardens was revitalizing."

Left
Hiss's original office with its built-in
storage including plan chests and
filing cabinets. The desk is flanked
with red painted chairs designed
by Charles Eames.

Right
The small kitchen area at the library
level can be screened off with full-height
folding panels.

Page 62-63
Hiss's library on the second floor of the
house. The original book racks still in
situ. Here, his collection of rare books
was protected from the damaging heat,
light, and humidity found in the
Florida climate. The marble tread
staircase is just visible.

Page 64-65
A former indoor garden,
the curvy steel and marble staircase
sweeps its way up to the library level.
The original 1950s wall sconces
remind us of the house's age.

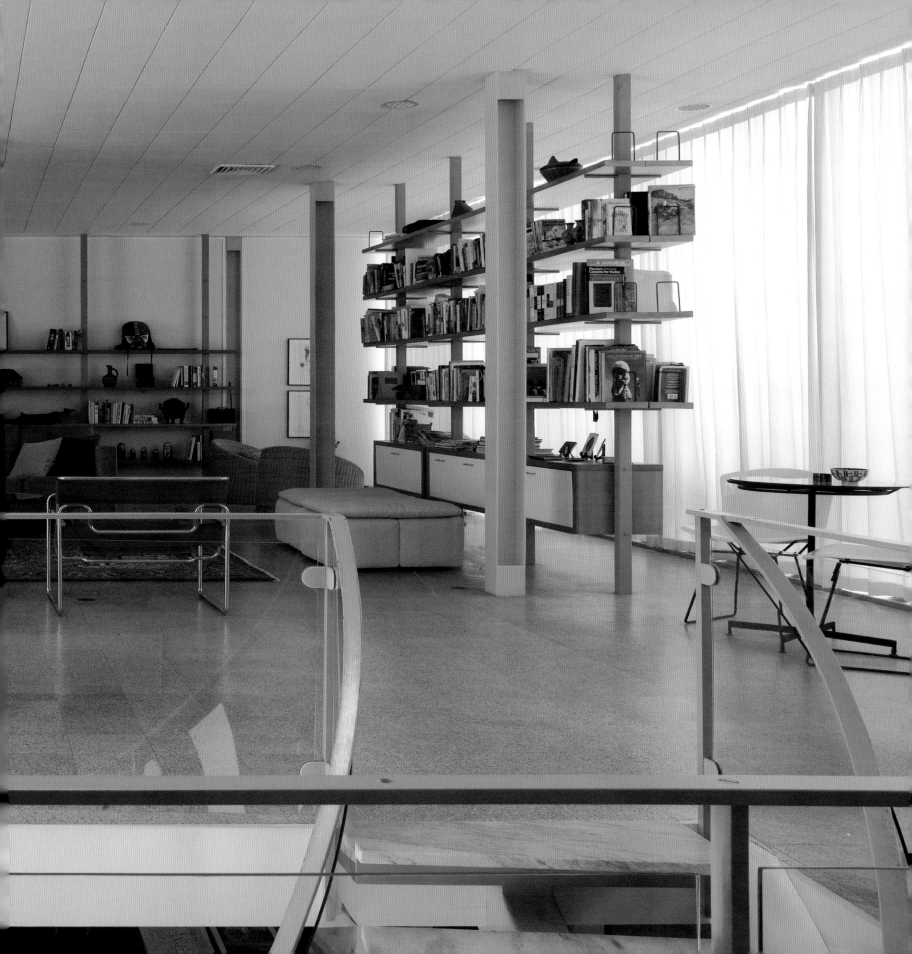

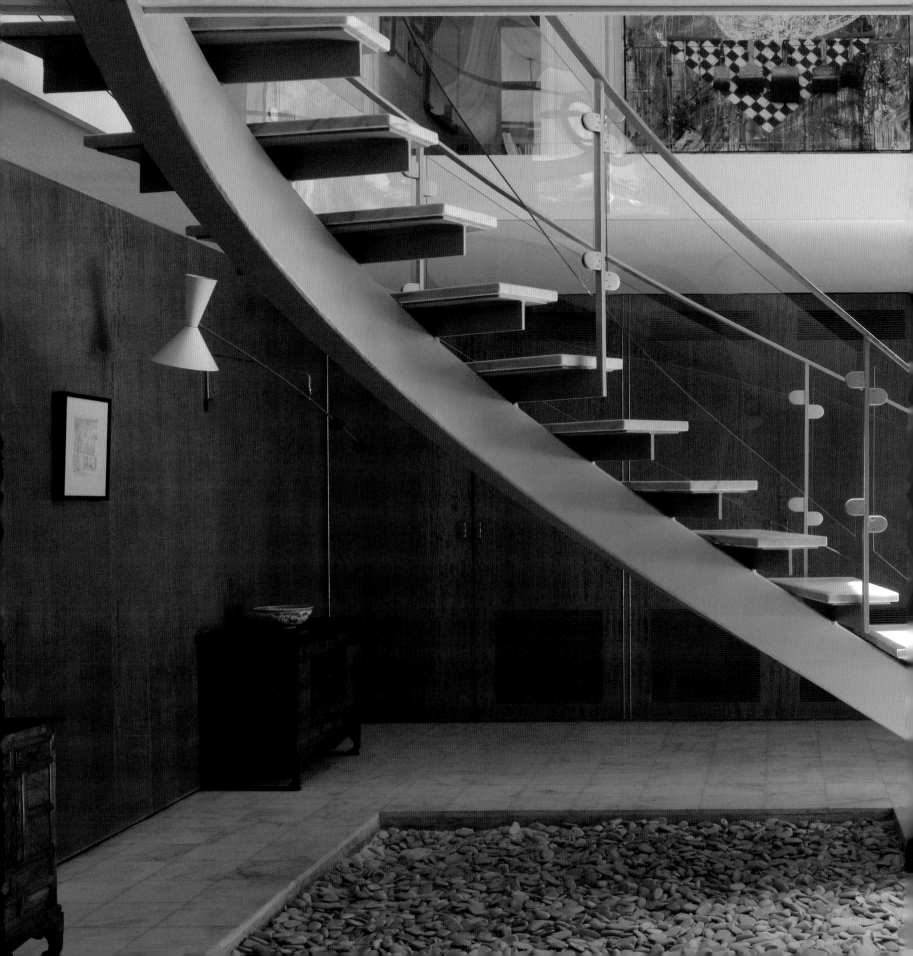

The Sarnas became importers of Indian artifacts and the house somewhat resembled a museum full of carvings and temple bells. The only significant thing the Sarnas did to the house was to install metal louver shutters to the front plate-glass windows, intended to shield against the afternoon sun and act as storm and hurricane protection. Sadly they also sold off half the lot, where there now stands pseudo-chalet ski lodge. They eventually sold off the house to Heather Salvatori, who was making something of a specialty of restoring interesting houses.

Salvatori did a massive restoration job on the building, ranging from removing the recent storm shutters to installing sliding windows in the library area. As the house was for the most part complete and untouched, most areas needed only restoration and refinishing, rather than replacement.

More drastic alterations and remodeling was done to the Brosmith addition. Rooms were enlarged by moving existing windows out to the edge of the building, incorporating the screened porches what were intended to be shaded overhangs. She also completely removed the end wall of the main reception room thus bringing in much more needed daylight as in the other rooms. With the high block wall added by Hiss, the garden became a series of outdoor rooms integral to the complete design of the house. The kitchen was also remodeled and brought up to date, with a central island incorporating the stove and new sympathetic cabinetry.

Bob Garvin bought the house in 1996 after the house had been on the market for three years. At this time the demand for modern houses in this area was very narrow. The masses wanted Mediterranean-style houses with bougainvillea around the door, as to some extent they still do now. Some simple reorganizing of the internal space and closet areas was carried out, and to cater to Garvin's cooking habits an exhaust fan was installed above the central island. After a simple updating of the paint color used for the steel work (now a gray green that matches the solar film on the windows), the studio looks as modern as it must have when it was first built.

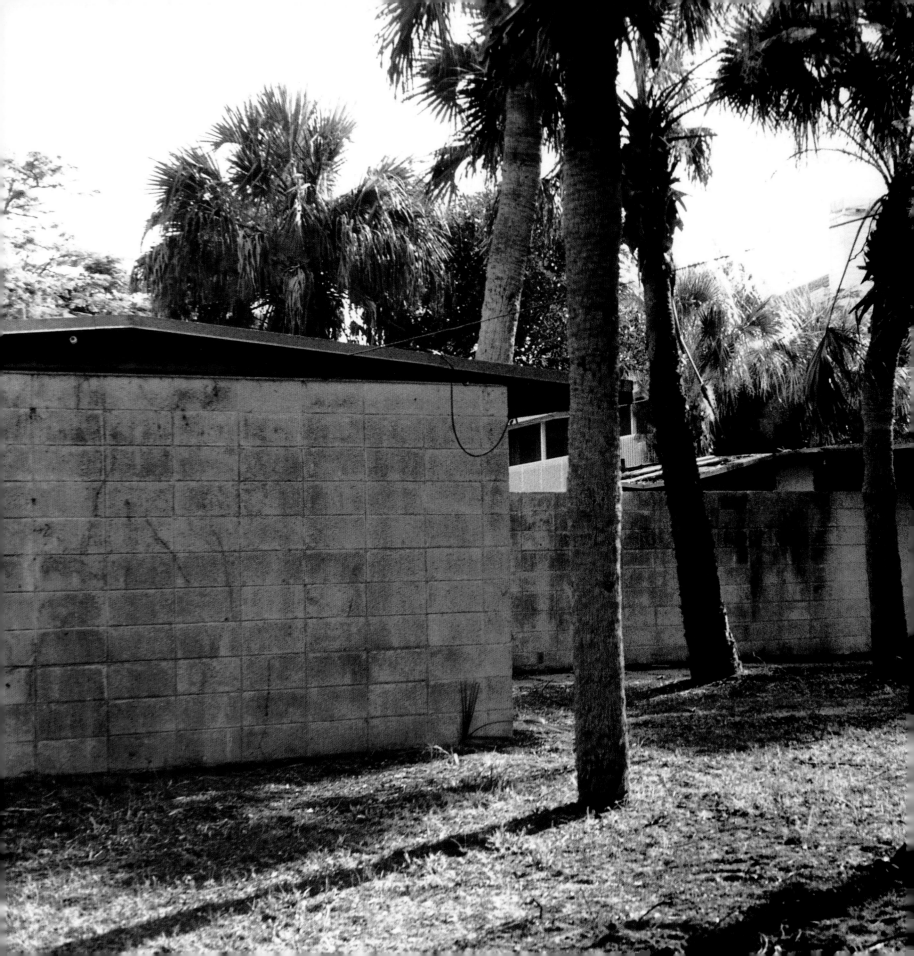

Spec House

Siesta Key

Ralph Twitchell, 1954

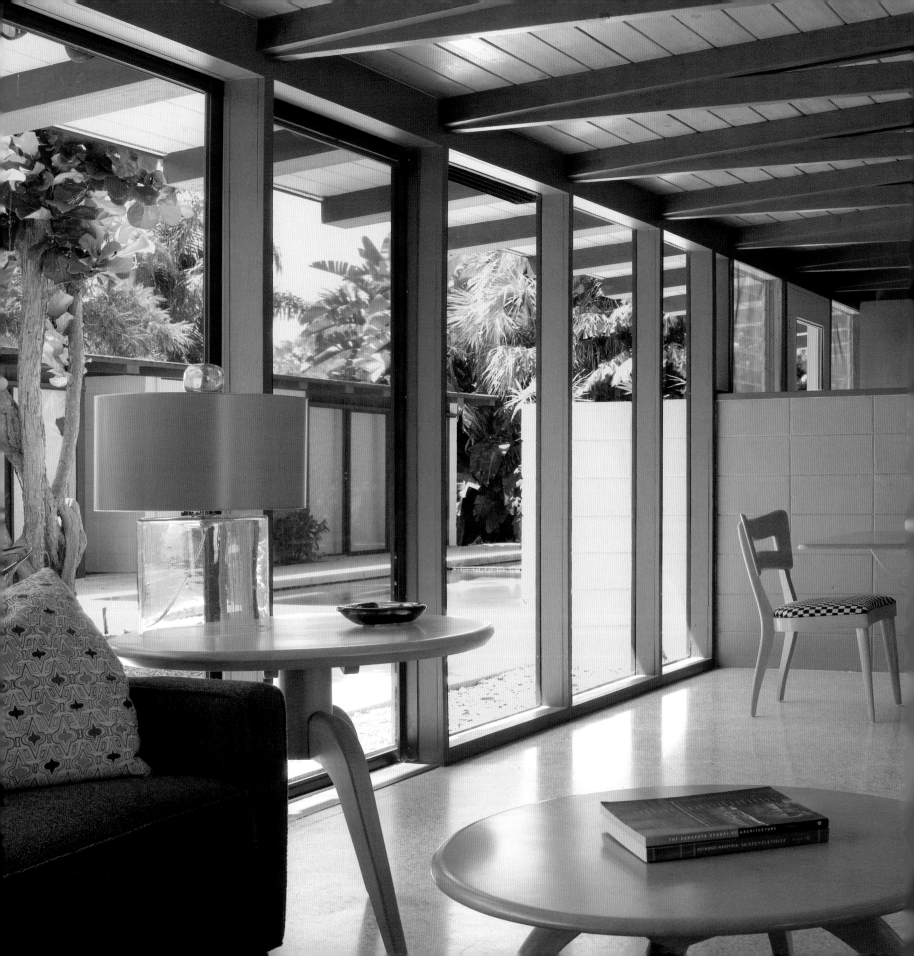

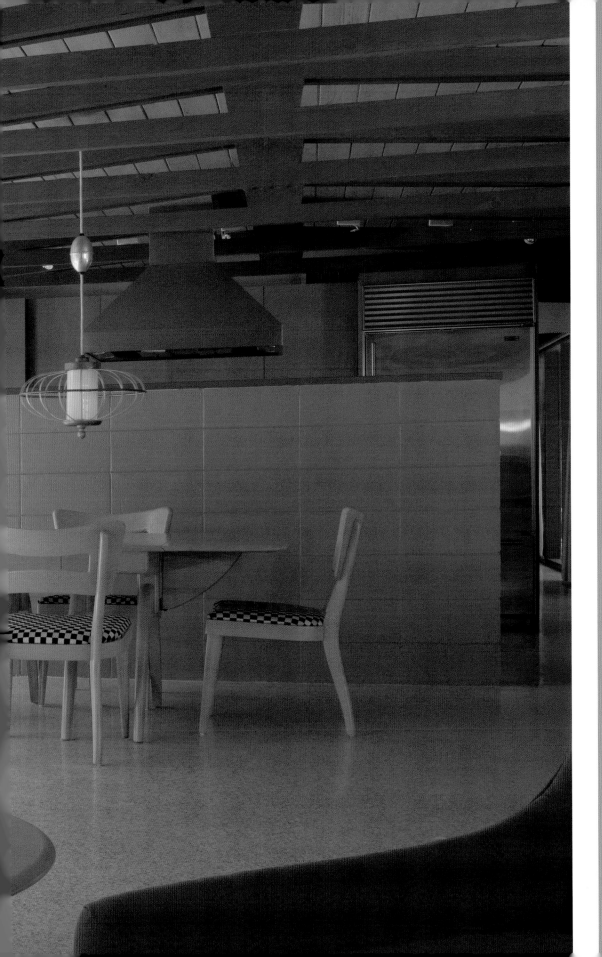

Page 66-67
An original photo of the speculative
houses shows the privacy block wall
installed by Twitchell. The construction
of stacked ocala block is typical of
his work.

Left
With the construction all on show,
the house is a simple piece of
engineering. The privacy wall,
now removed outside, continues
through the house to define the
kitchen space. Some of the timber-clad
walls have been removed and replaced
with full-height panes of glass.
The Heywood Wakefield furniture
adds sculpture to the otherwise
angular form of the house.

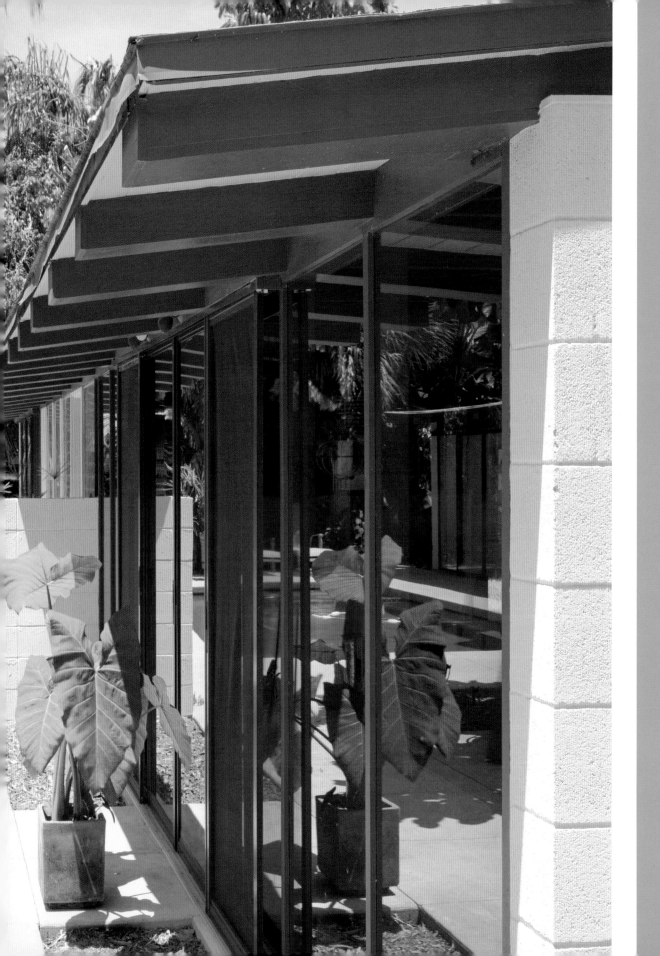

Left
The heavy cedar roof
trusses protrude to create
a sunshade overhang.

Right
Now, being fully glazed, both
sides of the transparent house
blend even more into the
landscape.

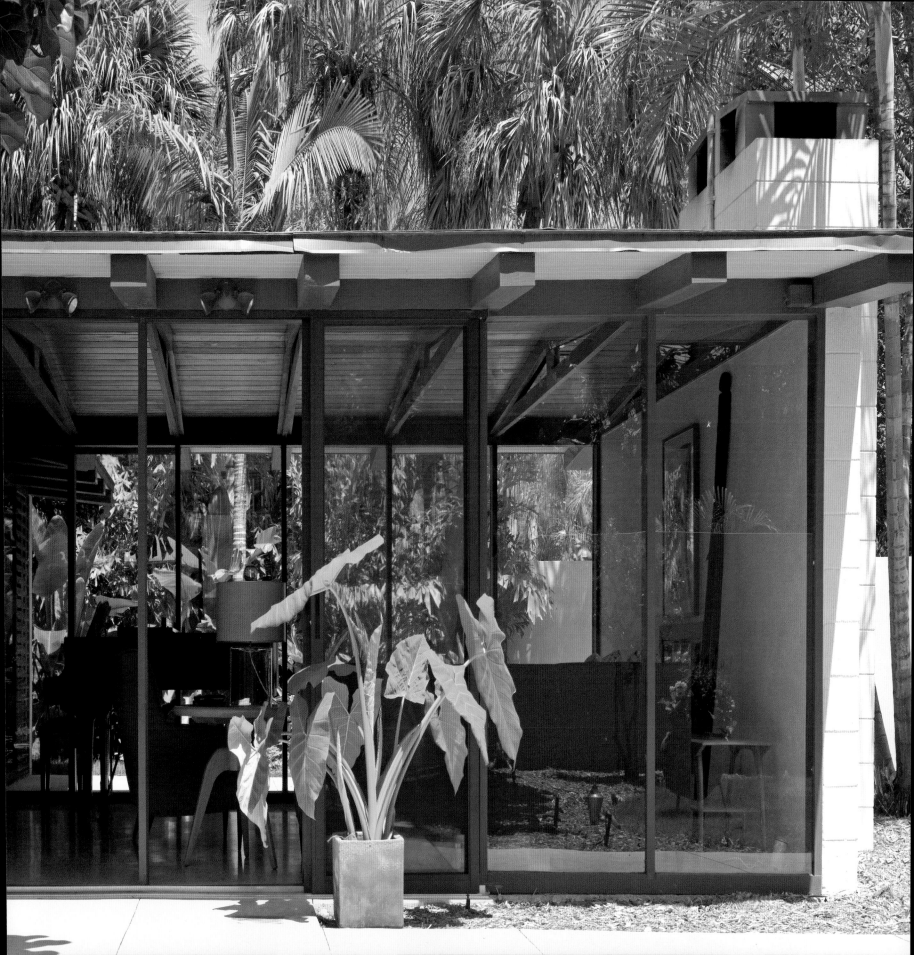

Opposite the Revere Quality House, Ralph Twitchell built two houses for speculation in 1954. He intended with them to try out "inexpensive" ways to build Florida houses, but he found out these were too labor-intensive to be truly inexpensive. Earlier, Rudolph had planned to build more group housing. The only ones actually constructed—the Lamolithic houses, a group of five identical speculative houses—were low maintenance, fire and hurricane proof, and also built on Siesta Key.

The two houses built here were mirror images of each other. Each house consisted of two structures (the main house and an unenclosed carport) with slightly pitched roofs with exposed beams connected by a four-foot-high ocala block wall.

An original "Open House" advertisement for the houses in the *Sarasota Herald Tribune* on February 21, 1954, reads "Ralph S. Twitchell, Architect, Presenting another Twitchell house—at a very moderate price—two two-bedroom homes—Ocala block and glass—Terrazzo floors—Central heat—Thermador range and Oven—Garbage disposal unit—Access to Bayou—for boat." In a later article Twitchell is quoted as saying the "keynote of this new type is simplicity. Glass is used lavishly to let in those ultra violet rays that the chambers of commerce talk about, and exterior gaw-gaws and decorations are conspicuous by their absence."

When the present owners came across it after years of updating and unsympathetic decoration by its previous owners, the house looked run down. The interior framing, intended to be stained dark, had been painted white and a Mexican tile floor laid down. The exterior walls of jalousie window panels, however, typical of Twitchell's work, remained.

Physician John Keiffer, and Jay Poindexter, a former Broadway performer who now works for the government, restored this house to its former simple self. Ripping out the ceramic tile required that the original terrazzo floor be refinished, while the fireplace, a later addition, was simplified by the removal of a large hearth. Now it is more in keeping with its surroundings and is more like some of the fireplaces in other modern homes of the time. While all of the sliding and fixed windows had to be replaced, Mr. Keiffer and Mr. Pointdexter retained the jalousies.

In adding a pool to the site, the ocala block wall that tied the two buildings together had to be removed. Some of the wall still exists on the outside, while inside it continues to act as a visual and physical break between the kitchen and the main living area of the house. Typical Floridian landscaping looping around the pool and the house reminds visitors of their tropical locale and shields the building's side elevations, made entirely of glass, from public view.

When asked about the proposed development of the Revere house opposite, Mr. Keiffer remarked, "We're both excited that they are renovating the Revere house. There is so little of the fifties architecture left here that it's great to be able to preserve some of what is left. Our idea with this house was to simply return it to its original structure as much as possible, which I think we've done."

Right
The chimney stack, a later addition, is typical of the "Sarasota School." A good example of how these houses can be updated and modified sympathetically.

72 HOUSE FOR SPECULATION, SIESTA KEY

Cohen House

Bayou Louise, Siesta Key

Paul Rudolph, 1953–55

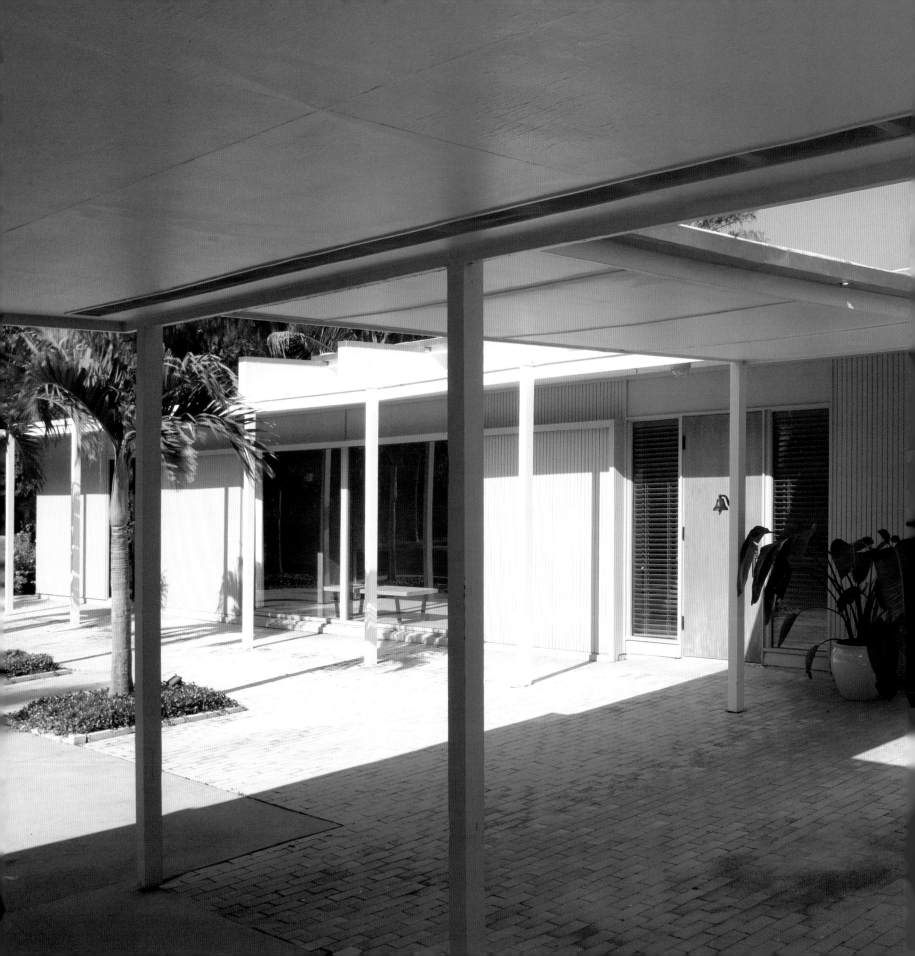

In 1953, David and Eleene Cohen commissioned Paul Rudolph, now in his own office, to design their Siesta Key house on Bayou Louise, with views over to the Gulf across a spit of land on the other side of the bayou. Along the opposite water's edge was the "Cocoon" house, the Healy guesthouse built for the Twitchells' new in-laws three years earlier.

The Cohens were important members of the high society that was coming together in Sarasota. David Cohen, a star violinist as a child, went on to co-found the Florida West Coast Symphony Orchestra, of which he was concert master for over twenty years. His long-term efforts were rewarded by the Van Wezel Arts Hall, built in 1968 by William Wesley Peters, chief architect at Taliesin Associated Architects of the Frank Lloyd Wright Foundation. He had previously collaborated with Wright on many projects including Fallingwater and the Guggenheim Museum. The landmark building is now a major venue for all types of musical events.

Cohen had arrived in Sarasota in 1949, when the symphony was just starting. His input made it what it is today.

The Cohens invited Rudolph to come up with a house for them that could be used as a rehearsal space for the orchestra and also for impromptu performances. Rudolph, a trained musician, realized the importance of space and acoustics. Rudolph entertained various ideas before this final version was built in 1956.

The various proposals included a two-part building with adjoining walkways, square in plan, with opening flaps to battle the elements and, in 1954, a two-story version with flaps on all sides that was recognized by *Progressive Architecture* magazine.

The final design combined elements from both versions. It was completely air conditioned, keeping up with the middle-class tastes and expectations of the time, even though Rudolph's design still took advantage of cross breeze opportunities. The

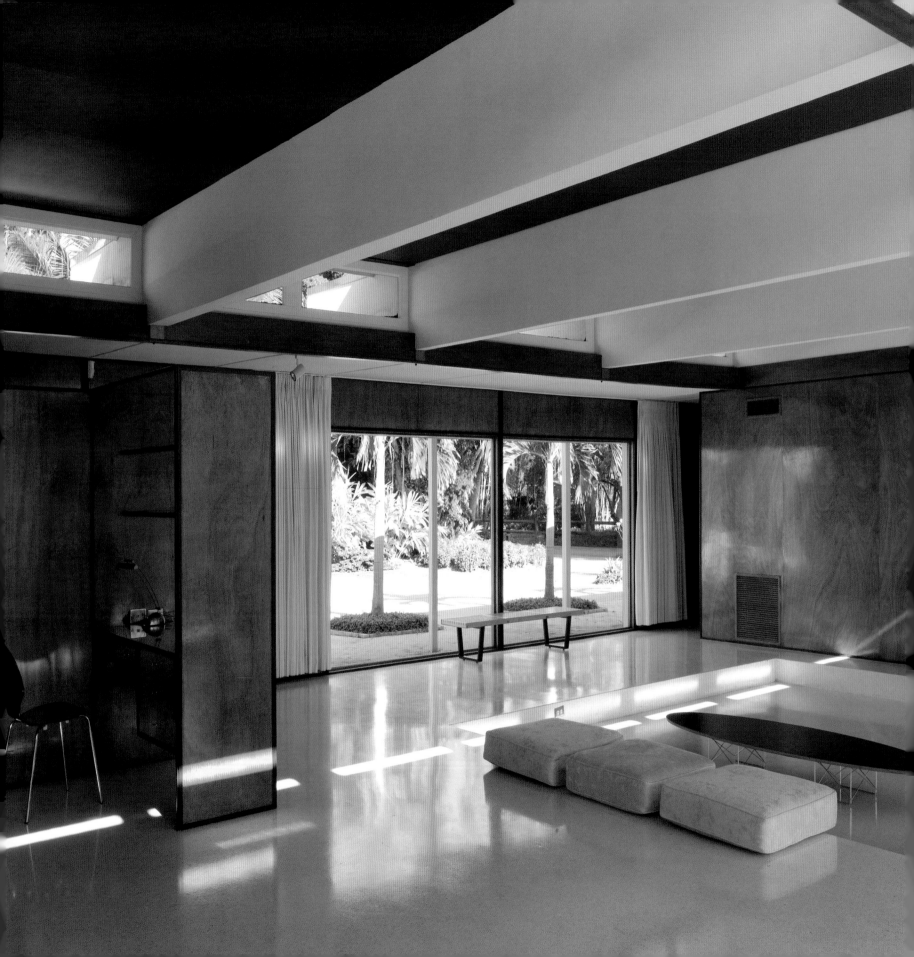

Page 74-75
The entry to the Cohen house,
with its post-and-beam
construction, is simple
and spacious.

Page 76-77
The ample overhangs and
carport give relief from the
overhead midday sun.

Left
The sunken seating area, was
originally intended for
orchestra recitals and
rehearsals. The large window
was intended to be open with a
trellis screen. Heavy shutters
slide into pockets when not
required.

Right
From the seating area the
accented kitchen block is the
entertainment hub of the house.
The massive ply beams
accentuate the ceiling height.

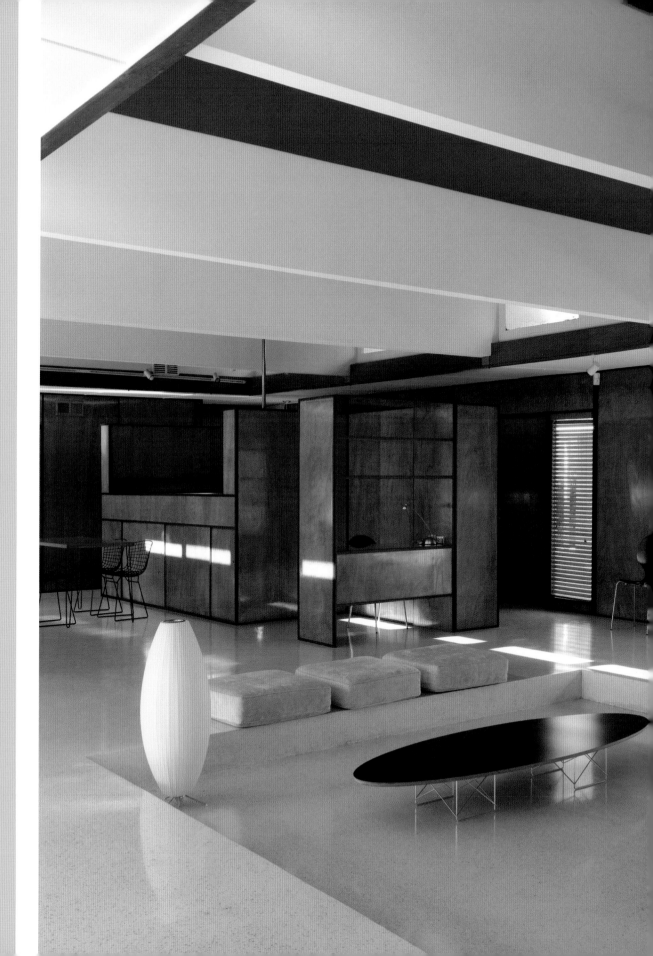

house included a massive open space of some fifty by thirty feet, with an open-plan kitchen and a sunken performance and conversation area surrounded by upholstered seating, fitted and angled. The relative unimportance of the kitchen area reflected Eleene's dislike of cooking, although it worked well as the social center of the space, where the hosts could serve as well as chat with many people.

Built from mainly prefabricated units with "sandwich" plywood panels for walls (a double-faced panel with a honeycomb core of phenolic-impregnated paper that is fire, decay, and termite resistant). The panels were also light enough to be used as doors. The stressed-skin box girders used to create the high volume of the main area of the house span some thirty-two feet across the space and consist of a timber frame, again faced with ply. These massive beams extend outside and support a suspended lower roof level that projects six feet into the room and creates a four-foot overhang outside. In between the box girders Rudolph placed clerestory windows to invite extra light into the living space.

While both were immersed in the musical world of Sarasota, the Cohens had successful businesses. David Cohen was involved in wholesale food distribution while Eleene Cohen had a successful dress shop in downtown Sarasota.

After many years in the house, Eleene passed away in 1998, and David a year later. The family had estate sales and unfortunately all the house's contents were sold. In 2000, the property was sold to the Vross family. By this time the house's plan was intact save for a few decorative alterations. The terrazzo floors had been covered over with large gray ceramic tile, while the mahogany walls surrounding the sunken area were coated with white vinyl wallcovering. In the course of nearly forty years in the house, the Cohens carried out only these changes. Nothing had been taken away. The bathrooms had been updated, but the kitchen was pretty intact.

The new owners started a sympathetic restoration. With the help of original drawings and photographs, they could see the original finishes, colors, and materials used. There were no visuals of the bathrooms, however, so these were unfortunately contemporized, rather than reinstating period fixtures and fittings.

The greatest task was removing the tile from the original terrazzo floor. So as to not damage the surface below, each tile had to be removed by hand. Even though terrazzo is quite easy to refinish, one wonders why it was covered up in the first place.

Now the house is owned by Martie Lieberman, co-chair of the Sarasota Architectural Foundation, which oversees the futures of buildings included in the Sarasota School of Architecture, and is thus in good hands. Lieberman plans to restore the house to its original specifications and reintroduce the seating elements designed by Rudolph specifically for this house. Another house saved from the developers.

Right
From the kitchen, the vast vista into what seem like distant bedrooms gives you the sense of space and scale of this house. On the right, the windows open up onto a screened loggia overlooking the bayou beyond.

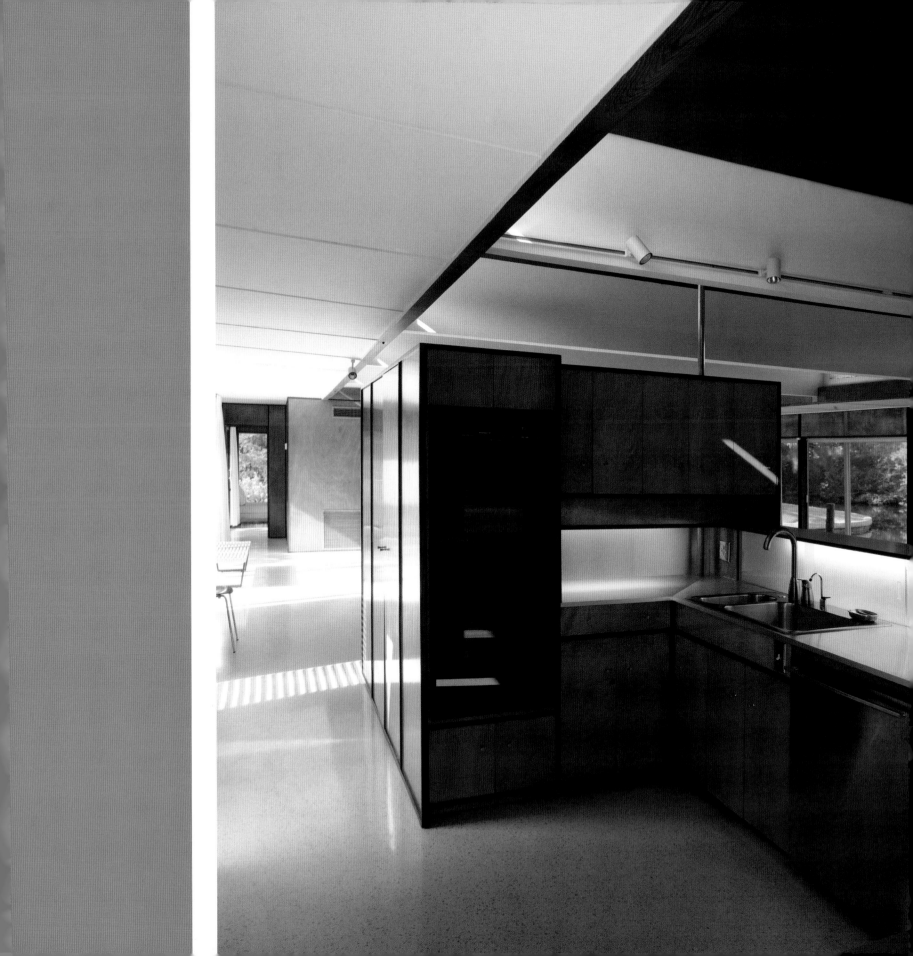

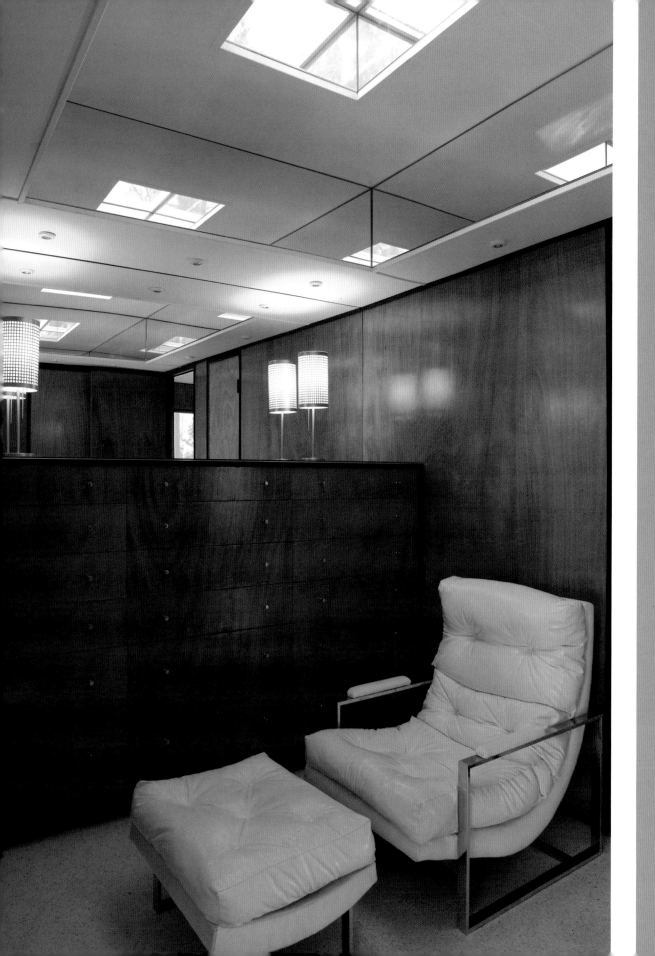

Left
An overhead skylight illuminates the enclosed dressing area. The built-ins have survived the restorations.

Right
From the dining area, the kitchen is dwarfed by the overall ceiling height. High-level clerestory windows bring light into the large, open space below.

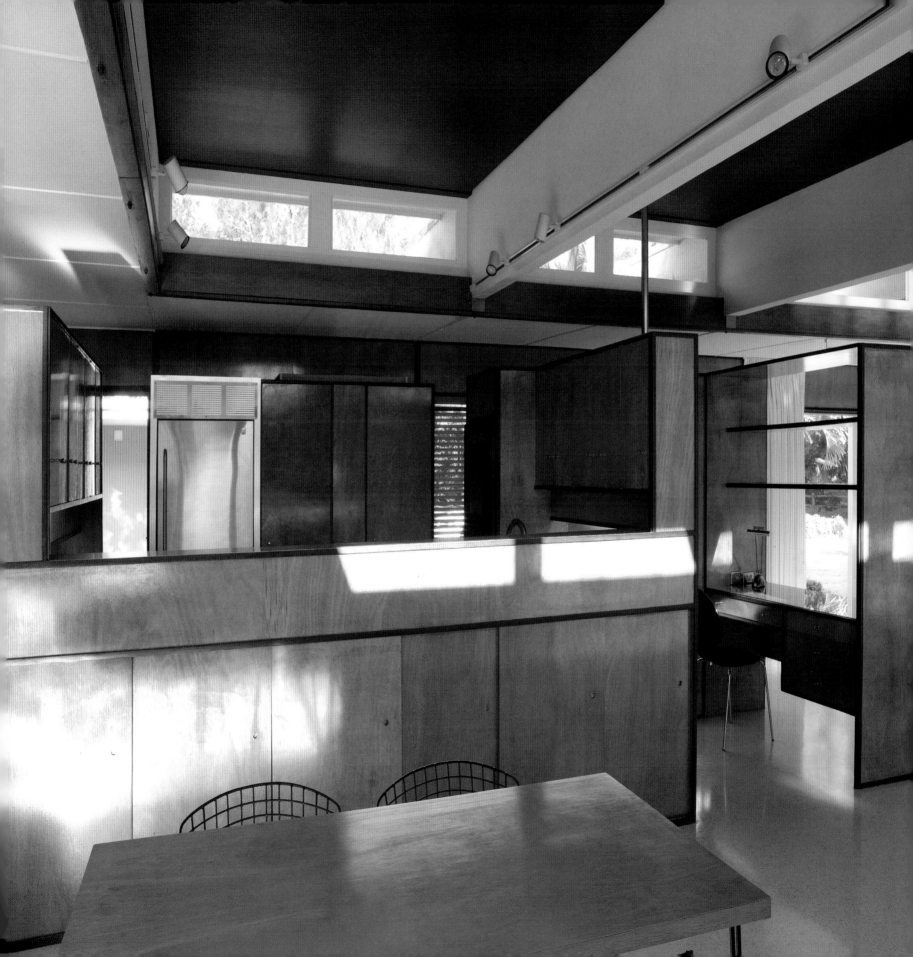

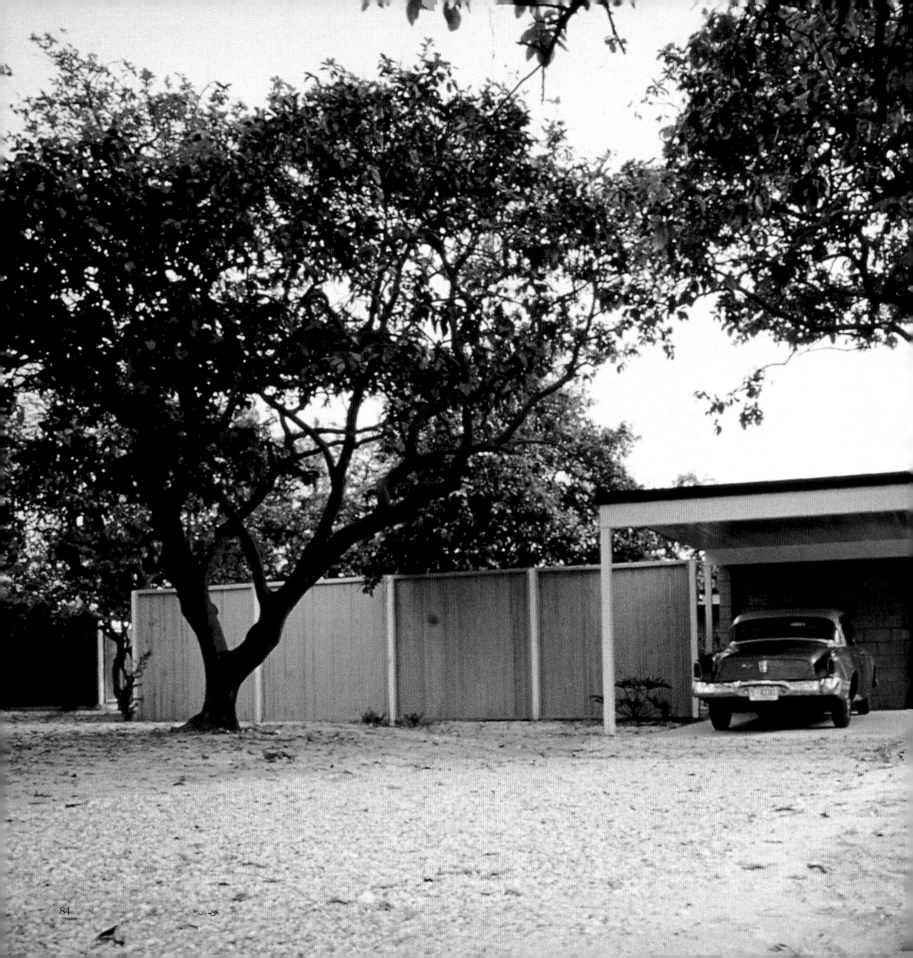

Craney Spec Houses

Winter Haven

Gene Leedy, 1956
with later additions

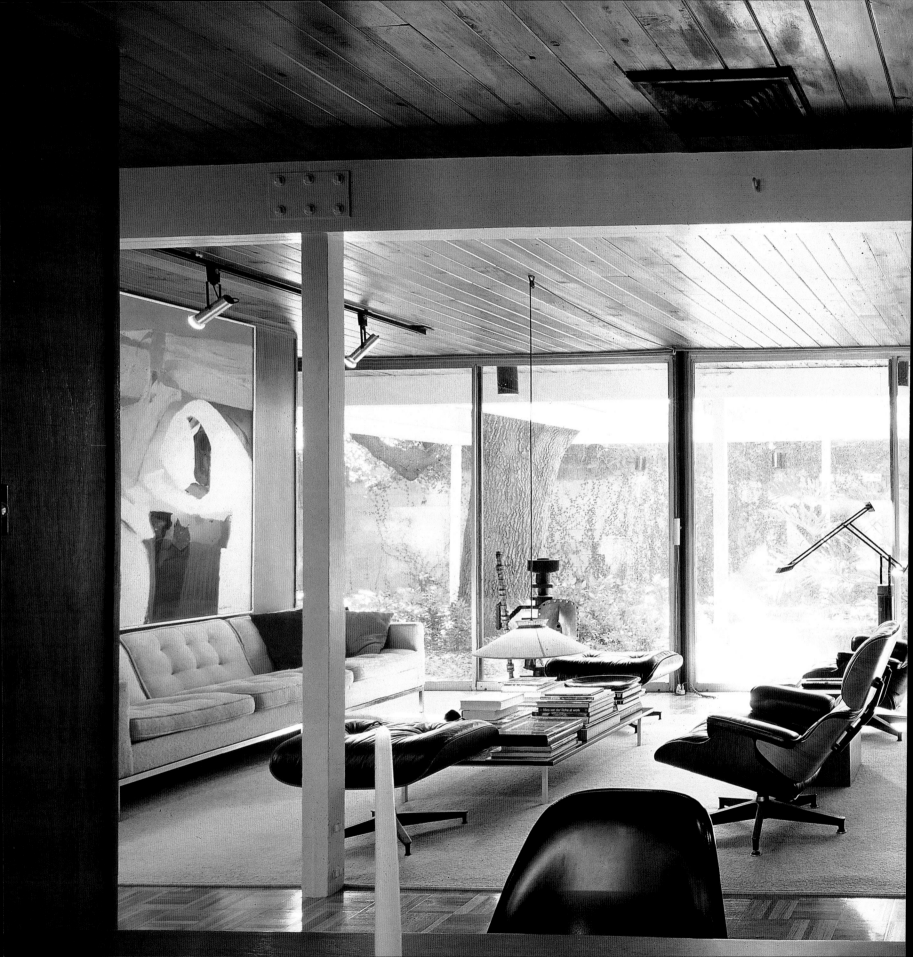

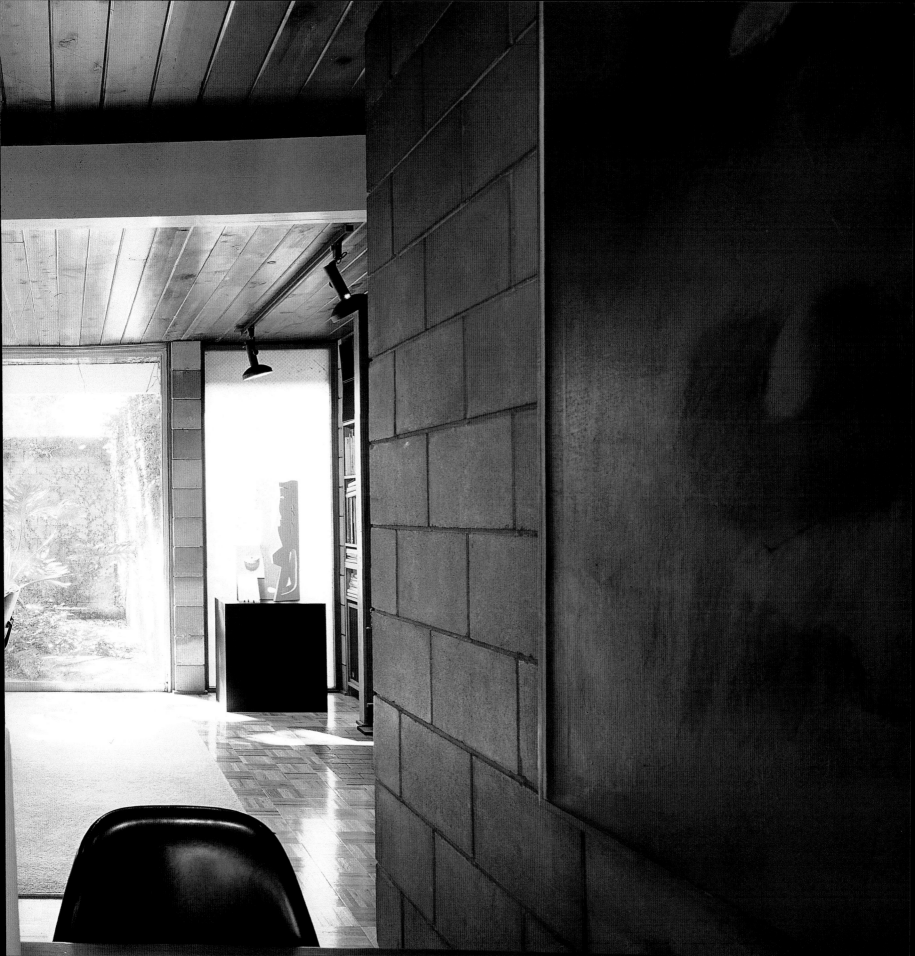

In 1956, Gene Leedy teamed up with a local lumber retailer and large-scale builder of traditional homes, Dick Craney, who had seen Leedy's published projects and decided to develop contemporary houses.

Leedy designed two, 1,500-square-foot prototypes, all with courtyards, and four variations made by flipping the floor plans. The 32-by-48-foot houses were on 90-by-150-foot lots. Craney built ten houses to test the market, offering them for an affordable $16,000 to $16,700 each. The site was a 1920s-era subdivision in Winter Haven, a forty-acre area on a hill planted with citrus groves overlooking a lake.

To generate excitement, Craney took out radio announcements and full-page ads in the local press with photographs of the models and drawings. Ten thousand people showed up for the grand opening and the houses sold within a week, several of them to architects—including one to Leedy himself, who still lives in it. "There were two reactions," Leedy recalls. "Some people loved them and others just hated them. They were so different, they told me."

The one-story houses rested on concrete slabs, with a timber post-and-beam structural system and nonload-bearing walls. Each house's three beams were supported by ten exterior posts, to which the roof extended on all sides to create deep overhangs for shade. With only two posts supporting the middle beam inside, the interior offered ample, column-free space. The house was enveloped entirely in glass, except for end walls of concrete block, one of which separated the dining area from the entranceway, and continued outside along the edge of the courtyard to tie the house to the utility room and carport.

The houses featured the first aluminum-frame sliding glass doors in Central Florida, on both long sides, a courtyard on one side and a broad terrace on the other, and exterior and interior jalousies. The roof's four-inch-thick tongue-and-groove cedar decking formed timber ceilings for the interior, whose concrete floor was surfaced with cork. Designed for young families, with three bedrooms and two baths, the houses followed a modular plan, with the posts delineating six sixteen-foot squares, making it easy to add bedrooms.

The houses were considered so radical that it was not certain that buyers would be able to secure mortgages. "The only mortgages available at the time were through the Federal Housing Authority and Veterans Administration," Leedy remembers. "They would not approve anything unless it was very conservative." Craney was a good salesman; he explained the design to them and he sold it. But the FHA would inspect. "You had to have a coat closet or they wouldn't approve the houses for loans," Leedy continues. "We didn't need a closet down here in Florida, but we built a coat closet on wheels, and they would inspect. Then we would move it to the next house."

The houses won an AIA Award of Merit and the buzz reached *Better Homes and Gardens* magazine, whose circulation at the time was over four million. The magazine chose the house as a five-star House of the Year for 1959, praising its design as "an exciting new way to build," with its non-load bearing envelope able to be specified in any material. It also cited the courtyard, "with its 'wide-open' privacy," and the kitchen, from which mothers could keep an eye on their children playing outside. And it admired the built-in drawers "a finger width apart" so that no pulls were needed.

The magazine offered the plans for sale at $7.50 each; Leedy netted seventy-five cents per set. "Their idea was that people in the boondocks could get a contemporary house where there were no architects to design them," Leedy says. "I thought I would be giving them back my $800 advance, but over the next four years, I got $6,000 in royalties." The prototype houses were built all over the world, as far away as Australia. "I was at a party in Los Angeles," says Leedy, "and a woman said, 'Oh, you're Gene Leedy! I have a house built by you.' I said, 'I've never done a house in L.A.' And she said, 'I bought the plans and I didn't change a thing.'"

Page 84-85
In its original setting with the simple slatted fence for privacy, the speculative Gene Leedy houses for Dick Craney were set among an orange grove. The car was the ideal accessory for the Sarasota School house.

Page 86-87
Leedy's living room has been slightly extended. The furniture includes a Knoll sofa and Eames lounge chair and ottoman. The artwork is by Syd Solomon.

Right
The welcoming entrance to the Leavey House has a covered walkway. Here, concrete block has been used for wall and floor.

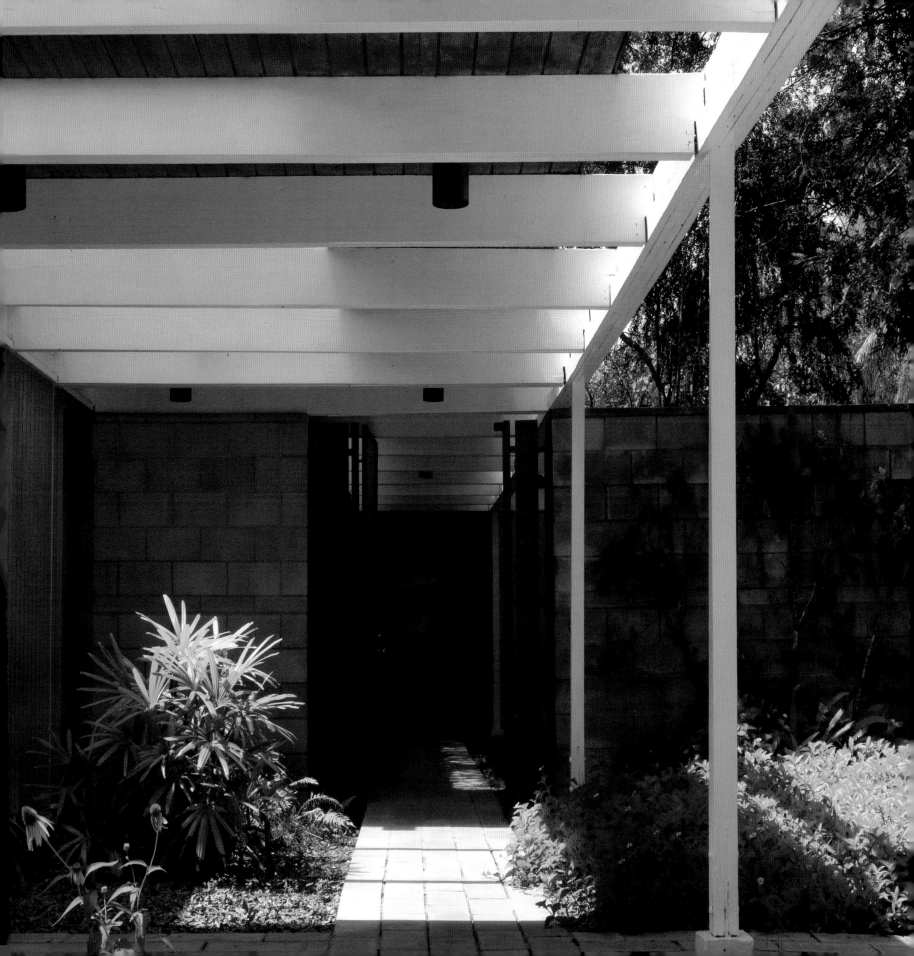

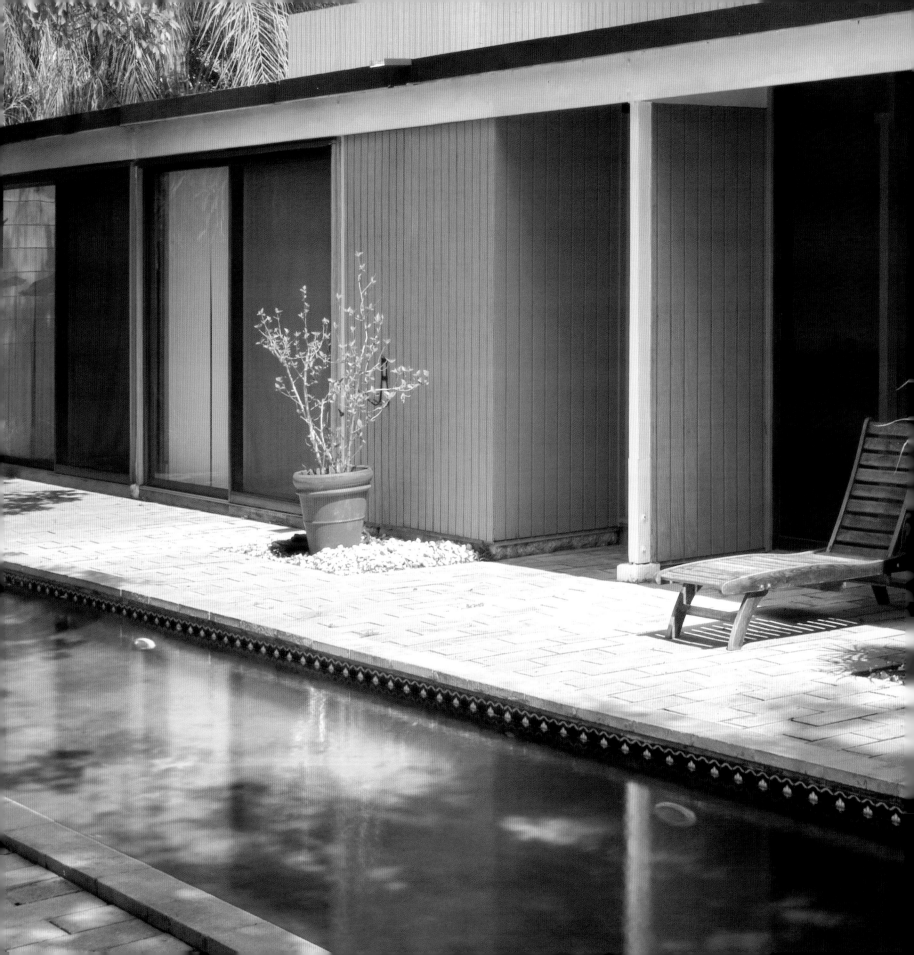

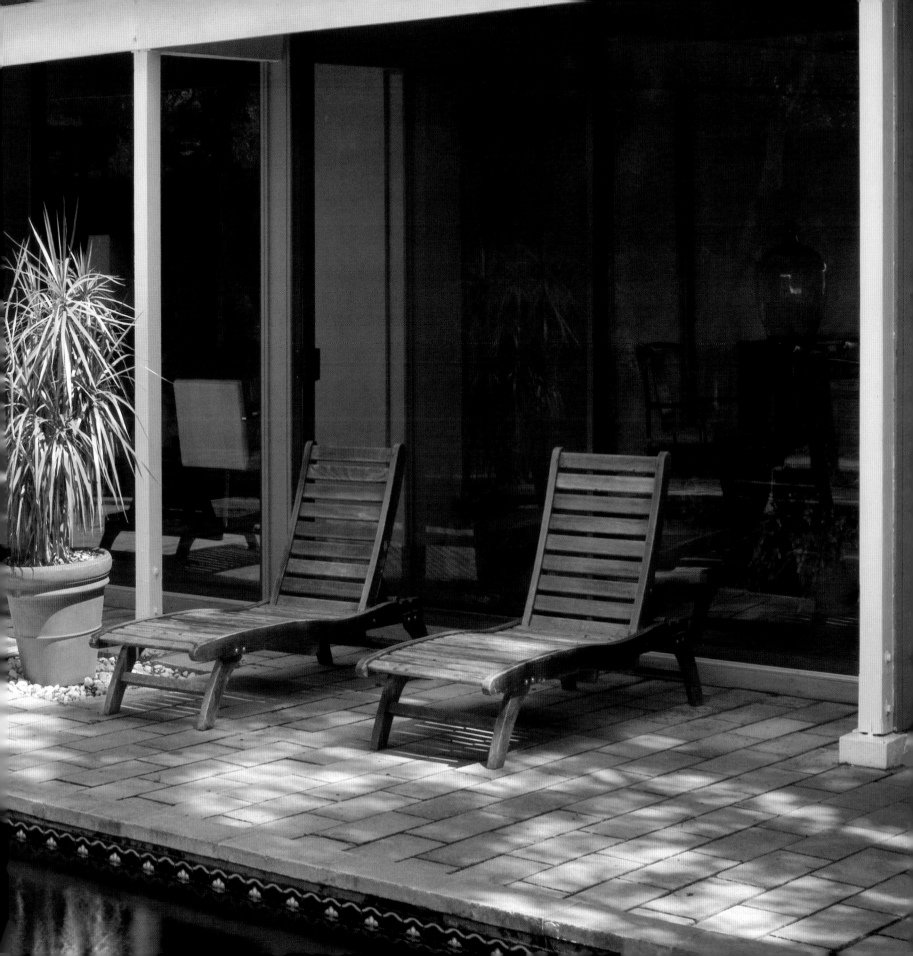

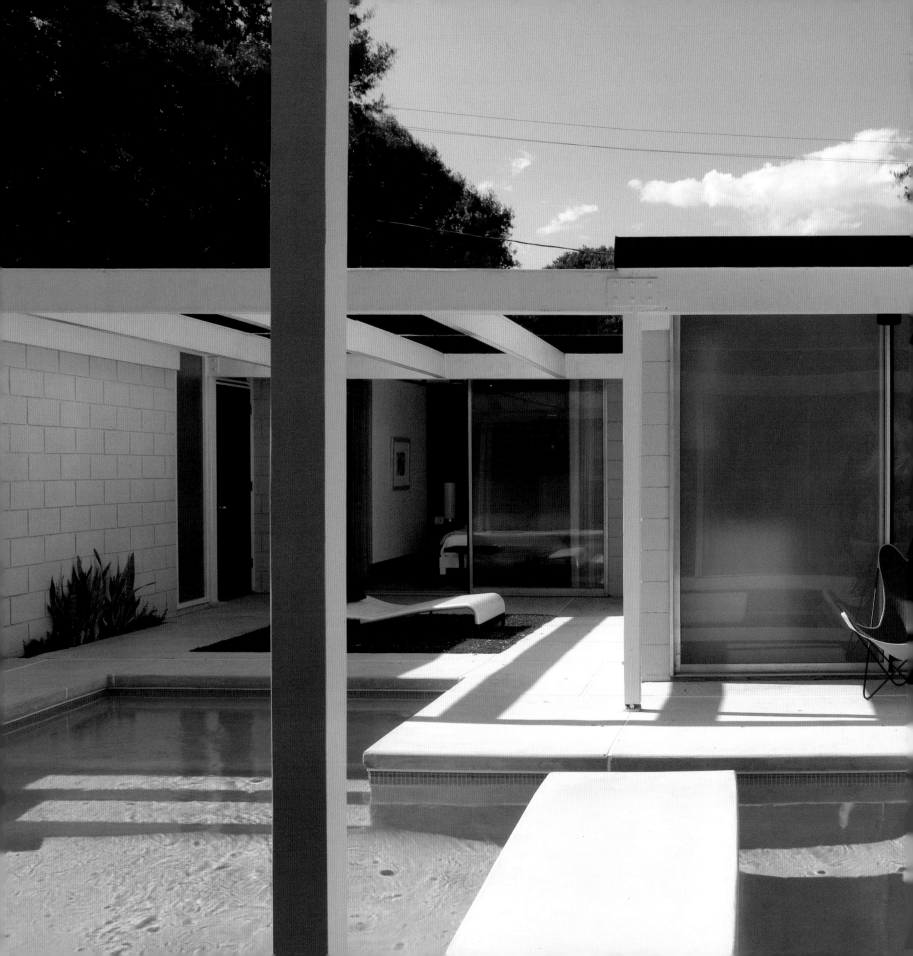

Leedy still lives in his Craney home and over the years he has fulfilled numerous requests to renovate and extend the other houses on the street. His own house has been pushed out to the edge of the roof overhang at the sides, and what were once two bedrooms are now one.

Of the two versions that were promoted it is a pity that a courtyard version does not now exist as its original plan. On Drexel Avenue, Leedy has remodeled six of the original ten built. For his own house and the Leavey and Kaiser houses he constructed guest houses that also included garages, all set into a compoundlike structure that puts a ten-foot-high concrete block wall along the boundaries.

At the Leavey house, Leedy enclosed and roofed over the internal courtyard to create a dining room, rare for a Leedy house. The original carport and utility room is now the kitchen, and a lap pool occupies a portion of the enclosed garden. The street side of the house includes drop canopies and trelliswork over the walkways, typical of the Sarasota School ideals.

In the Kaiser house, formerly Gregory, the new owner Robert Kaiser, a theme park designer from Orlando, already has all the alterations done. Here Leedy has done much the same as he has done to his house, in addition to totally updating the space with white paint over all the wooden surfaces white and a new brick floor. There was no pool here, so Kaiser squeezed a perfectly proportioned one between the existing house and guest suite, uniting the two areas. With Kaiser's selection of new mid-century classic furniture, the house is a modern-day version of the original.

Page 90-91
The Leavey house, the first house of the group
to undergo massive remodeling by Leedy,
incorporates a lap pool.

Left
Once the Gregory house, now transformed
by the new owner with the addition of a pool,
the guest suite is united into the main house.

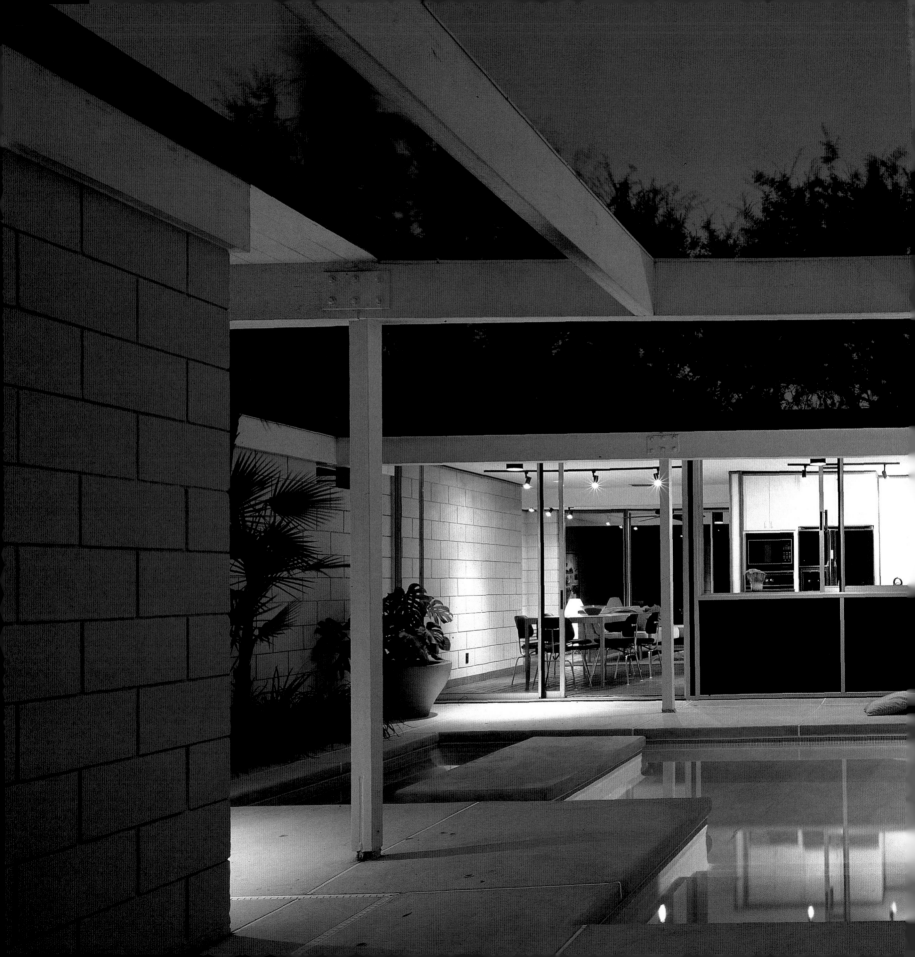

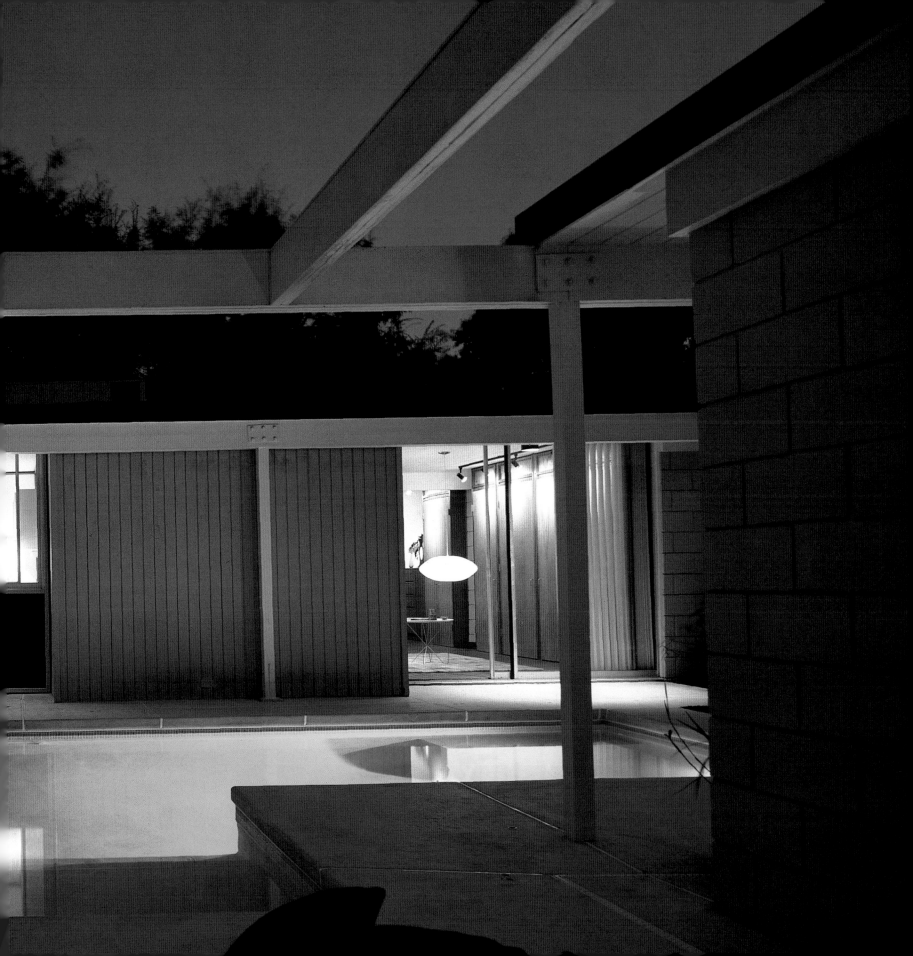

Page 94-95
At night, the drama begins.

Right
Leedy's own house from the courtyard.
This view shows the expanse of space
created by the use of the full-height
concrete block walls. Eames furniture
is used in the dining area.

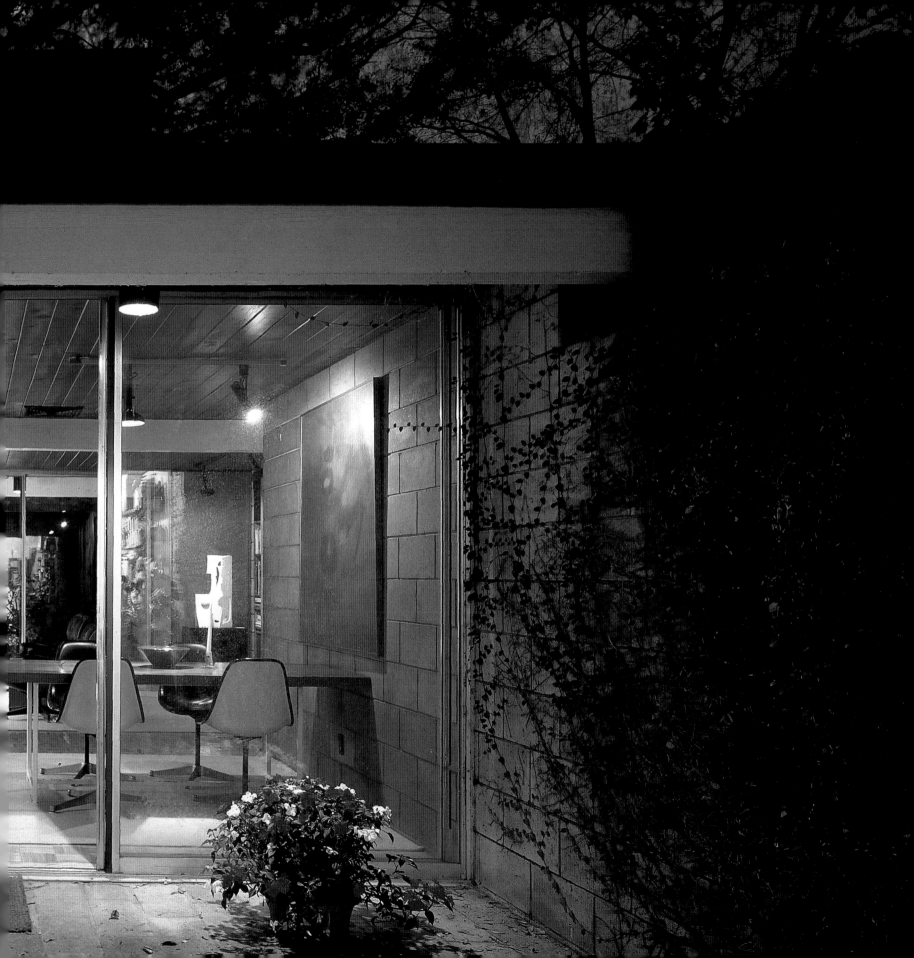

Weaving/Thomasson House

Winter Haven

Gene Leedy, 1956

Page 98-99
*From the street, the low-slung house
is hidden behind the high block wall.
The massive oaks and camphors
are typical to the area.*

Left
*The recently planted garden has
quickly become a jungle.*

Page 102-103
In the courtyard, the materials of the house construction can be clearly seen. The posts and beams, the full-height sliding aluminum doors, the jalousie windows, the timber siding, the concrete block, and the trellis areas for shade, all make up a typical Sarasota School house.

Page 104
The den room, with a desk salvaged from a Neutra house, looks out onto the garden with a pool. The outdoor furniture is by van Keppel and Green.

Page 105
From the dining area, the living room also looks out onto the pool. The cedar ceiling accentuates the space while the revived cork floor makes the space one. The stainless steel oven by General Motors is like new. Here, furniture by Eames and Nelson complete the mid-1950s scheme.

Page 106
Until recently, this kitchen was covered with sticky back wood effect Fablon. The jalousies have been removed and a crystal chandelier hung over the breakfast bar.

page 107
In the living room, an Eames sofa accompanies a Surfboard table. On top of the McCobb credenza is sculpture by Brian Willsher and a painting by Peterson, both Londoners.

Page 108-109
By night, the George Nelson bubble lamps within create a welcome glow.

In 2000, my partner and I were looking for a modern house in the United States for vacation and investment. We had been looking in California, but besides the high prices, we determined that at the end of the day perhaps it was too far from London to get away for a week or so. An alternative location was required. On a previous trip to Miami, we had bought John Howey's book *The Sarasota School of Architecture*, which opened our eyes to this area.

The only research available to us in London was via the Internet; looking for something in Sarasota as an ideal location was fruitless since nothing of architectural interest was turning up. Every realtor I spoke to would say the same thing: nothing like that here. Some had no idea what I was talking about when I referred to the Sarasota School. In Howey's book there was a reference to architect Gene Leedy, who was Rudolph's first employee. He had moved to Winter Haven, in central Florida, in the mid-1950s to build a group of speculative houses, and he ended up staying there.

I managed to track down Leedy, called him, and by the end of our conversation had verbally agreed to buy a house that had just come up for sale on the street where he lived—directly opposite his house and next to an old Mediterranean Revival house.

So we bought the house unseen, unsurveyed, and unappraised. On eventually arriving at the house we found, I suppose, what we really expected: shag pile carpets and crystal chandeliers. Why these houses always end up decorated this way, who knows? At least it was things added and not details taken away. This was one of the Craney development houses Leedy built in 1956. We were lucky to find one that had not been altered, extended, or remodeled. It was just what we were looking for: an original example of mid-century architecture with the majority of fixtures and fittings intact, although somewhat disguised with various coverings and coatings. A few dumpsters full later, the house had returned to the shell of Leedy's original design.

Inside, the house still had its Luan veneered plywood walls untouched, and the cedar tongue-and-groove ceiling deck was unpainted. It had a few too many coats of gloss-finish varnish, perhaps, but it was still wood. The jalousie windows in the kitchen area were notably missing, but these important features were easily found and reinstated, making this area complete. Luckily, under the shag pile that ran throughout the entire house except the kitchen, was the original cork tile floor, laid in a square grid. These had deteriorated somewhat around the edges, but replacements were found and relaid. All the full-height sliders were in place and the house had returned at last to its original specifications.

What made all the difference was the installation of Gene Leedy's eight-foot-high boundary wall around the lot. While it cost almost as much as the house did, the wall made the house spread from one end of the site to the other, bringing the all-important outside in. Historically the yards are communal, a sociable aspect of this type of housing, but these days privacy seems to be the way forward. Moreover, this outdoor room makes the house appear much larger than it really is.

As these houses were built on what was originally a citrus grove, many orange and grapefruit trees still existed in the garden. Unfortunately, most of them were in unsuitable positions and now only two of the original have survived. With the addition of a pool, concrete deck, and typical landscaping the back yard soon became a tropical paradise. Palms were lifted over the house by crane, and what were at first small indoor plants have grown into large specimens of fascinating species. The garden has matured so quickly it's hard to believe that the garden is only about three years old.

We were very lucky with the structural elements of the house. A couple of the wooden posts were slightly rotten, but overall, the roof, exterior cladding, and beams were fine. The damaging sea air of central Florida means the houses of Sarasota are more likely to survive if they are well maintained. A more dangerous threat is the dreaded termite, but even that

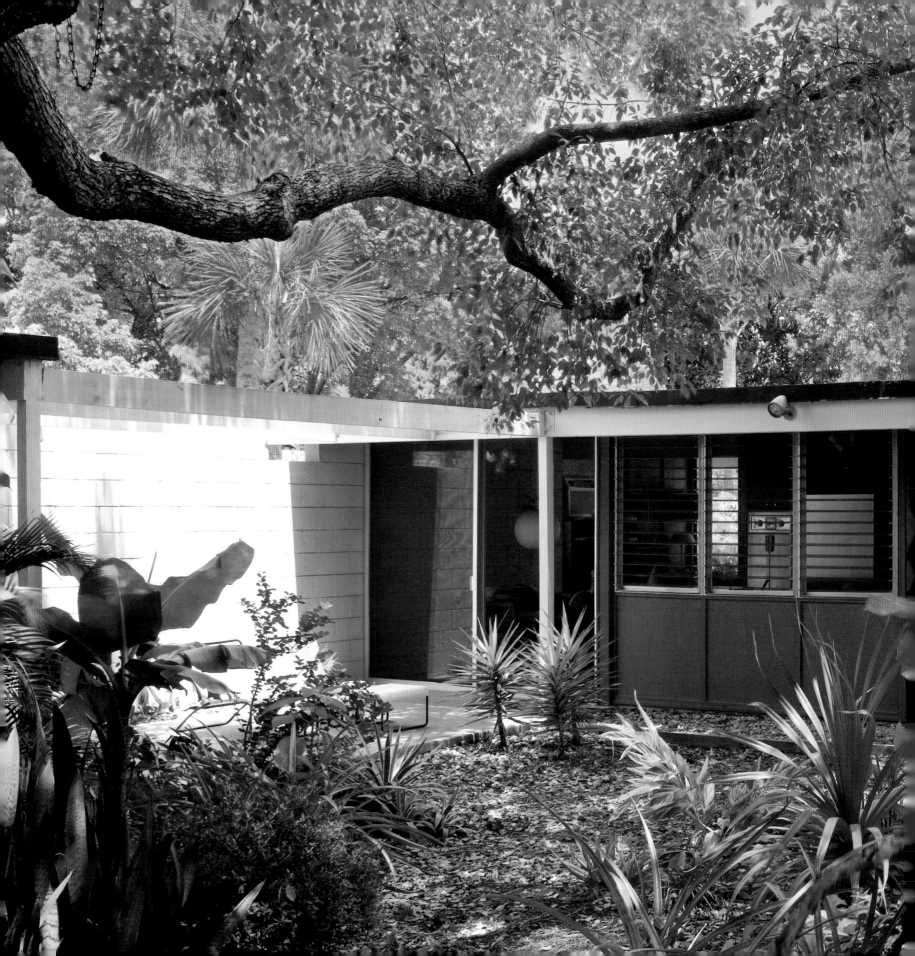

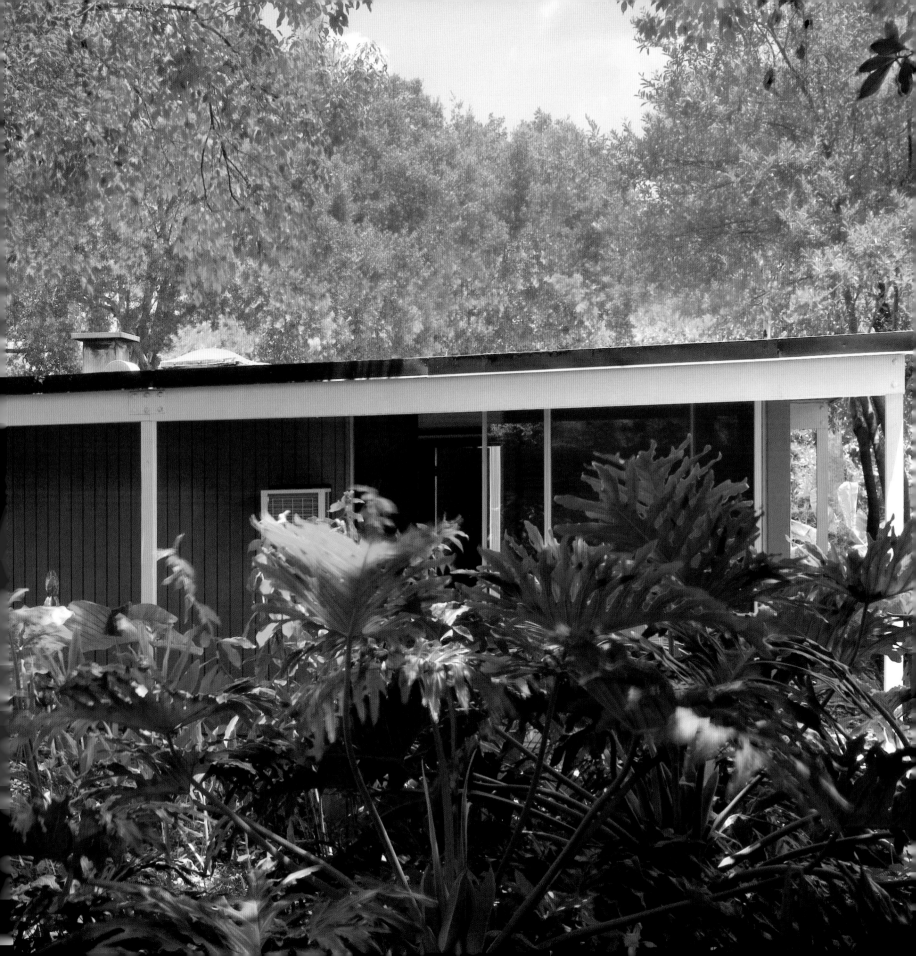

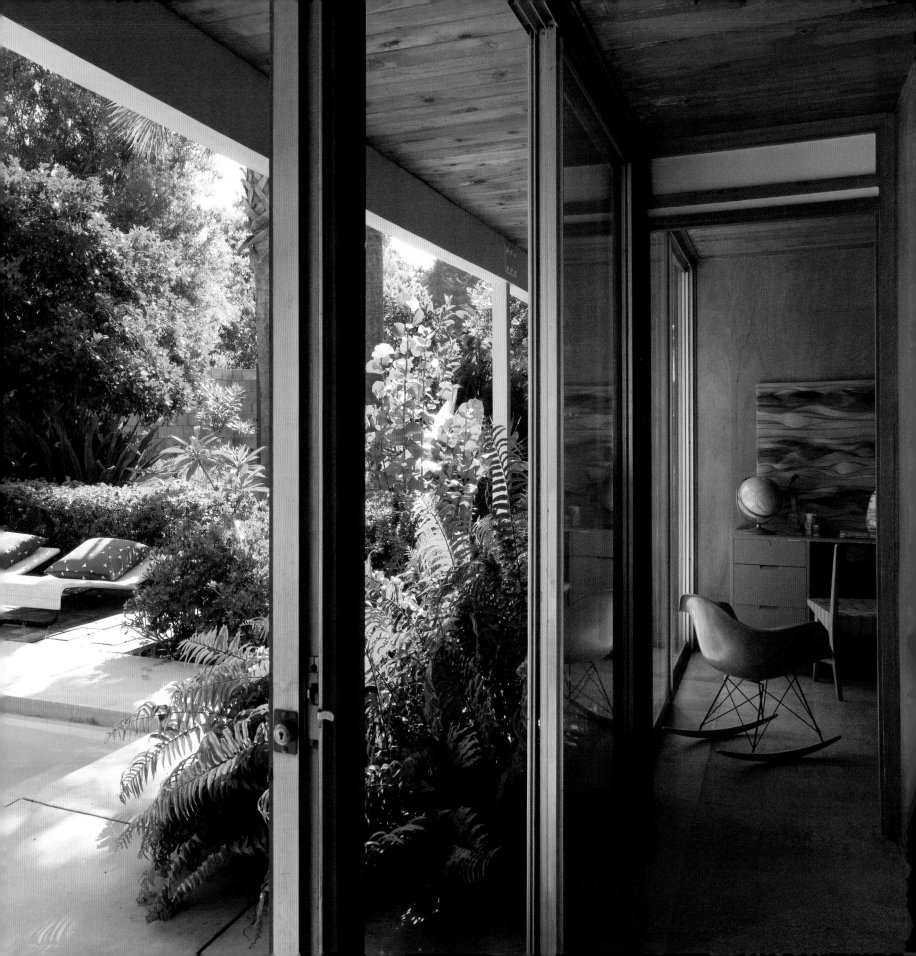

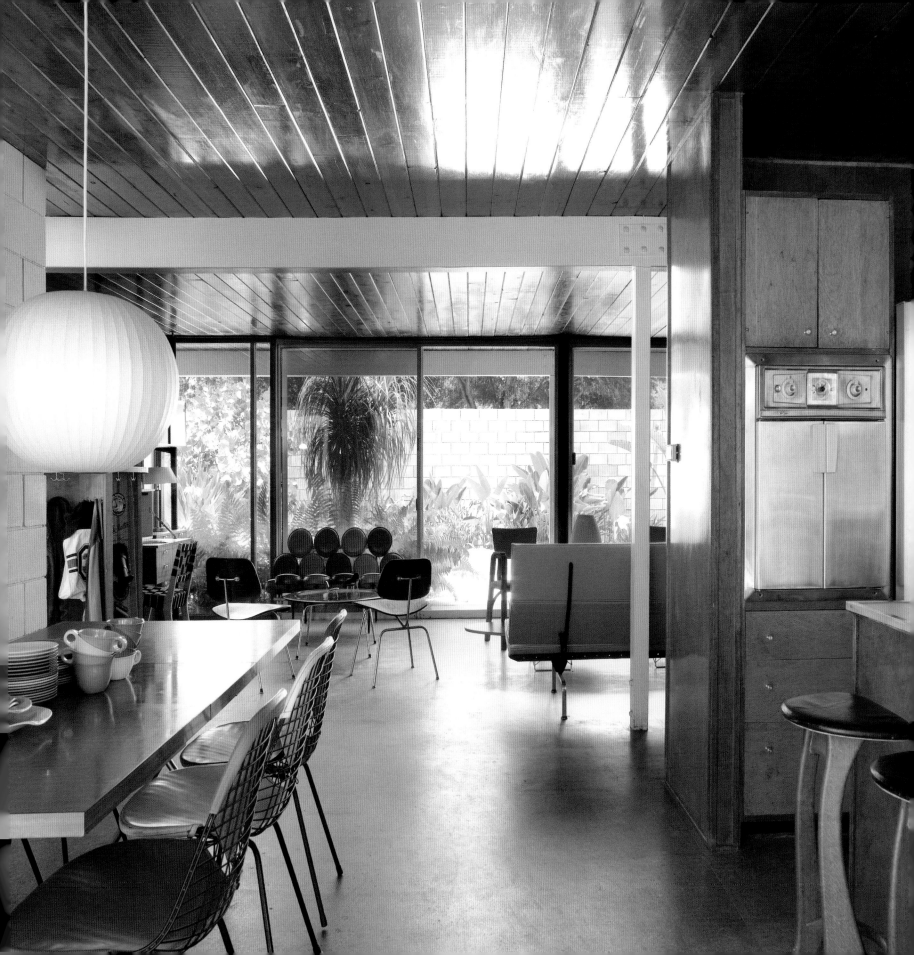

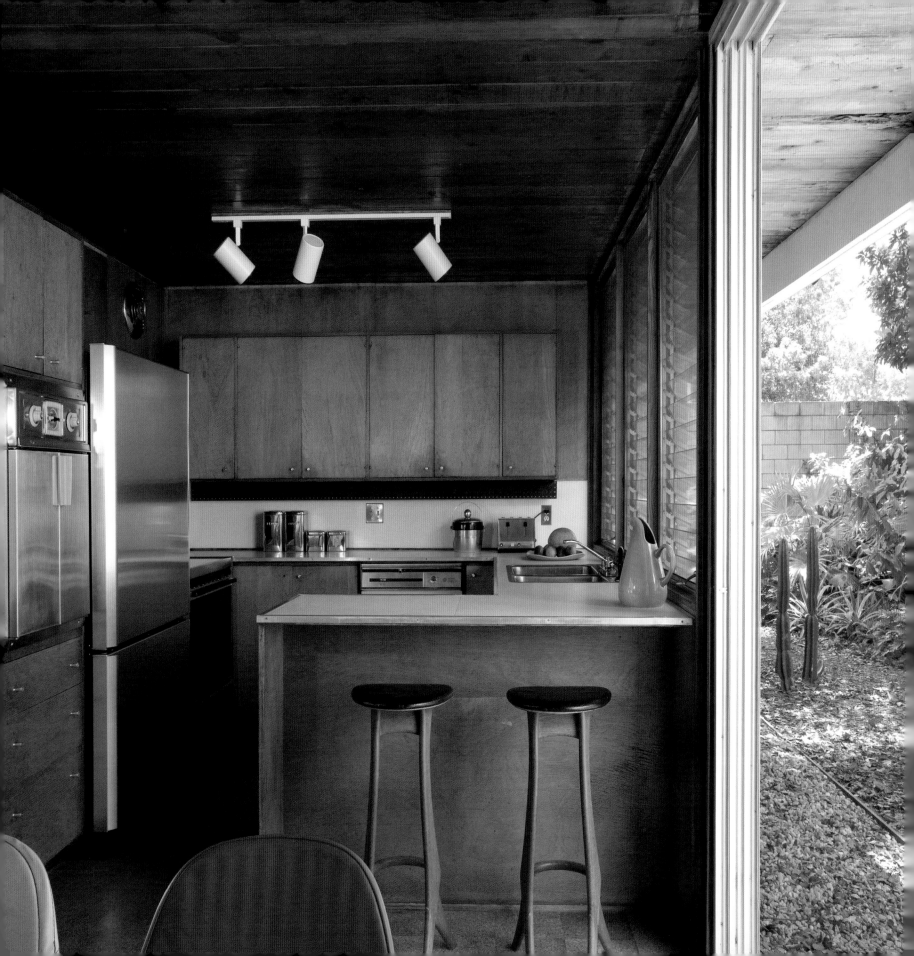

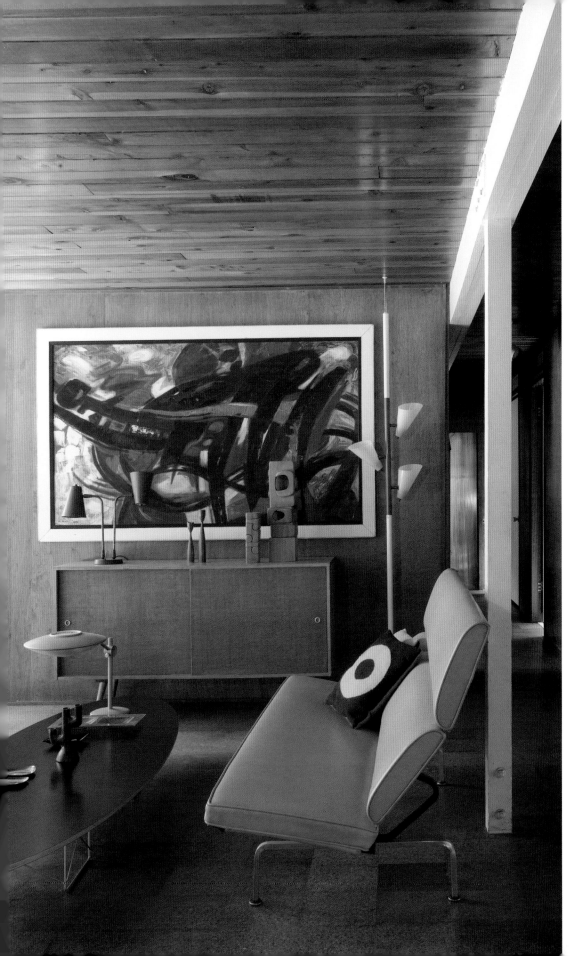

problem can be treated. In the recent hurricane season in the summer of 2004, the area has suffered badly three times. The live oaks that surround these houses also act as a protective canopy over them. As a result most of the houses were untouched and the trees took all the battering.

When it came to furnishing, the idea was to present the house as it would have been at the time it was built. While the intention was maybe a little extreme, the proportions, materials, and construction of the furniture at that time naturally would work well in the space. Work by the Eames, George Nelson, Paul McCobb, and Neutra have been included and color has been bought in through the use of original chair coverings on chairs and accessories. It is somewhat unrealistic to live among this selection of furnishings, but since the house is a vacation escape we can put up with slightly uncomfortable chairs and sticky vinyl coverings.

This house originally had no air conditioning; the cross breezes created by the sliding doors on either side were to be intended cooling method. Now there is an in-wall unit that does the job when needed. Neighbors who have installed central cooling systems do suffer from the occasional leak in a heavy downpour. As the roof deck is basically a slab of solid tongue-and-groove cedar, anything that cuts into it is bound to cause a problem.

Being at a remove from Sarasota has preserved this house. Besides the salt air and the risk of a flood sending the house into the sea, the reason so many of these houses are being torn down is the value of the land. Efforts are afoot to save them, but let's hope it is not too late.

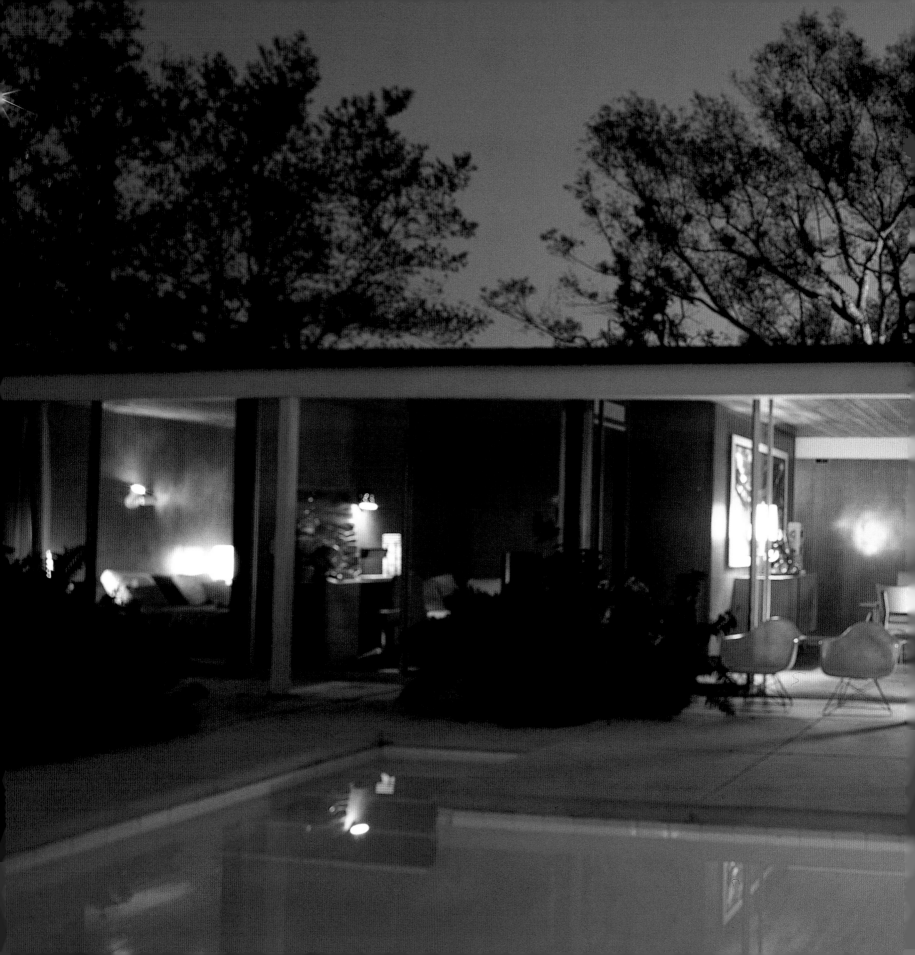

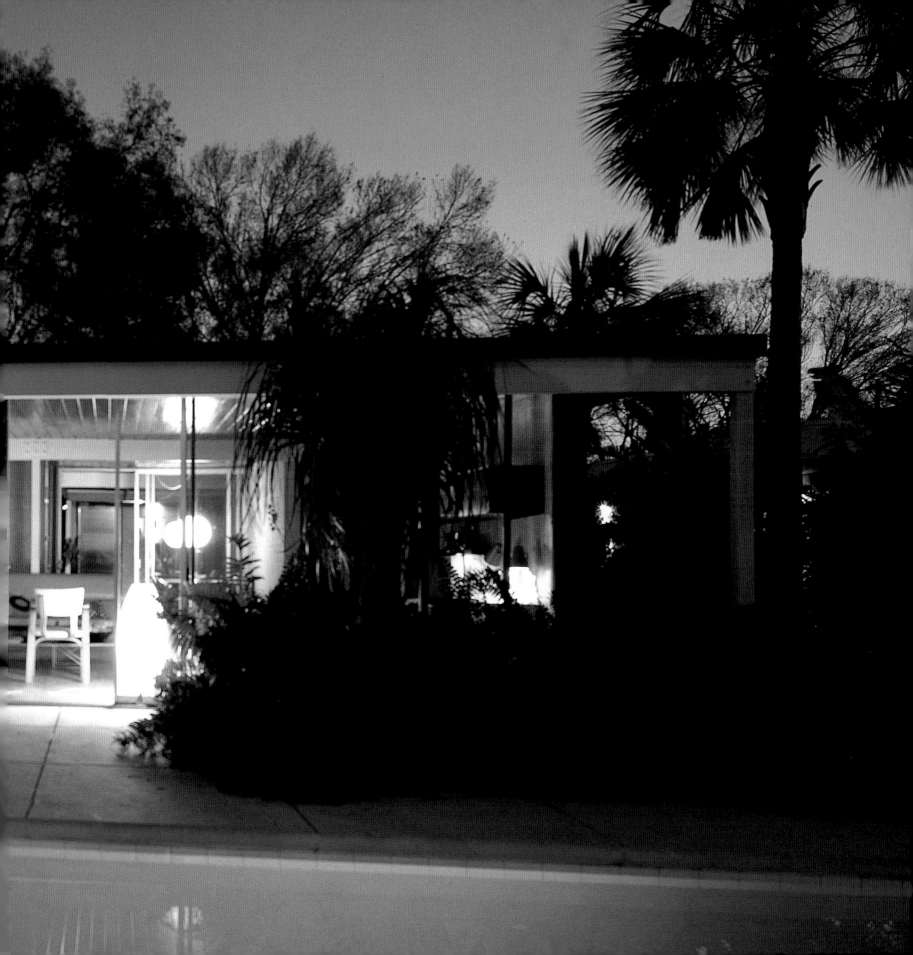

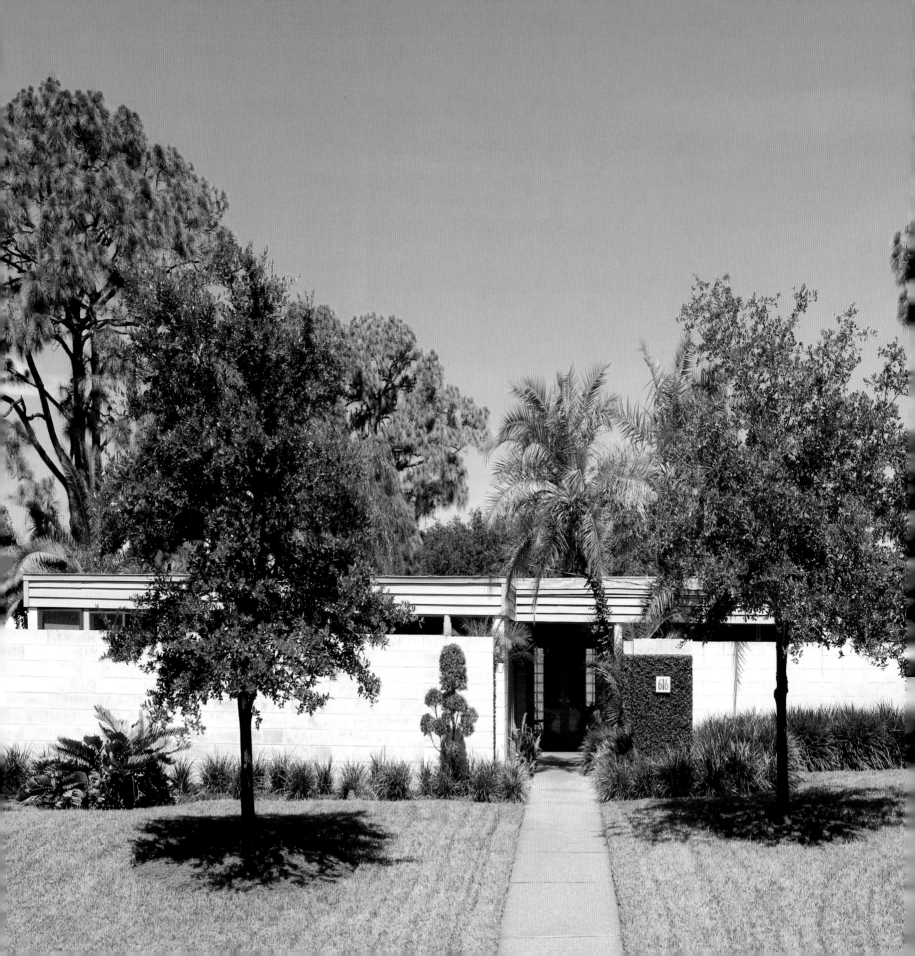

Hudson/McMurray House

Venice

Ralph Twitchell, 1953

Venice, an island some fifteen miles south of Sarasota, was a somewhat underdeveloped area in the late 1940s, with ample space for new modern houses.

In 1948, Twitchell and Rudolph built a house for use by the Siegrist family during the winter months, away from their colonial residence in the north. This house, one of nineteen postwar houses in America picked by the Museum of Modern Art for "quality and significance," was featured in *House & Home* magazine in April 1953. The article says that this "may greatly influence the popular designs of the future," which it certainly did.

The house was also once picked by the schoolchildren of Venice for a special distinction: an entire fifth-grade class asked to be taken through it the week after they toured the municipal power plant. The Siegrists were duly honored by the request. They thought it was a pleasure to live in, much better than their house in the north. The *House & Home* article described it thus: "It brackets the view, all the rooms inline would have a southern view. It sieves the breeze, every room had ventilation. It uses the outdoors, the south facing terrace divided for four uses, outside dining, reflecting pool, screened sun porch and bedroom-sitting porch. It concentrates on the inside, the place is divided with space walls that stop short of the ceiling. It standardizes the framing, the lumber lenghths and sizes are the same throughout. It plays on the structure, the house rejoices in the art of the carpentry. It floats the roof, the roof was conceived as one large thin sheet hovering over the frame. It interprets the materials, Twitchell and Rudolph gain a regional flavor with their familiar Ocala lime block and native cypress. It controls the climate, the 'fishbowl' south side is protected from summer sun by an accurately designed 4'8" overhang." The article added, "Some will consider this house too skinny, too wide open and unprotective. But the architects believe that man, in the last 20 years, has undergone a change: he is no longer afraid of his natural surroundings, and a

house like this one will help him live in nature easily and efficiently." Apparently this isn't so these days, this house has been remodelled beyond recognition.

A few years later Twitchell, without Rudolph, designed a house for the Hudson family, who wanted a small vacation house. With only one bedroom, the house was conceived so that it could be extended with the addition of another bedroom at the rear. When the house was first built it was situated right at the edge of the natural buffer between the beach grasses and civilization. Unfortunately since then more houses have been built in the west, bringing the house seemingly further away from the gulf, which is in fact just one block away.

The original house included a large indoor lanai with a rectangular opening allowing light through to the large planter, placed on the breezeway below perpendicular to the block wall of the living room. The opening, now closed up, was within the roof plane. Typical of Twitchell's work, the majority of walls were glass, with sliders and jalousies for the cross breezes from the Gulf. The wooden sliders were made by Twitchell himself in his custom wood shop, his daughter recalls. Again, ocala block is used throughout including, in this case, as a low-level partition between the kitchen and living areas. The block also appears outside to create a visual extension to the living room with a much higher wall, which shields the area from the street.

Brad and Melanie MacMurray have owned the house since 1999. Both teach within the Sarasota school system and are involved in the local arts scene. They plan one day to open their own art school on Venice Island. The house is a backdrop to an ever-changing collection of art, furniture, and accessories. Much of the artwork is by Brad, who used to be an art director in Seattle and recently spent a month in Toronto as an artist at the Gibralter Point Artist Retreat. The couple started the geometric work as soon as they moved in, inspired by the colors of the outdoor gardens framed by the green painted window frames within.

Page 110-111
One block from the gulf, the original house was built as a vacation home for the Hudson family.

Right
Contemporary sectional seating surrounding a Mies glass-top table fits well into the layout of the house. A screen wall outside creates both a small courtyard and garden and gives privacy from the street.

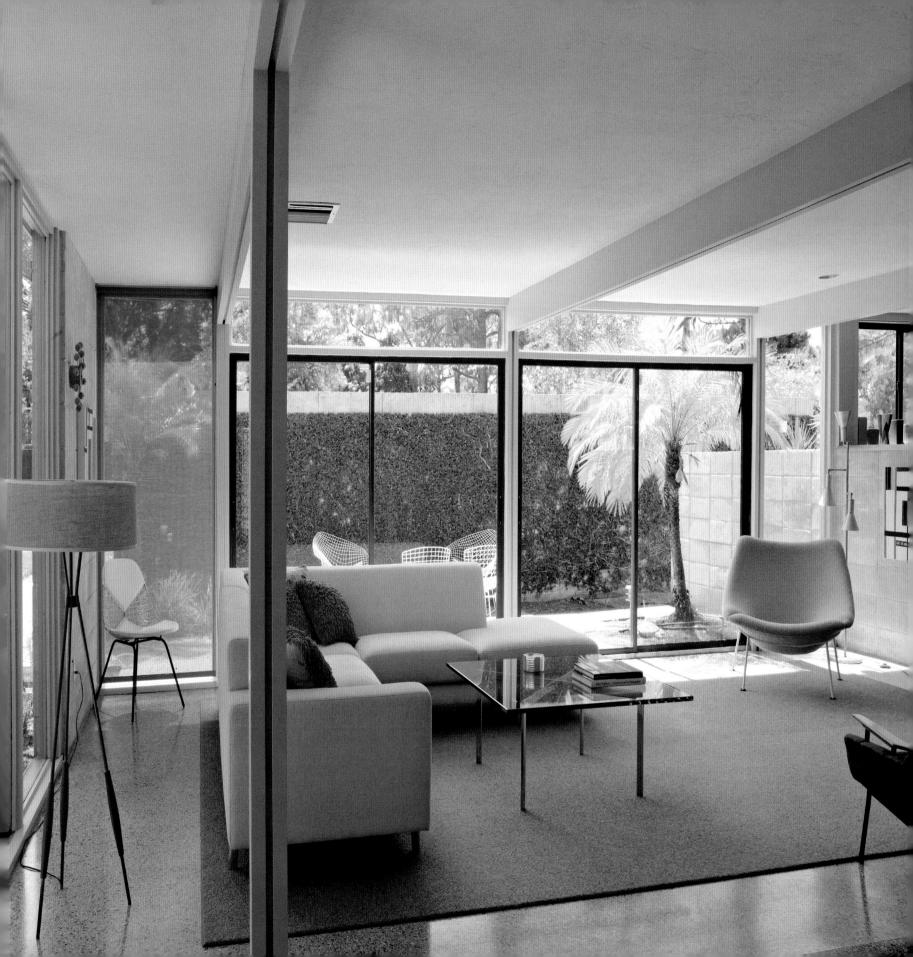

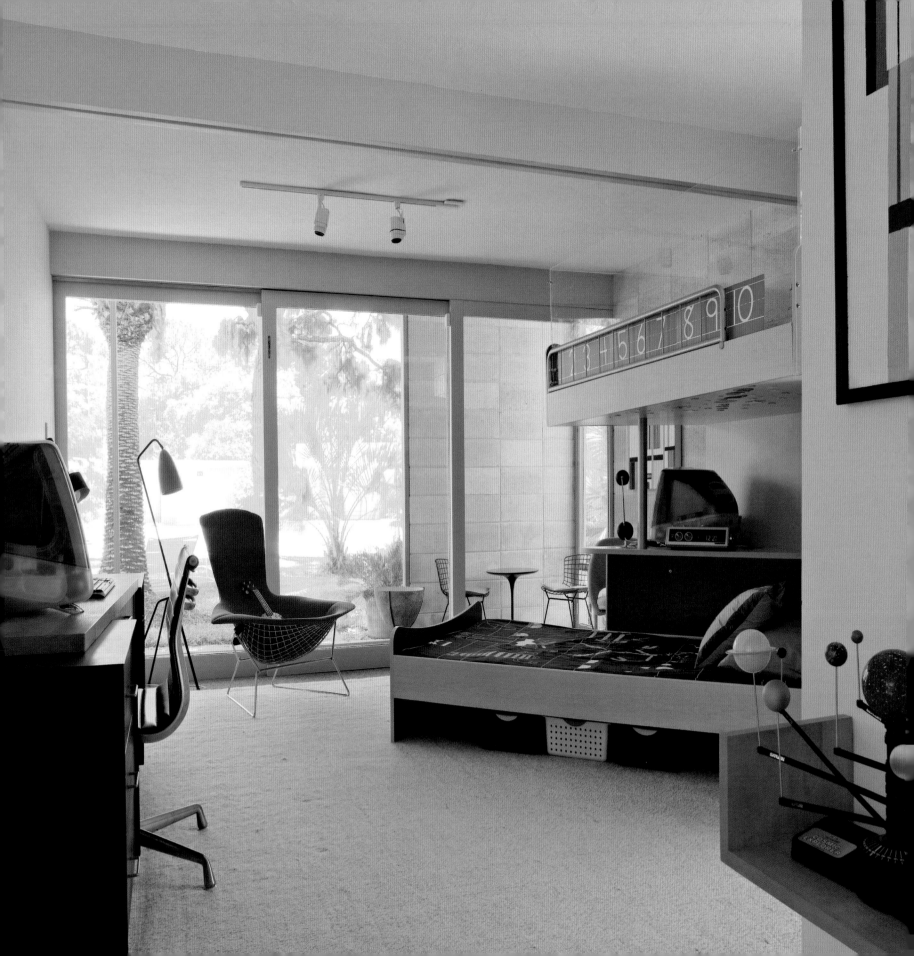

Avid collectors and thrift store fans, the couple has assembled a number of mid-century classics. Bertoia is their favorite designer, and a few examples of his work are featured in their son's room. The collection includes works by Eames, Nelson, Knoll, Saarinen, McCobb, Albini, and several more. The favorite piece in the house is the Eames red bikini dowel leg chair, a thrift shop find.

When they moved into the house the MacMurrays had to replace the roof and repaint. The grounds were rather sparse with stately royal palms in front of the house that appeared to be guarding it. They replaced these with live oaks and worked to improve the garden. They intend also to replace some later additions, so that the black framed sliding doors will eventually give way to the original wooden framed examples, hurricane permits permitting.

Guy Peterson, a Sarasota-based architect, is working on an addition to this house. He says, "The large living area in this space was originally half enclosed and half screened. Previous owners have moved the glass walls out to the edge of the house to enlarge the space. I hope to replace these windows with ones that work more in harmony with the structural system."

The entry area has been moved to a new foyer that is part of an earlier addition by another architect. While respecting the overall spirit of the original building, this part of the house brings in newer materials and details that are not consistent with Twitchell's work. Peterson adds, "We want to modify these areas as well. Our assignment is to rework the existing house into a more suitable and functional plan for the McMurrays and to add new space to house his art studio and her work studio. We are also adding a new two-car carport and a swimming pool.

"We propose to use exposed masonry units much like Twitchell's original house," Peterson continues. "While the ocala block is no longer available, we want to contrast it in some meaningful way. Our new additions add vertical height and variation to the roof line as well as, by their placement, create exciting new outdoor spaces and courtyards."

The addition and updating of this house will respect the original work of Twitchell and will return it as close to the original design as possible, which is not far off already. As Guy Peterson says, the intention is "to improve and create a new modernist identity for the entire house by our new additions and renovations."

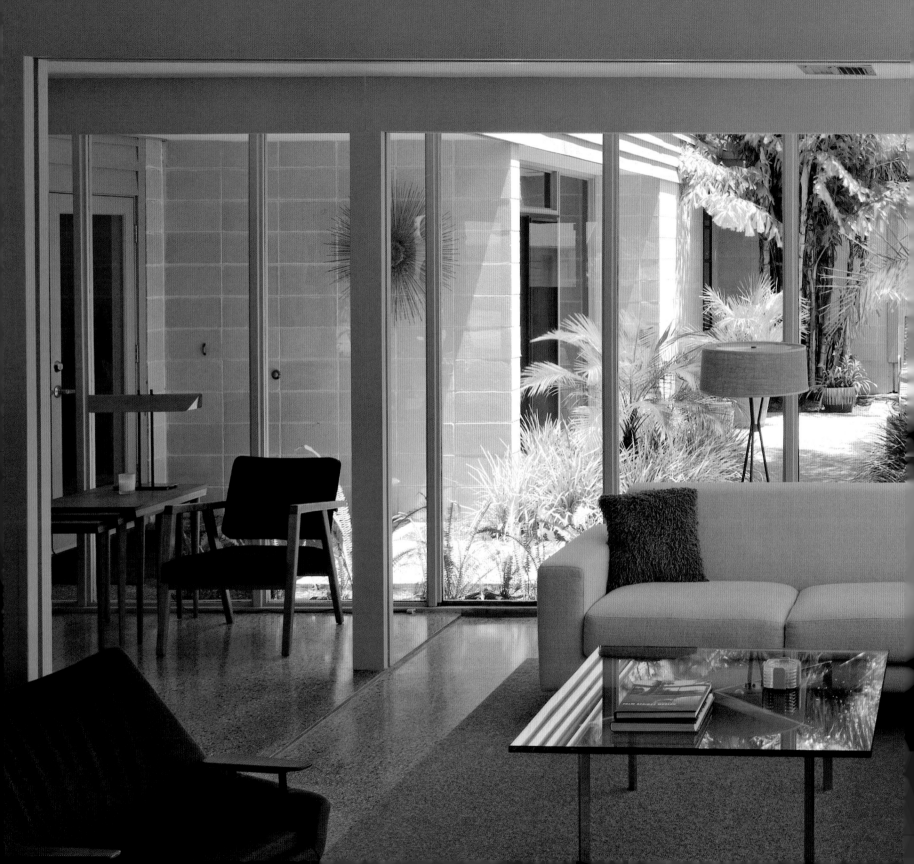

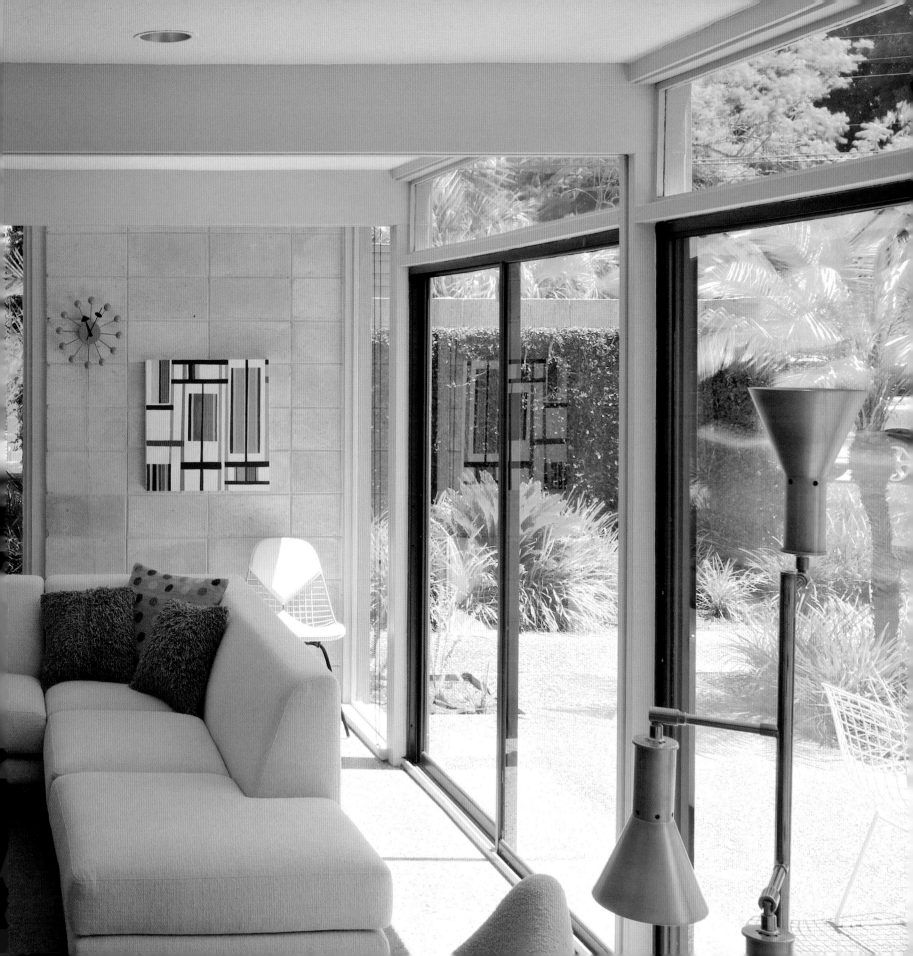

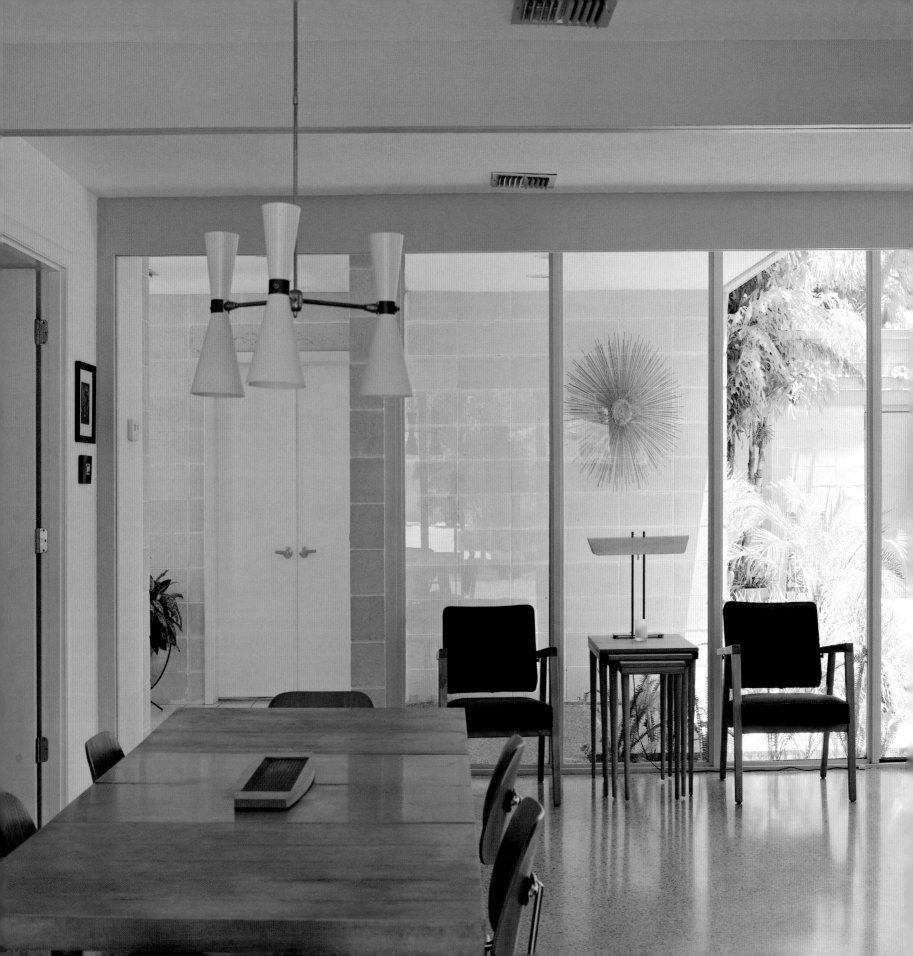

Left
The dining area leads to the entrance lobby. Just outside is a wall sculpture by Jere. Throughout the house the original terrazzo floor gleams.

Right
The lengthy loggia is completely screened to enable comfortable cooling. Twitchell's daughter recalls that he made the wooden frame sliders himself in his custom woodshop.

Page 120
The entrance lobby, a later addition not by Twitchell, unites the original house to the later wing. Here their favorite piece, an Eames dowel-leg chair flanks a Nelson bench.

Page 121
The master bedroom leads to the bathroom. Even though of slightly different construction, it gels well with the origins of the house. More pieces by McCobb and Jere are found here.

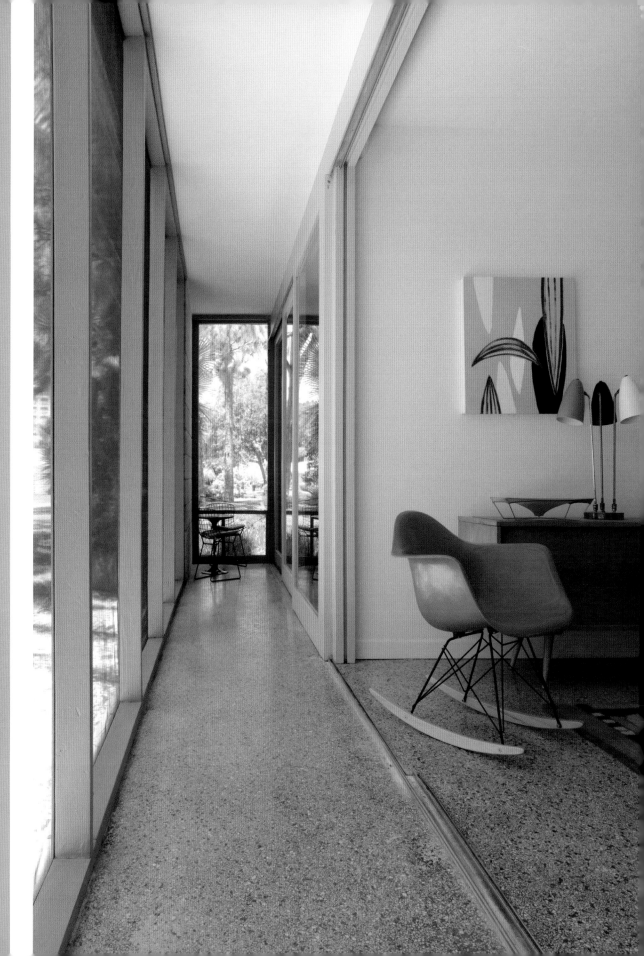

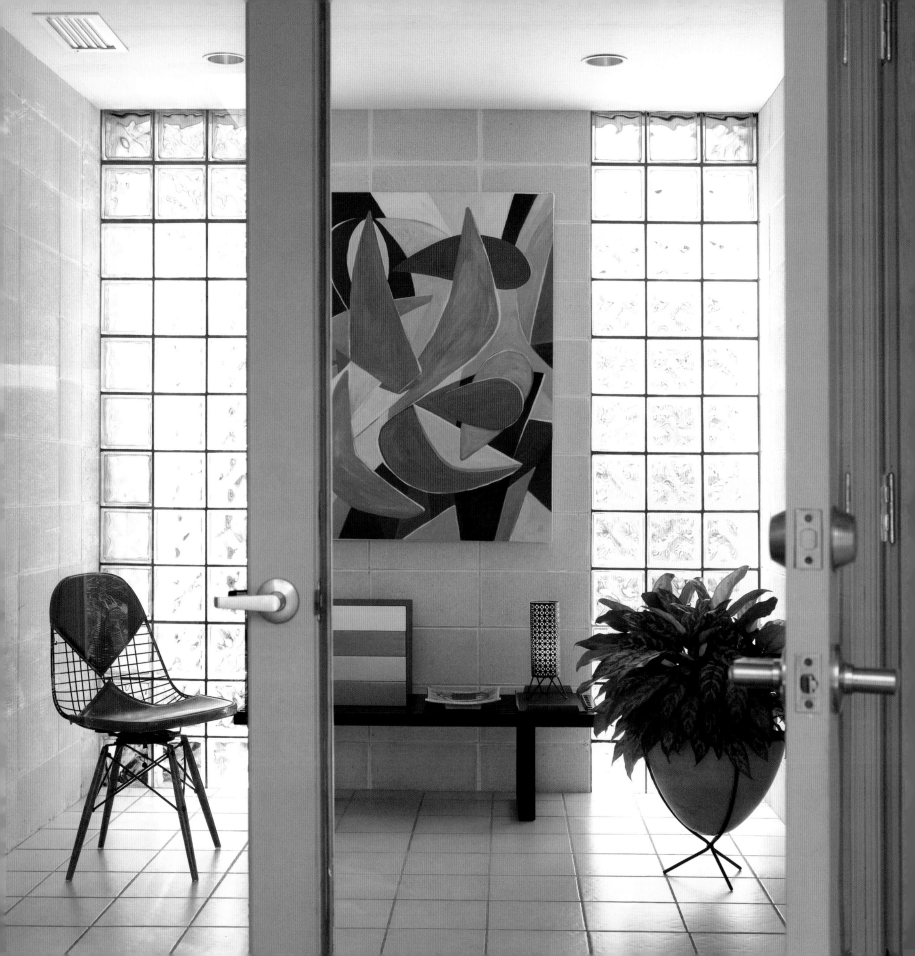

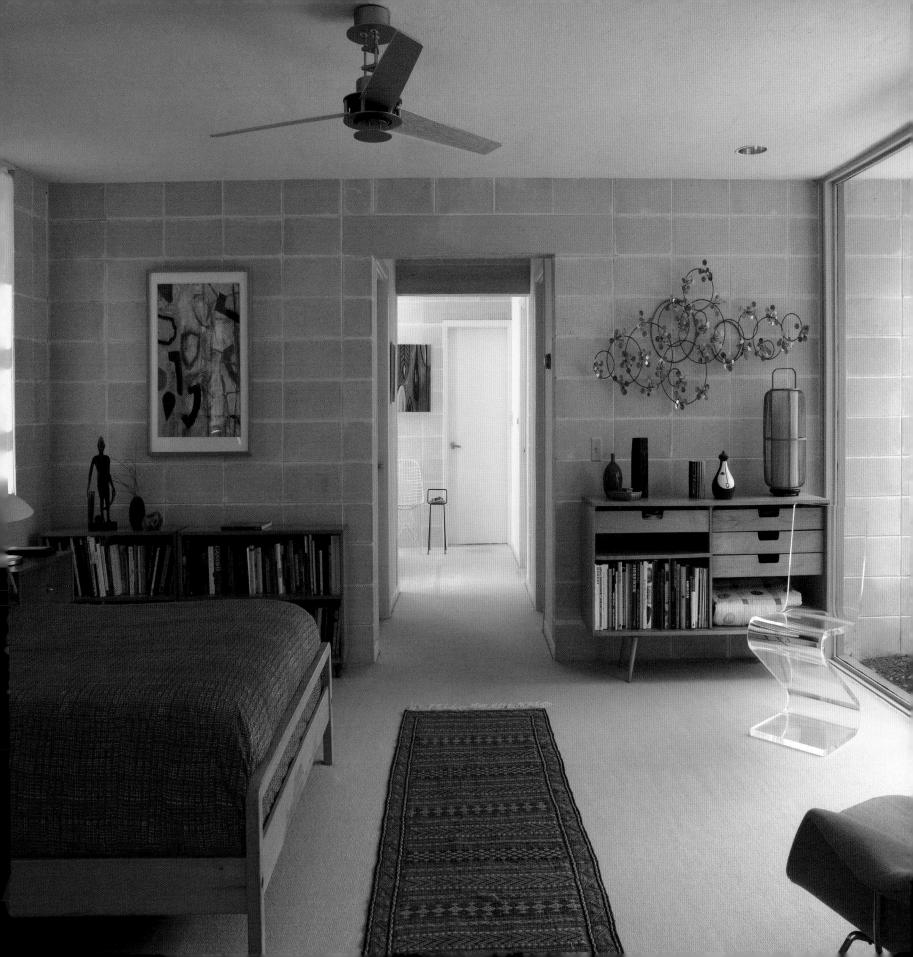

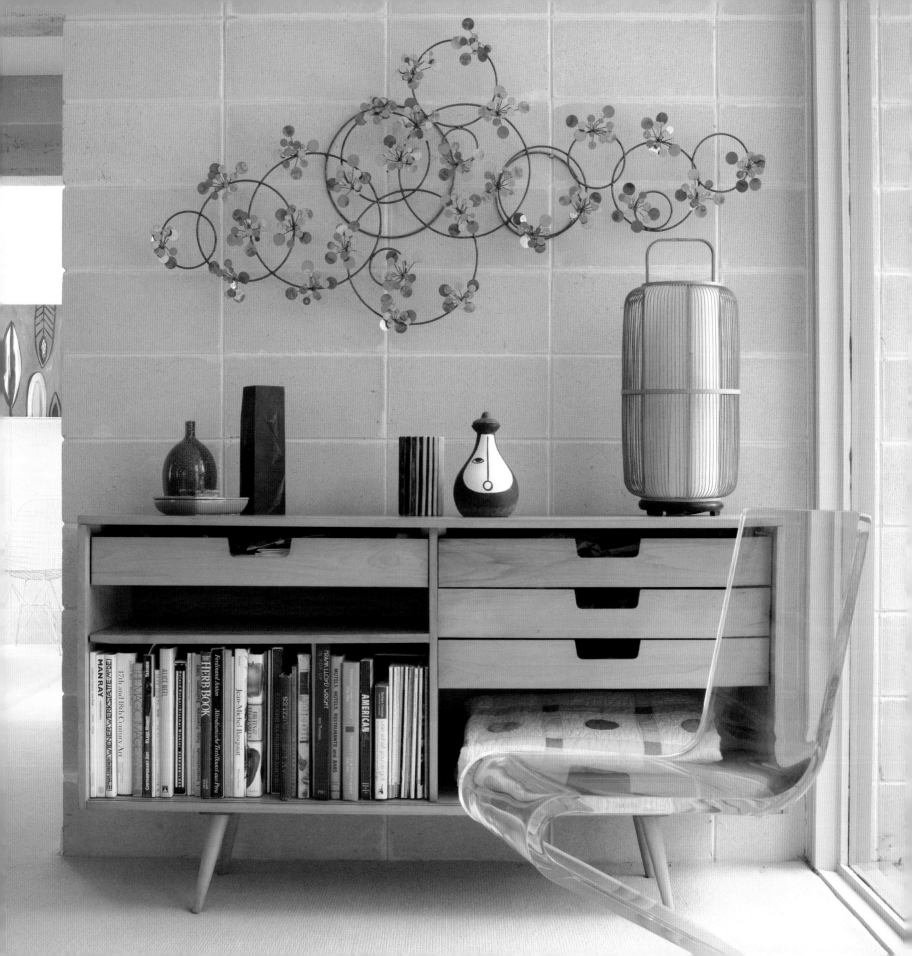

Left
An open-fronted McCobb sideboard gives ample storage and displays their thrift shop finds. The Jere sculpture above floats across the wall.

Right
The welcoming womb chair by Saarinen stands its ground.

Jordan House

Lake Wales

Mark Hampton, 1955

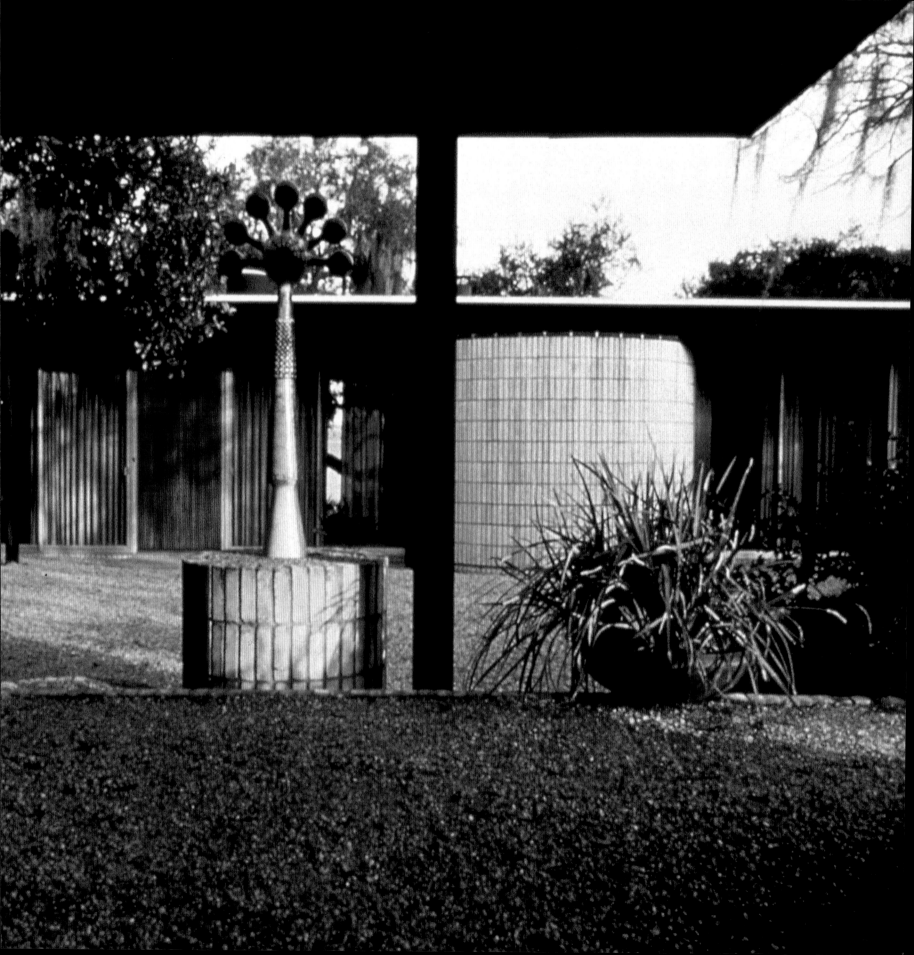

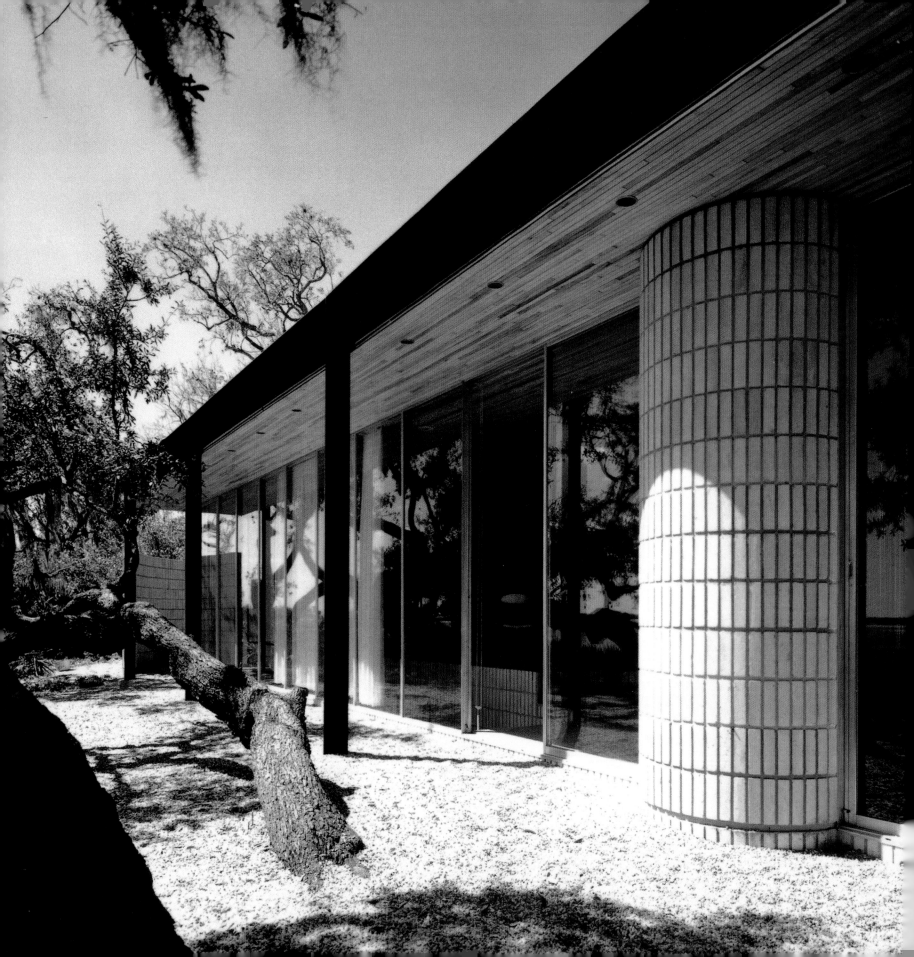

Page 124-125
A view of the house from the carport. With this house, Hampton introduced new building materials to the Sarasota School. Here, the white brick is used for construction as well as for features.

Left
The rear elevation includes a semicircular structure that incorporates a fireplace and chimney. The overhang is finished with same pecan wood strip as the inside, creating one visual plane.

Page 128
(Small)
An internal pool runs half the length of the back of the house. A chair of Danish origins sits alongside.

(Main)
Here is "The Bachelor Pad" with the Hampton-designed furnishings in the sunken seating area. The wall behind is of blue glass. Hampton said, "The house...has been the most complete architectural statement I have ever made."

Mark Hampton, a Floridian born and bred, graduated from Georgia Institute of Technology with a bachelor of architecture degree in 1949. In 1951, after teaching there for about a year, he joined Twitchell and Rudolph's firm. Once he had received his architectural registration in Florida, however, Hampton established his own firm in Tampa, his hometown, some forty miles north of Sarasota. He became well established very quickly, designing both commercial buildings and homes in Tampa and throughout Florida.

Hampton built two striking houses in central Florida in the mid-1950s. In 1955, he designed a house in Lake Wales for Stan Jordan, then, in 1957, he planned a house in Lakeland for Mr. and Mrs. Rayburn Perry, who were nearing retirement. Hampton later went on to build new showrooms for the modern furniture store Galloway's in Tampa, a large-scale Miesian temple, in 1958, and a couple of schools in Sarasota. Now based in Coral Gables, he is still working.

Both central Florida houses have rectangular plans; the Perry house uses square or rectangular partitions to break up the area, while the Jordan house uses circular partitions to divide the space. For both houses, particularly the Lake Wales house, attention to details and materials is paramount.

Situated on the banks of Crooked Lake, the Jordan house is a combination of rectangular glass planes among brick-built semicircular partitions. Way ahead of its time, this house deservedly received the 1957 Homes for Better Living award sponsored by *Time, House & Home* magazine, and the American Institute of Architects.

Stan Jordan, an employee at Disney at the time and still very much part of it now, commissioned Hampton to build a "bachelor" house. The lot was ripe for development and the result was a glass box nestled among live oaks. Jordan had seen illustrations of the house Mark Hampton built in Tampa for his mother, Laura, in 1953. The Laura Hampton residence was a one-story, steel-framed house settled into a thicket of oaks. Its very open plan incorporated two bedrooms and one bath. The exterior walls were either glass with wooden shutters or white brick.

Keen to be the ideal client, when Jordan first contacted Hampton he was told that the lot he had selected was inappropriate. The next day he came up with the present site. Says Hampton, "He wanted his quarters to produce an effect of uncluttered simplicity: He stressed the seclusion of the site and the fact that he entertains small groups informally, but he also wanted his guests to feel comfortable."

Hampton created a box almost sixty feet long, with white brick half-round walls that carved out areas within the space for the kitchen and bathroom. What is really a one-room space, with walls of storage open and closed, concealed track drapery that divided areas. Thus, the entire space is flexible. With its sunken semicircular conversation pit, this house is more for the future than from the past. Many typical Hampton elements crop up—for instance, a reflecting pool runs half the length of the house, from the main living area to the sleeping quarters. The kitchen and bathroom areas are concealed behind full-height, brick-built circular walls. Introducing brick to these Sarasota school houses added another dimension to the overall concepts, even though Ocala concrete block was heavily used already. Besides the architectural elements, Hampton's concern for the interior was evident in all of his houses. He would work on the project as a complete concept and design all the built-in elements as well as select the decorative materials used. In earlier houses by fellow architects, the interiors had been put together mainly for the photographs that were to be published in journals.

At the Jordan house, the interior materials used are everywhere luxurious: timber from local pecan trees applied in thin strips, poured terrazzo, penny-round mosaic and marble-laid floors, veneer-faced storage. Every surface featured an applied finish and texture. Ten years after building the original house, Hampton added a guest house for Jordan, a glass box within a circular white brick wall.

The house has truly stood the test of time. Fifty years later, this standout masterpiece of its time is fortunate to have its original patron still in residence, a man who is as enthusiastic about the house now as he was when he first moved in. As Hampton says, "This project, the house built in 1955 and the guest house in 1965, along with the improvements of floor materials and art works added through the years, has been the most complete architectural statement I have made."

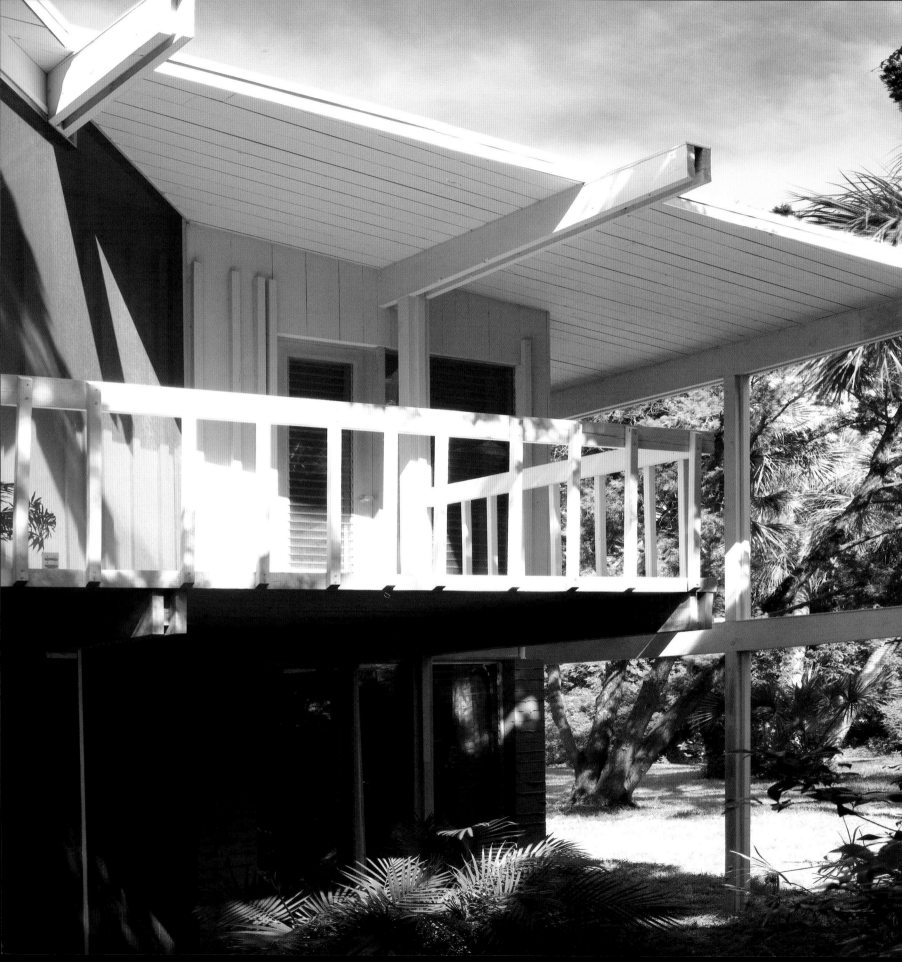

Dudley House

Sandy Hook, Siesta Key

Victor Lundy, 1956

While **Paul Rudolph** was finishing at Harvard another architect was in the making. Victor Lundy graduated a couple of years after Rudolph with a totally different outlook. With his art training he added a new direction within the Sarasota school. His colorful presentations gained him many public commissions.

Victor Lundy's first architectural project in Florida was a drive-in church. He built a Presbyterian church in Venice, just down the coast from Sarasota. Lundy arrived in Sarasota as a qualified architect after receiving a bachelor of architecture degree in 1947 and working with various firms in New York. He already had professional recognition in New York and California. The church, built in 1954, was a simple structure of wood and glass set among the pine trees and featured in *Life* magazine. An entire career of church-building throughout the United States would follow.

In one of his few residential projects, in 1956, Lundy was commissioned to build a family house for the Dudleys, who had purchased a lot at the exclusive enclave of Sandy Hook. The fifty or so acres of land, purchased by Mary Hook in the 1930s, were edged with the pale sand of Siesta Key. It wasn't until the mid-1940s that Hook began to develop the site; by 1952 two houses had been built on the estate. Hook herself built and designed six houses at Sandy Hook. By 1963 the group included work by Rudolph, Twitchell, Seibert, Rupp, West, and Folsom Smith—a real showcase of the Sarasota School of Architecture.

For the Dudley house, Lundy created a two-story rectangular house with a carport that occupied some of the ground-floor level. Offered several schemes, the owners realized they wanted the upper level to be the main living area, giving the lower level over to the children, separated from the adult's quarters. The children would have access to the outside areas, safely sheltered from the elements by the screened balcony above. The upstairs living area also provided views of the gulf in the distance, but sadly these disappeared when other houses cropped up on the site.

The visual aspect of this house accounts for its longstanding appeal. A series of built-up columns and beams clearly stand away from the curtain wall of the main structure, creating a wooden "space frame." The skeleton structure was built before any of the walls, sheltering the workers below from the midday sun. Douglas fir trees comprised the main construction element—various-sized beams ran through the building, some of them reinforced with steel plates where necessary. The lower part of the house consisted of a brown concrete block with what look like expanding joints of mortar that add great texture to these areas since the block was left exposed on the inside. Other interior finishes included various widths of cypress-faced paneling with applied beading at various distance intervals. The roofs were lined with tongue-and-groove planks, as was the floor on the second level; however, this was eventually covered with straw matting.

Living in this house was really like living above the trees; its outside terraces, decks, and balconies were open to the surroundings. "Because the site is separated by the road and is some distance from the Gulf of Mexico, and because the owners wanted the 'living' part of the house to be above for views, the best breezes, and isolation from the kids and the TV below, a two-story scheme evolved," Lundy once said. "Once upstairs, the owners really stay there. It comes as a definite surprise to come up the stairs from a closed-in, almost jungle atmosphere below to the view of the gulf and water beyond."

The Dudleys sold the house in 1973. The succeeding owners, still in residence, have restored and updated it for today's comfort demands, installing central air-conditioning to replace the through-wall units that had been added over the years. Architect Nan Plessas handled a very sympathetic restoration. Due to some forty years of exposure to the Florida atmosphere there was a great deal of wood decay. Portions of both the columns and beams had to be cut out and replaced, while new stainless steel U-straps were made to replace those that had rusted at the footings.

Page 130-131
The skeleton structure of the two-story house stands away from the curtain wall of the living accommodation, creating a space frame that enables shaded balconies.

Page 133
The side elevation of the house showing the protruding terrace from the upper level living floor. The area adjacent was screened-in to make a more usable area suited to the Florida climate. The roof line shows Lundy's use of different angles and overhangs to create an individual structure.

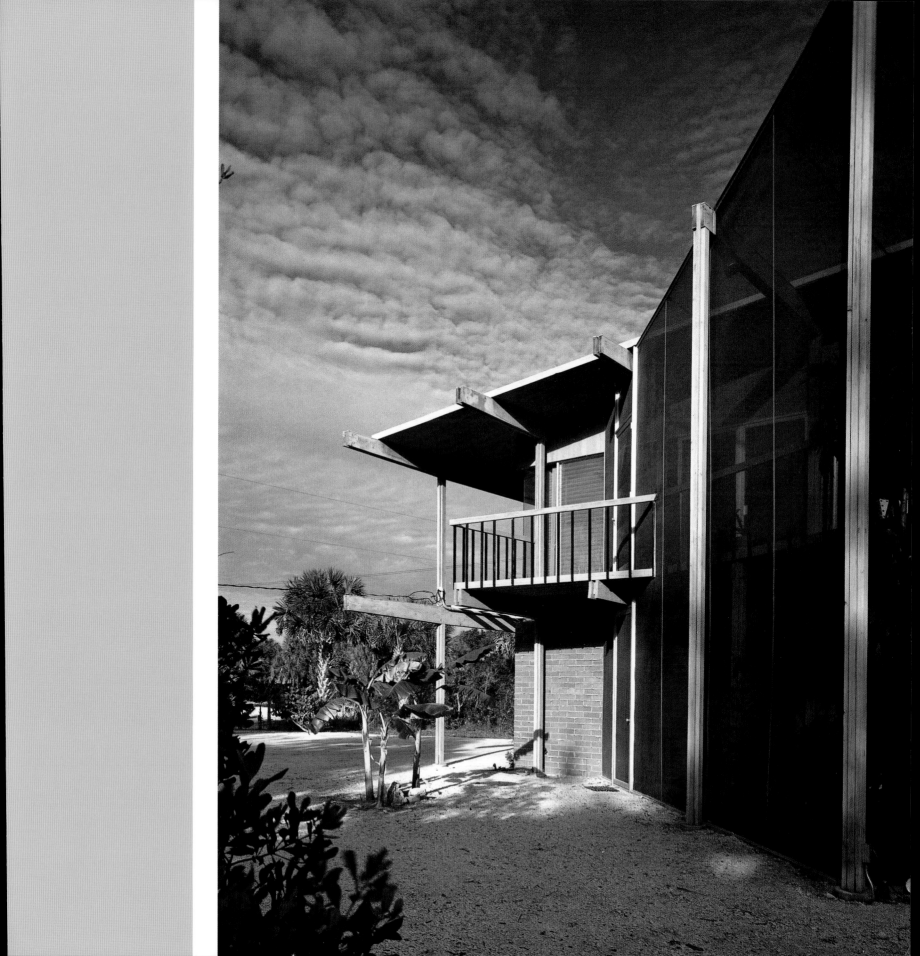

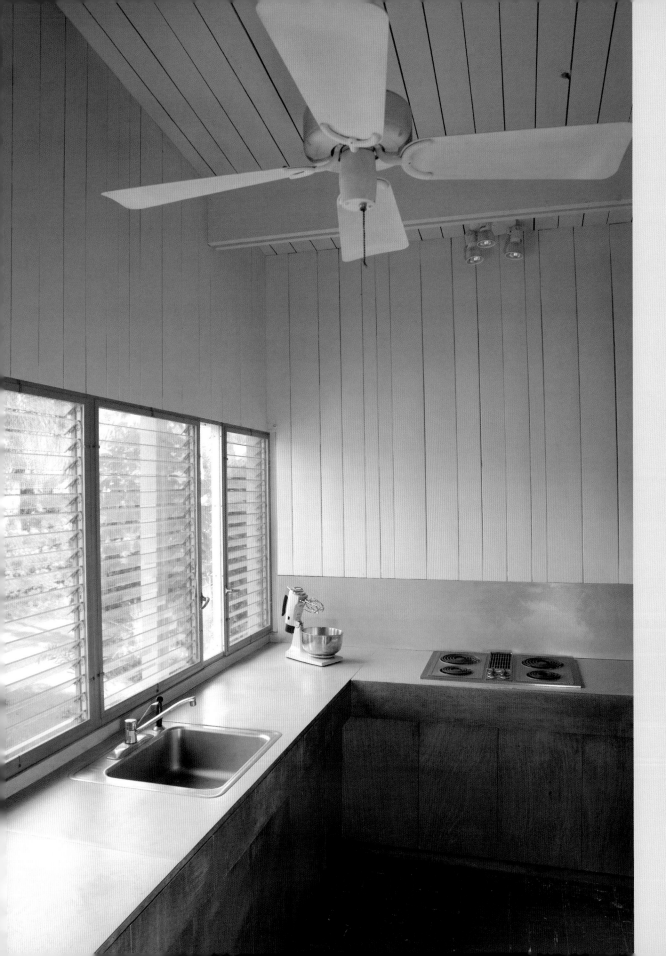

Left
*The kitchen walls of cedar planks
at varying distance intervals
reflect the applied beading on the
exterior elevations. The original
Lundy kitchen is intact with its
orange laminate surfaces and the
narrow jalousies.*

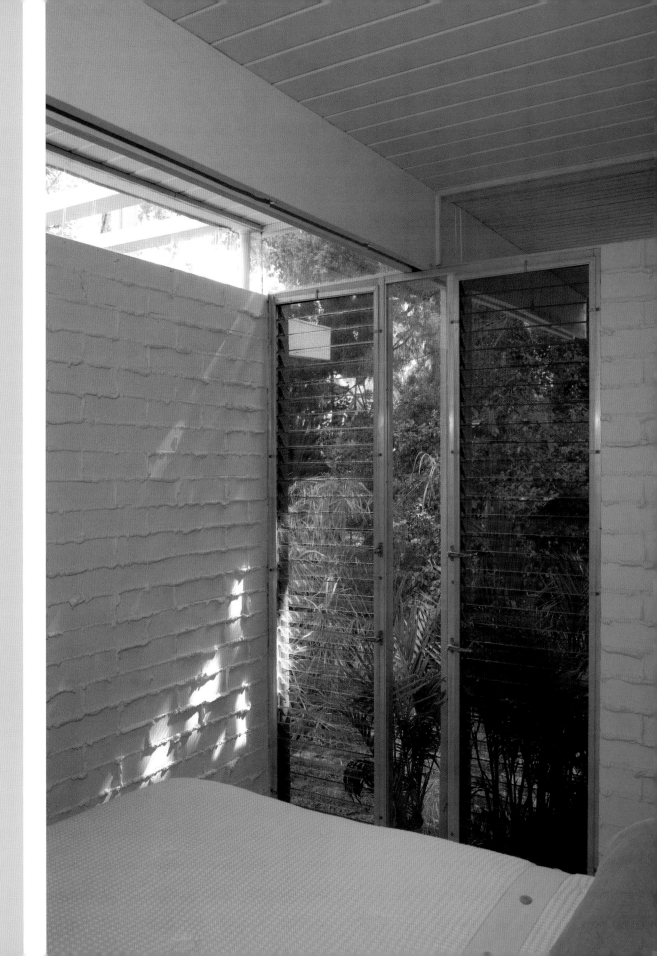

The lower level of the house is built of small concrete blocks originally brown in color. Here the oozing mortar has been left for a great effect.

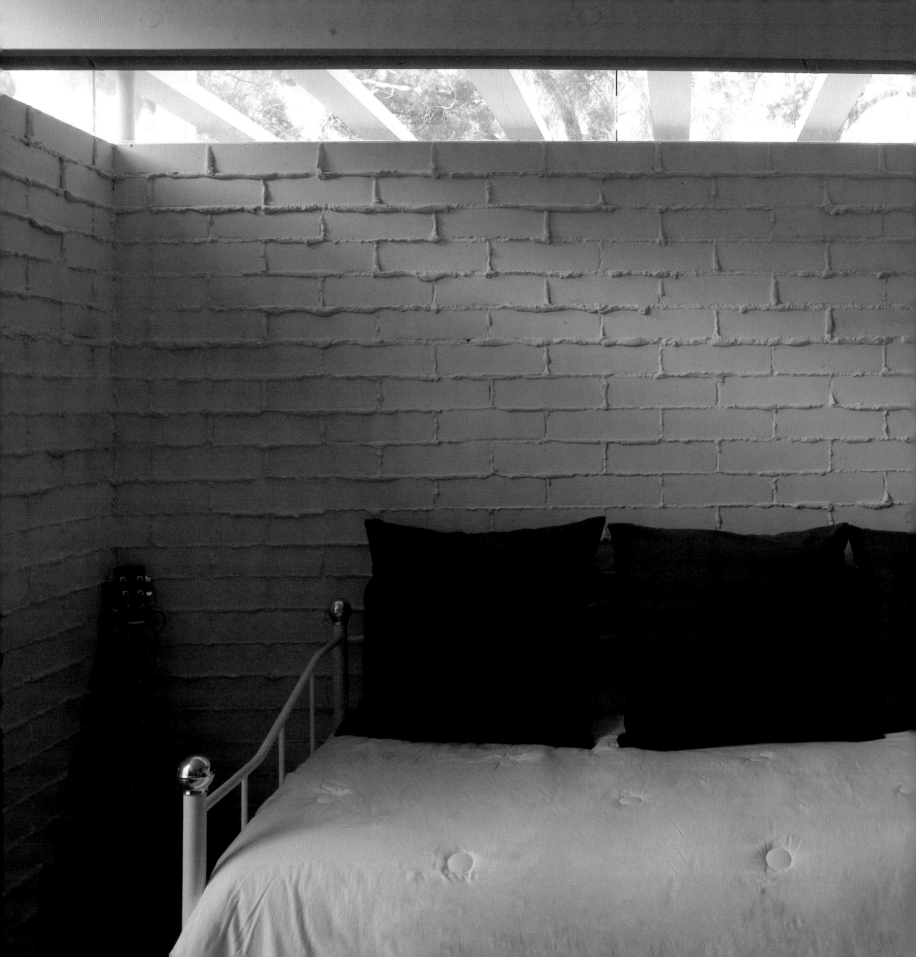

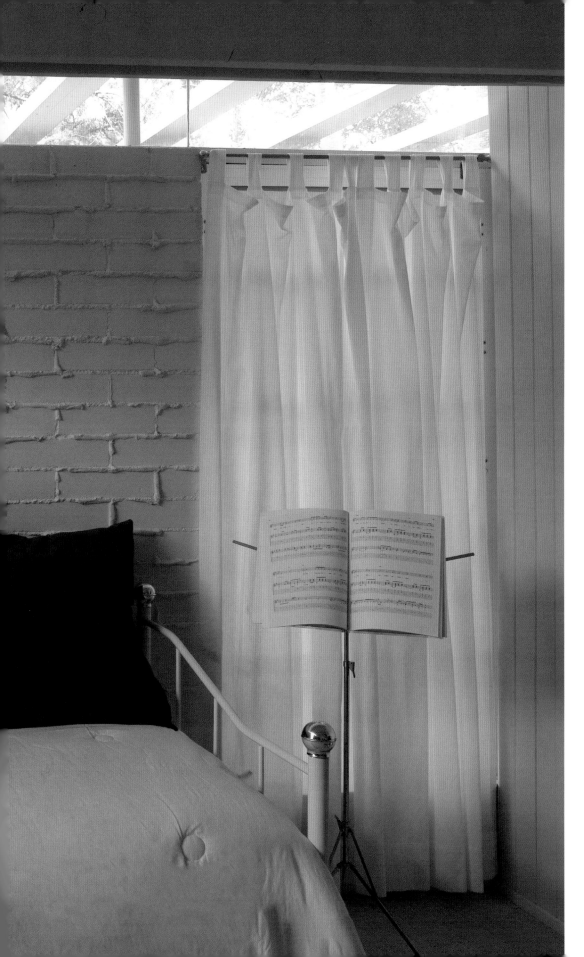

The house has since been added to the National Register. In Plessas's report regarding the application, she said, "The house is a fine example of both Victor Lundy's personal quest for new forms and his individual response to the personalities of his clients, the climate, and the surroundings."

In Venice, Lundy went on to build the Herron house, based on an H-shaped plan—a freestanding, upswept roof over a series of laminated wooden arches. Featured in *Architectural Record Houses* of 1958, the house also received an Honor award in an American Institute of Architects–sponsored competition in 1959 for the best modern houses in the South.

While Lundy built a few one-off houses in Florida he has become more renowned for his governmental, commercial, educational, and religious buildings throughout the United States and the world.

Left
In another lower level bedroom, the clerestory strip windows add to the lightness of the main timber structure. The living accommodation floor above appears to float above the block wall.

Page 138-139
From the front of the house, the two levels comfortably sit together, nestled in the naturalistic landscape. The openness of the carport below exaggerates the lightness of the timber structure above the block wall. Adjacent to the jalousie windows, the wooden beading is applied at irregular spacings.

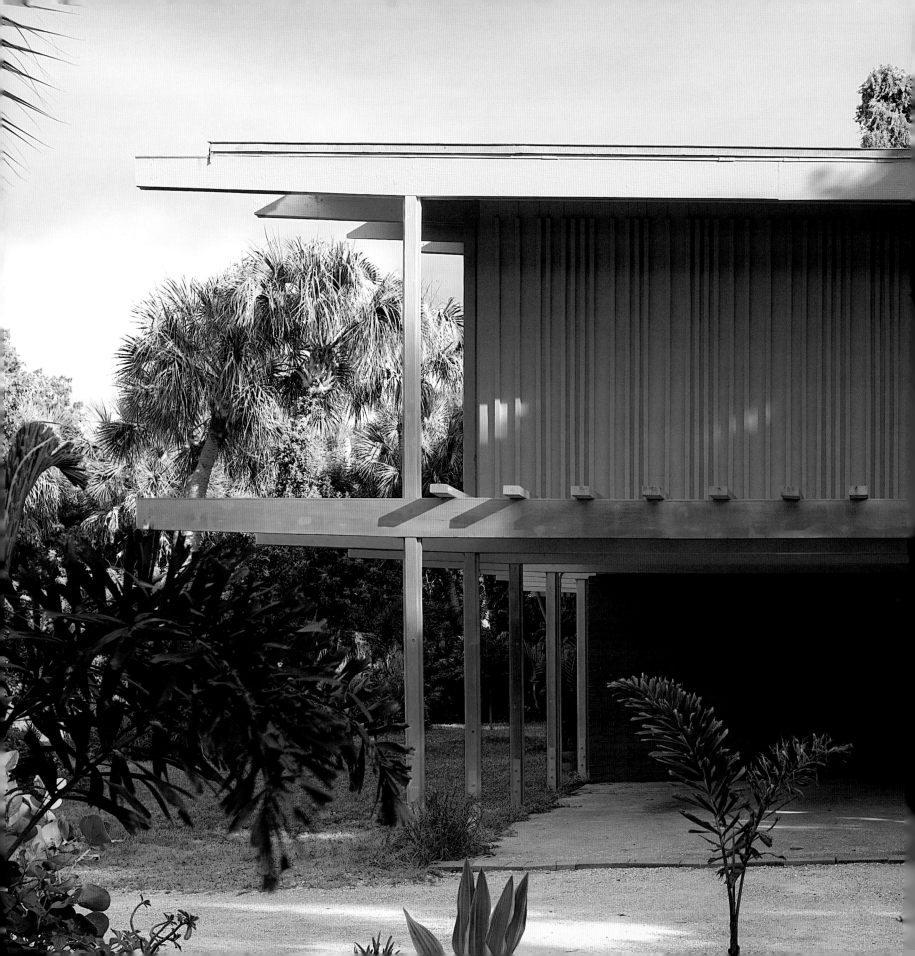

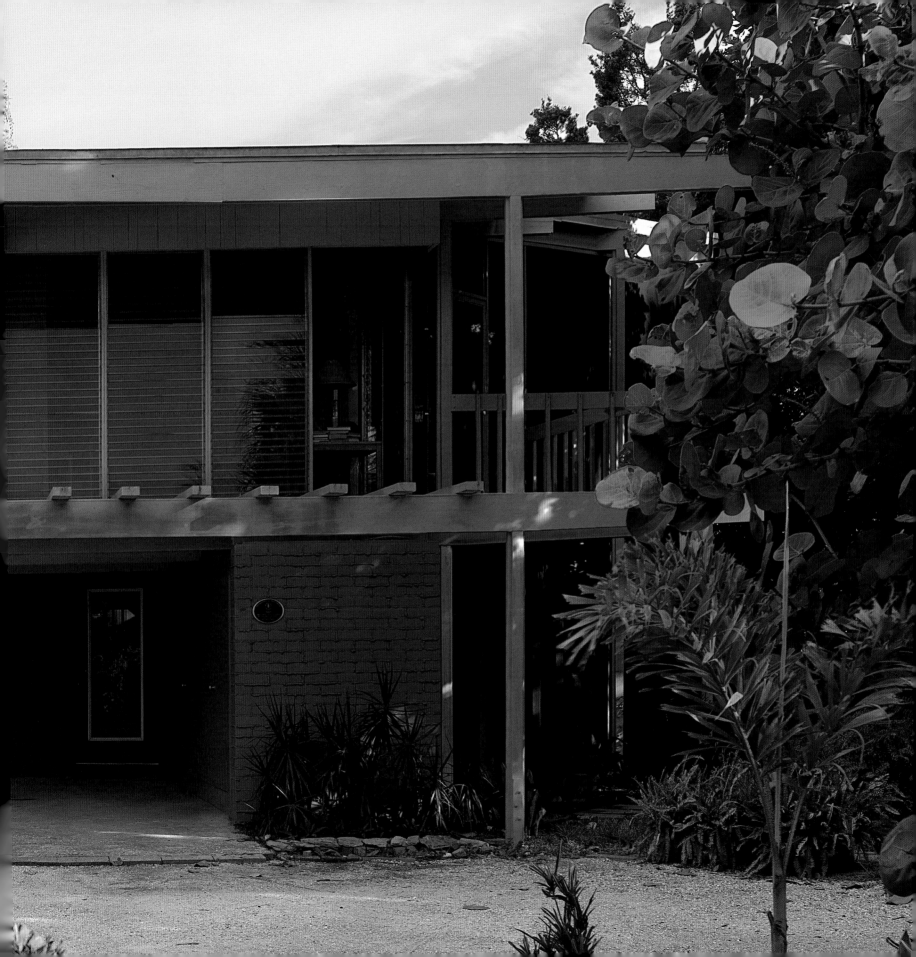

Lu Andrews House No. 3

Sarasota Mainland

Ralph Twitchell, 1959

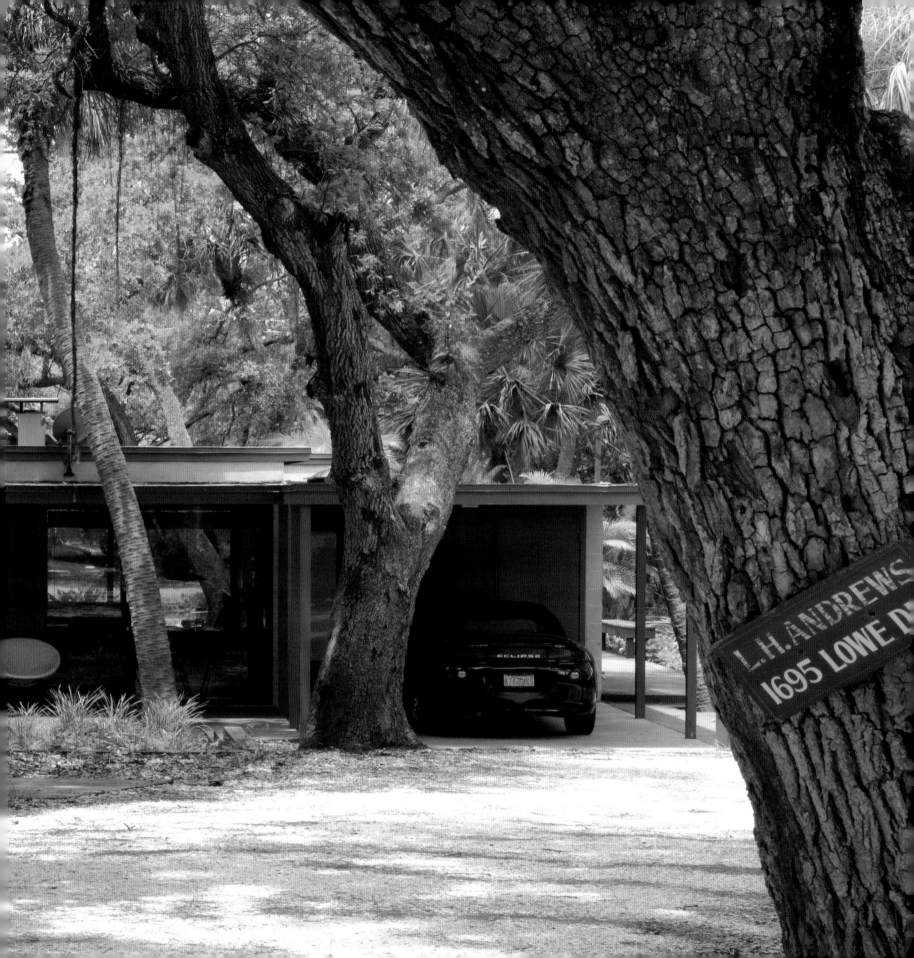

Page 140-141
On a bayou, Lu Andrews house No. 3 is surrounded by palms and live oaks. Being hidden away on the Sarasota mainland has perhaps saved it from developers' eyes, even though it could easily be moved to a safer site for preservation.

Page 142-143
From the front of the house, the openness is apparent as are the series of skylights installed by Lou Salvatori who rescued this house from its deterioration some years ago. Lu Andrews's name-plaque is still in situ.

Left
A typical setting with palms and live oaks on the bayou.

Ralph Twitchell built quite a few houses for family and friends that reflected radical new ideas he deemed too forward-thinking for most clients. Such houses could be seen as a tangible catalog of ideas, which prospective clients could compare to what they were being offered from the drawing board.

Twitchell built three speculative houses for Lu Andrews, his secretary/bookkeeper. The first house, built in 1939, used John Lambie's Lamolithic system, later used in other Twitchell and Rudolph projects such as the Revere House. The second house, built in 1940, was the first Twitchell house to use stacked concrete block construction, typical of much of his later work. Lu Andrews No. 3 came about in 1959, almost twenty years after Twitchell's first "gift." Its site was a bayou in Sarasota.

Kim and Lou Salvatori rediscovered this forgotten gem in the late 1980s. While Lu Andrews had lived there since 1959, it had deteriorated somewhat over the years. Lu Andrews had moved to a nursing home a year before the Salvatoris first encountered the house.

The Salvatoris brought with them a passion for restoration and renovation. Once they understood the house's construction and materials, they planned a sympathetic update to the building. After spending weeks clearing the site, they revealed, intact, a stacked concrete block wall, cypress beams and paneling, clerestory and jalousie windows, and a terrazzo floor.

At this time the Sarasota School of Architecture was little-known, and was only then being reassessed. That the house was neither demolished nor remodeled was remarkable. Perhaps its location, down a little lane off the main drag, kept it from developers' eyes.

With tender loving care the new owners were able to retain many original features, fixtures, and fittings. Only the kitchens and bathrooms were in need of a major cleanup. Cabinets had to be resurfaced and stainless-steel worktops added to update the kitchen.

The Salvatoris' biggest job was installing a new roof. It turned out that the house was not entirely empty; termites had moved in. Reroofing also allowed the Salvatoris to install new lighting and air conditioning. They also were able to add several skylights to bring more light into the overall space.

The concrete block suffered the most during the decline of the house, but the use of pressure washers bought it back to life, and a sealer was then applied to keep it pristine. The terrazzo floors, of course, stood the test of time and were immaculate.

At the rear of the house looking toward the bayou is a screened-in box, another typical Twitchell element. Many of the original jalousie windows were removed to give a clearer view to the outside. With an up-to-date cooling system a cross breeze was now less important. The Salvatoris installed a large deck to enlarge the indoor/outdoor areas and the entire house was furnished with thrift-store finds and updated or restored items from the original house, like the built-in bed and the Paul McCobb dining set.

According to Joseph Spinella, the most recent owner and steward of the house, the house has needed little work since. The addition of exterior wood and stainless-steel outdoor lighting continued to open up the inside/outside elements of Twitchell's designs. A dramatic tenor, Spinella sings opera, performs with symphony orchestras throughout the United States, and is a national vocal coach for all styles of music. "The house has been an inspiration because of it has an 'artsy' feel to it. I feel that I am part of the architecture rather than simply being an observer of it. It inspired me to write the most amazing rendition of the 'Star Spangled Banner' ever written," he adds, "which is on my CD called 'Sparks to Fire.'"

As the years pass, Spinella notes that he continually sees new features he hadn't noticed before in the perfectly conceived plan. "It may be the evening light casting interesting shadows on the walls and floors, or the way a single candle in the bedroom, can reflect off the door glass, giving the illusion that it is also burning in another room," he says. Spinella plans to sell his house when the time is right, but in the meantime, "many surprises are built into this little jewel box."

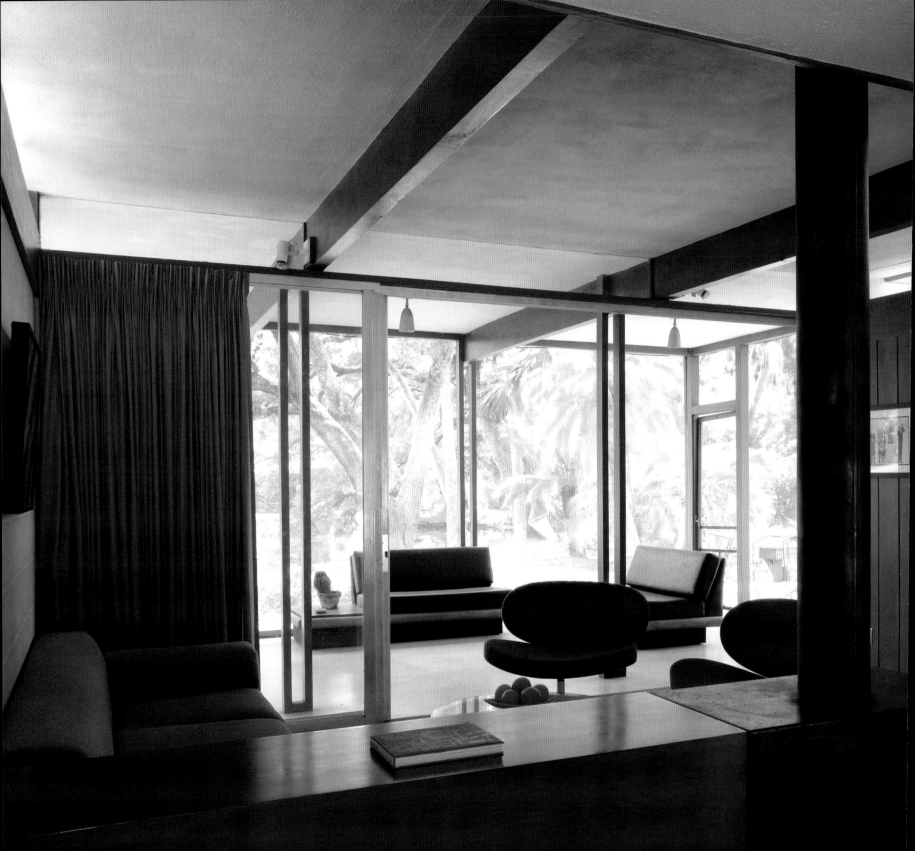

Left
A mix of original furniture and very contemporary pieces brings this house up to date. In the foreground at right is the original wood-burning stove alongside a Twitchell built-in piece.

Right
The open kitchen has two skylights to bring more light into the galley area. A large plasma-screen television has been installed into the breakfast bar.

Page 148
The dining area is furnished with a Paul McCobb dining set from the 1950s. A wall of built in storage separates this area from the entrance lobby.

Page 149
The bedroom is dominated by the large built-in bed. The sliders on the left open up onto a screened loggia. The terrazzo is immaculate throughout.

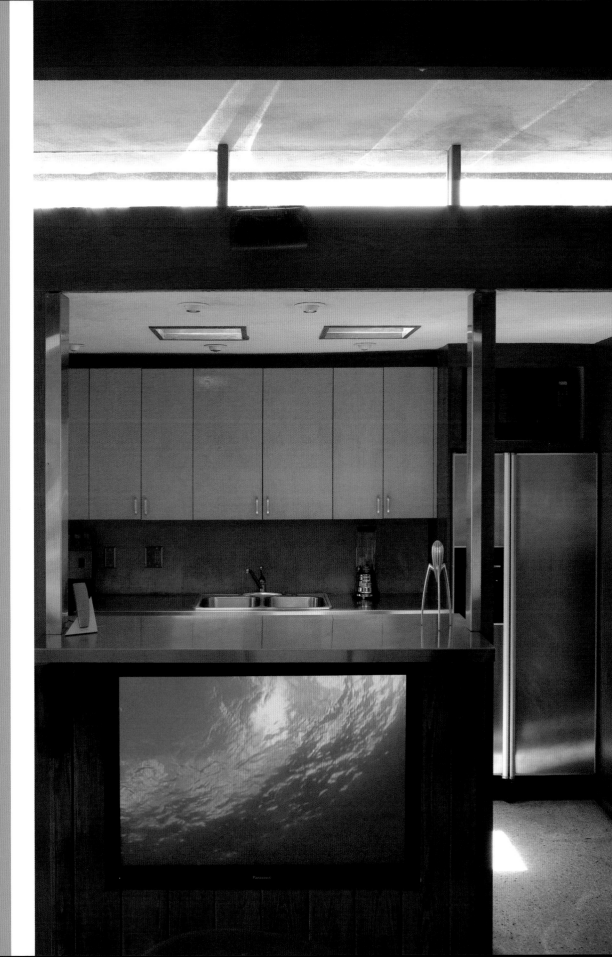

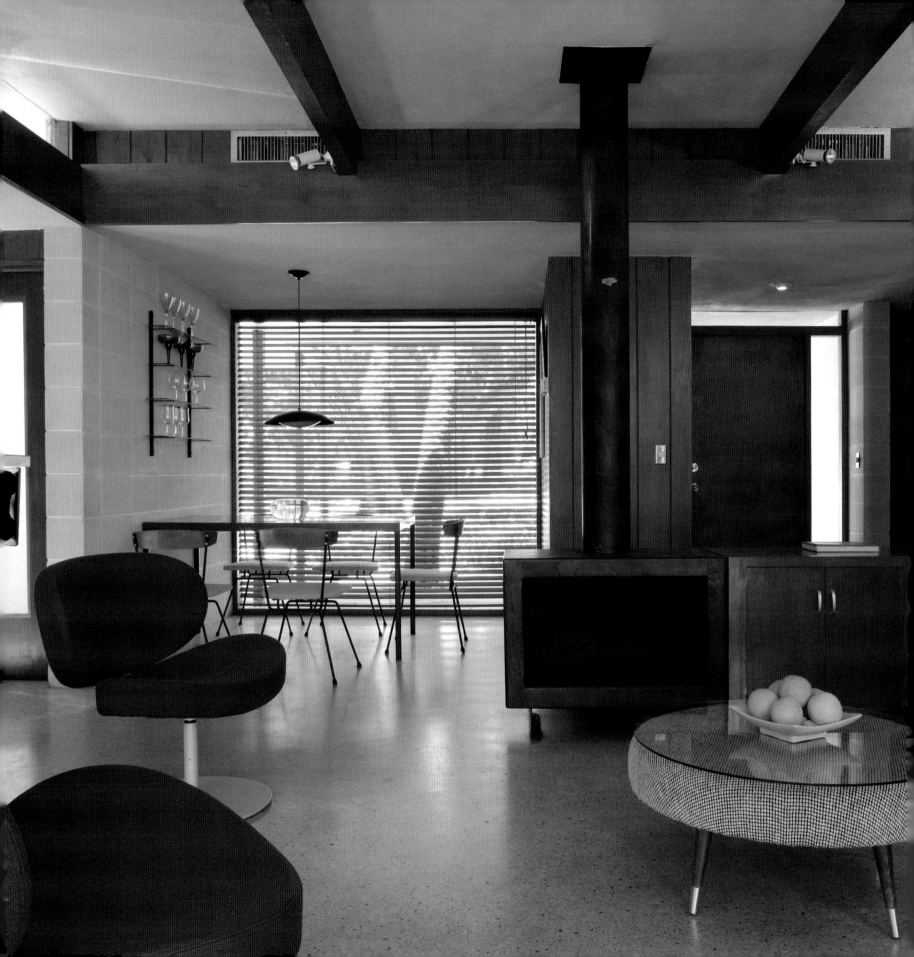

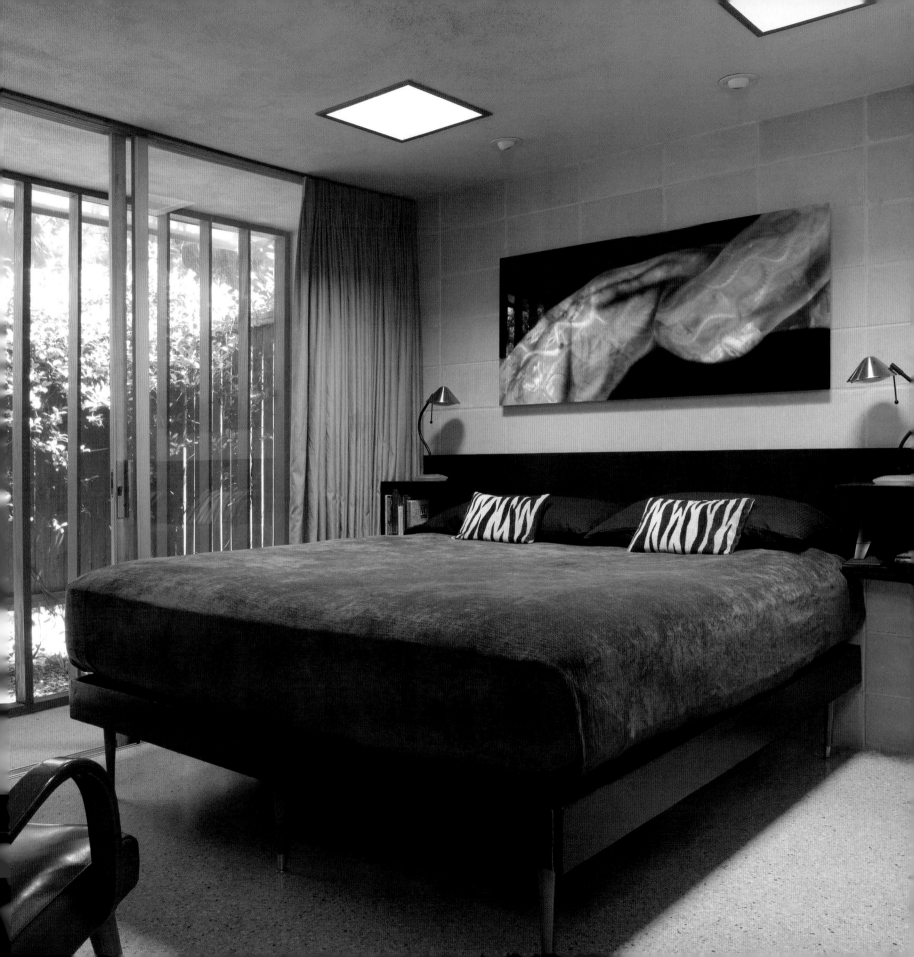

Cichon/Mitchell House

Tim Seibert, 1961

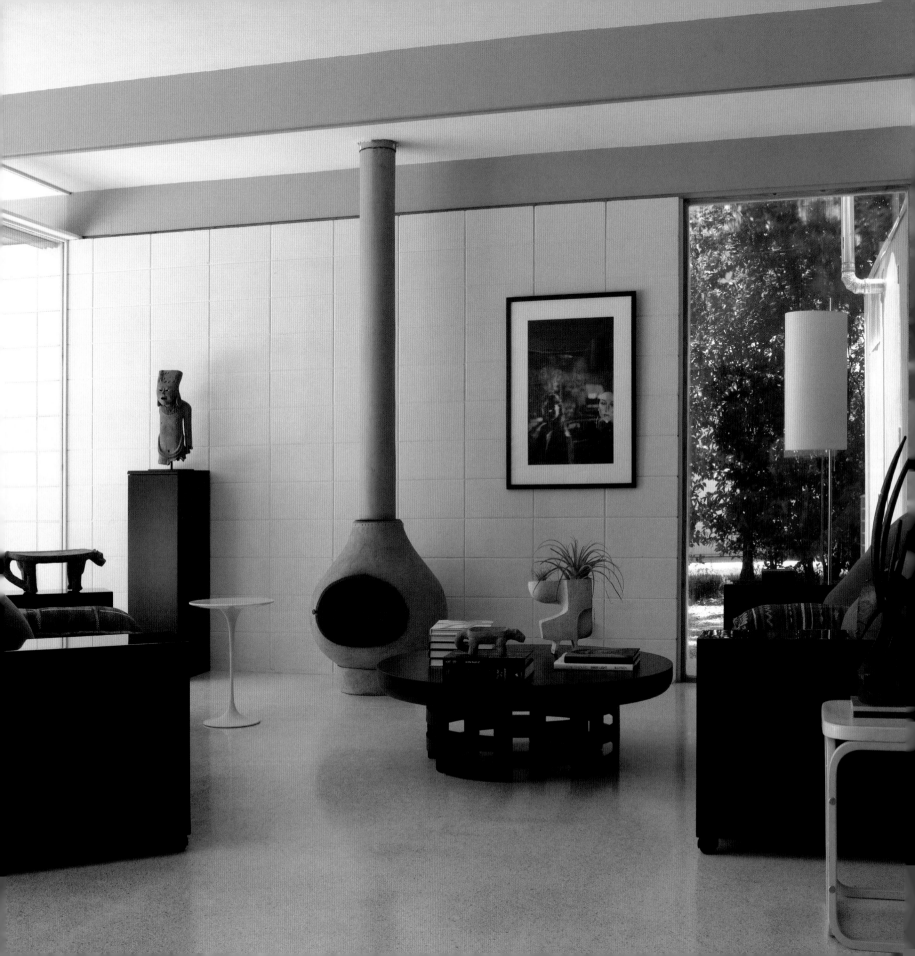

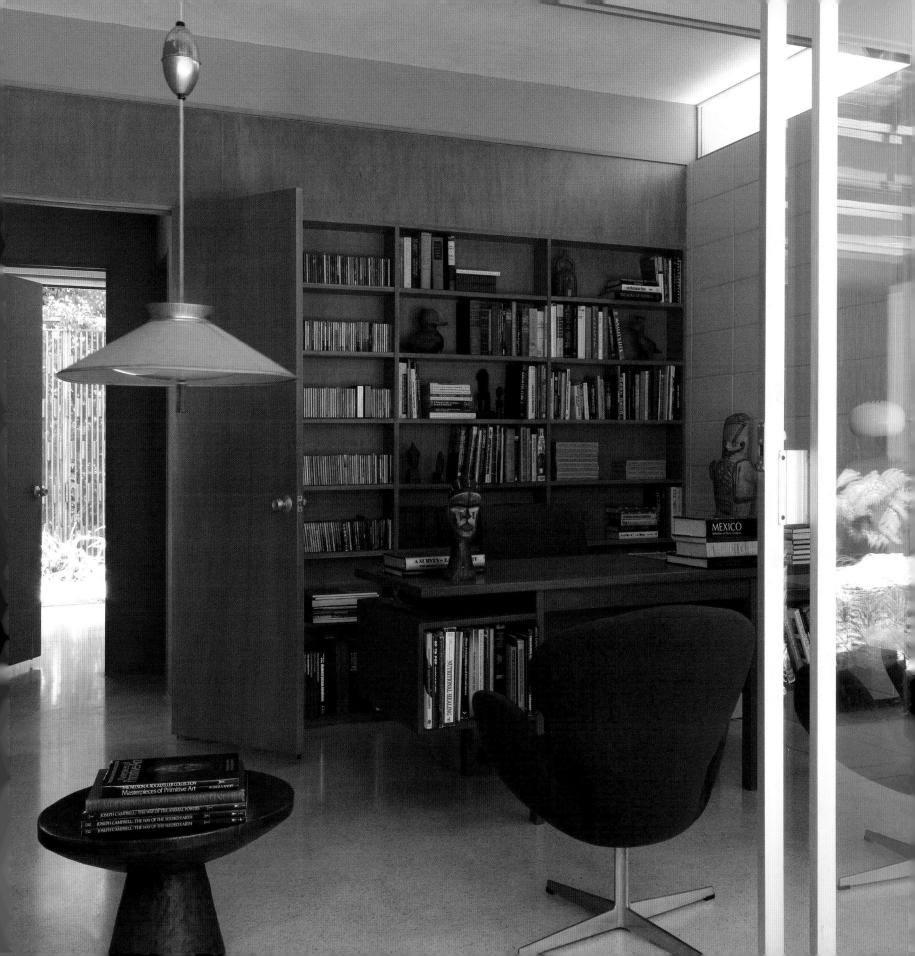

THE NELSON A. ROCKEFELLER COLLECTION
Masterpieces of Primitive Art ALFRED A. KNOPF

MODERN AMERICAN PAINTING

JOSEPH CAMPBELL: THE WAY OF THE ANIMAL POWERS
JOSEPH CAMPBELL: THE WAY OF THE SEEDED EARTH
JOSEPH CAMPBELL: THE WAY OF THE SEEDED EARTH

MEXICO
Splendors of Thirty Centuries

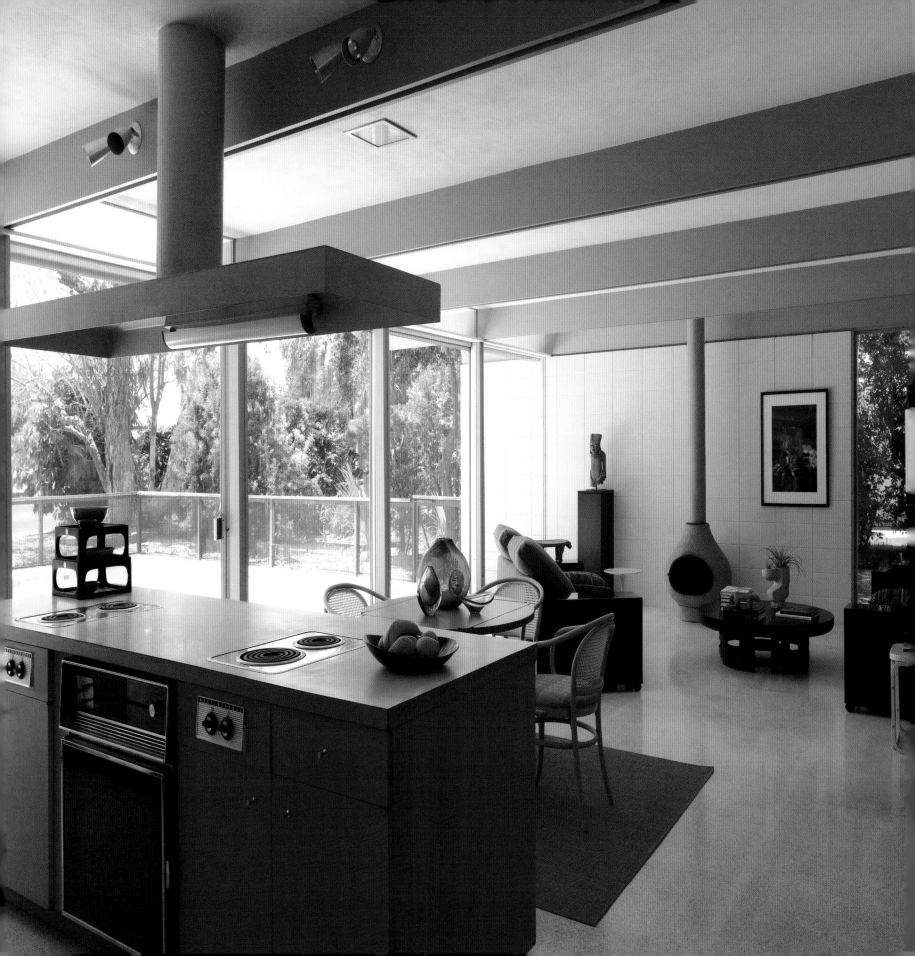

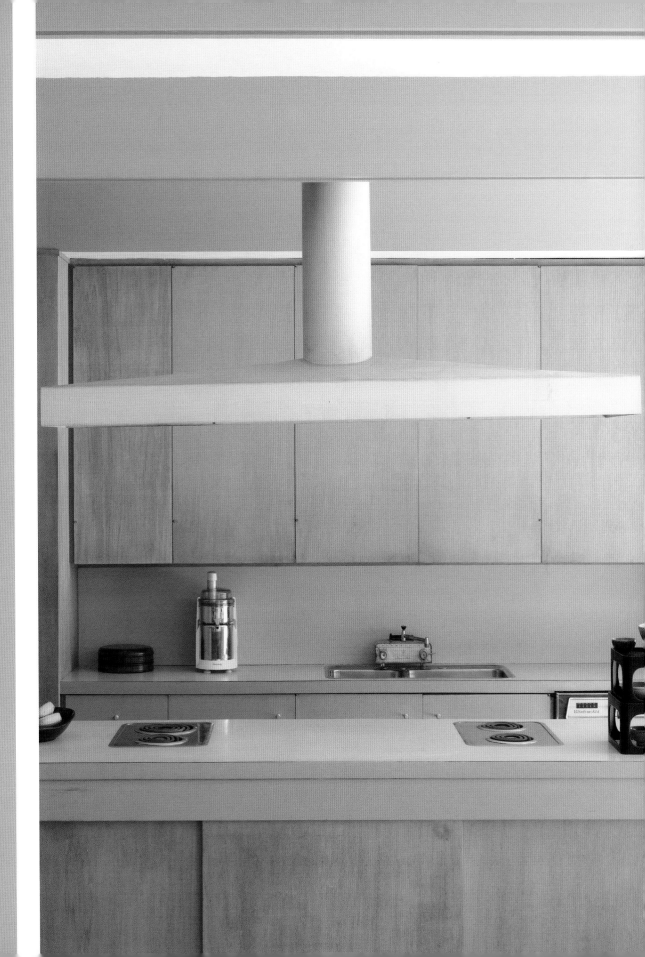

Page 150-151
At the time of construction, the landscape was well matured, bringing scale and proportion to the low-slung house. The double front doors lead in to an enclosed, screened courtyard garden.

Page 152
The room has been restored to its former glory. The original stove is still in situ. The full-height window to the right was once enclosed with wooden louvers.

Page 153
Off the courtyard, the office is built-in with floor to ceiling bookcases. The Danish modern desk and Arne Jacobsen swan chairs add to the period authenticity of the house

Left
On entering the living area, the kitchen island is intact creating a sociable environment to entertain. The furnishings in the living area ranges from Thonet bentwood chairs and Eileen Gray lacquer sofas to Saarinen marble top tables.

Right
The kitchen in its original finish is as modern as those installed today. The cooktops are placed far apart to enable the partially blind Mrs. Mitchell to cook successfully without any mishap. The extractor above defines the space.

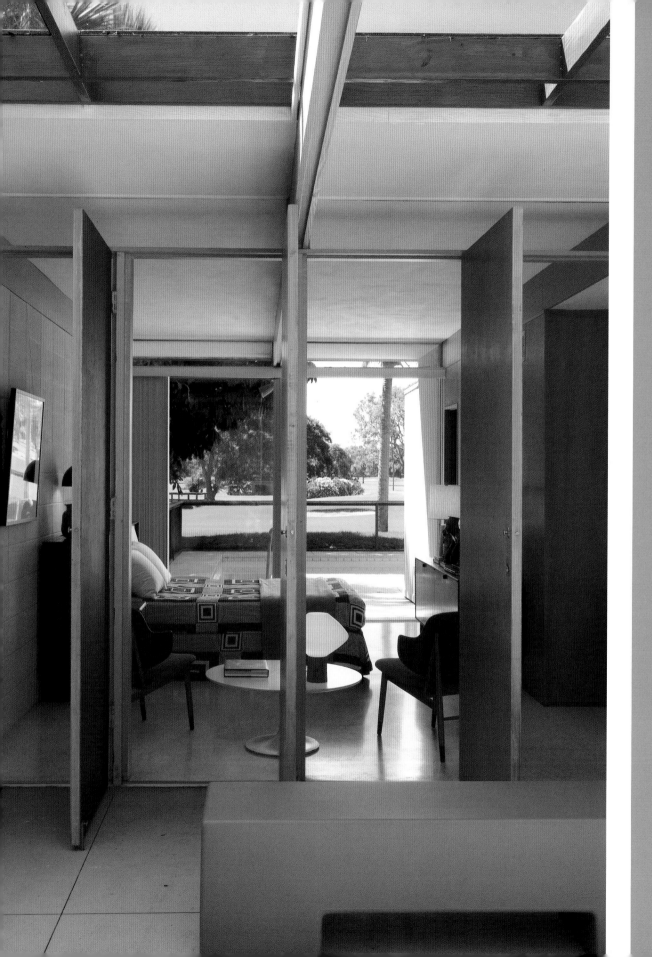

Left
Looking from the courtyard and through the open full-height doors, one can see the bedroom, pool, and far off onto the golfing green. These four doors have varying fixing positions that allow for a range of levels of airflow.

Right
In the bedroom, a Knoll credenza faces the Nelson bed. The opening of the doors increases the bedroom size considerably.

Page 158-159
The internal courtyard, with its garden reinstated by Cichon, is accessed from the bedroom and the office; it also acts as the main entrance of the house. The cedar lattice screening is typical of Seibert's work

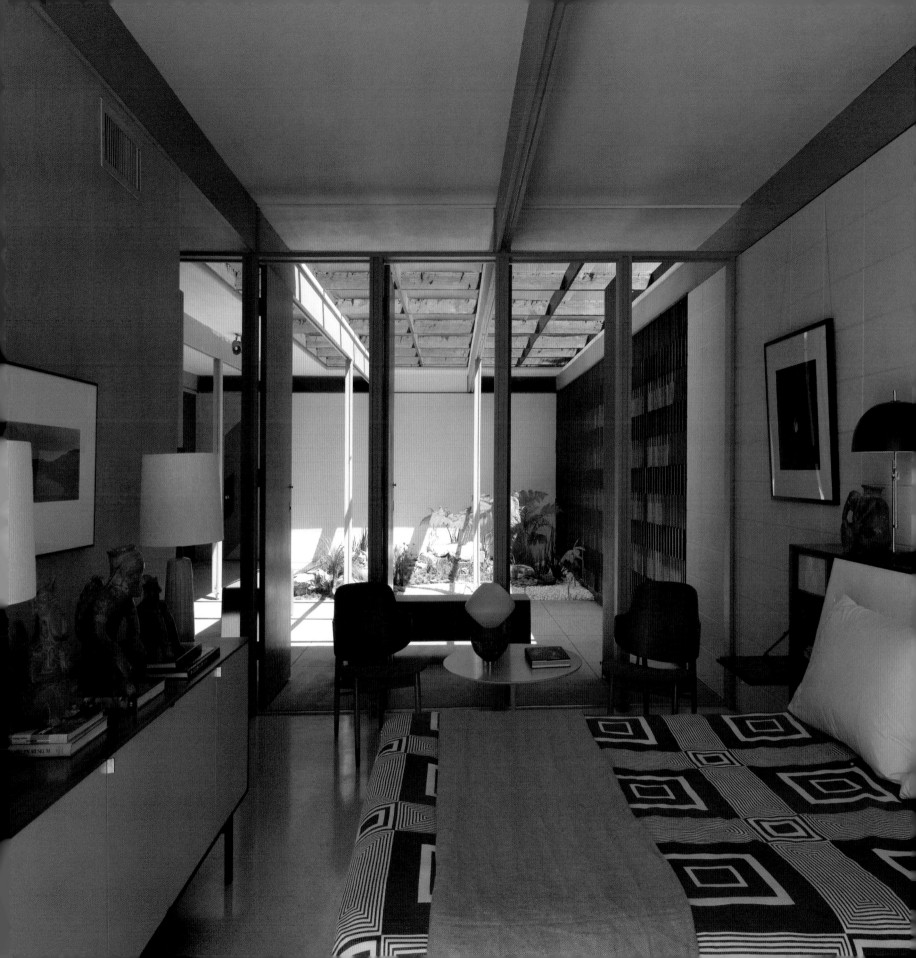

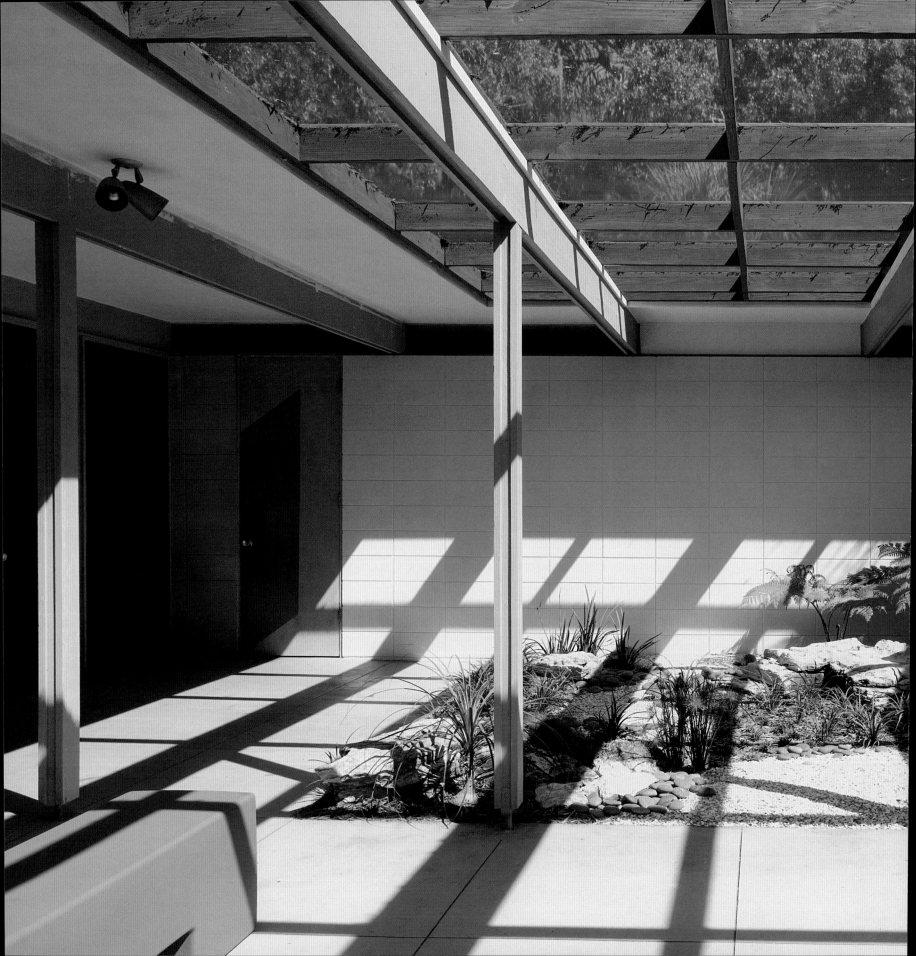

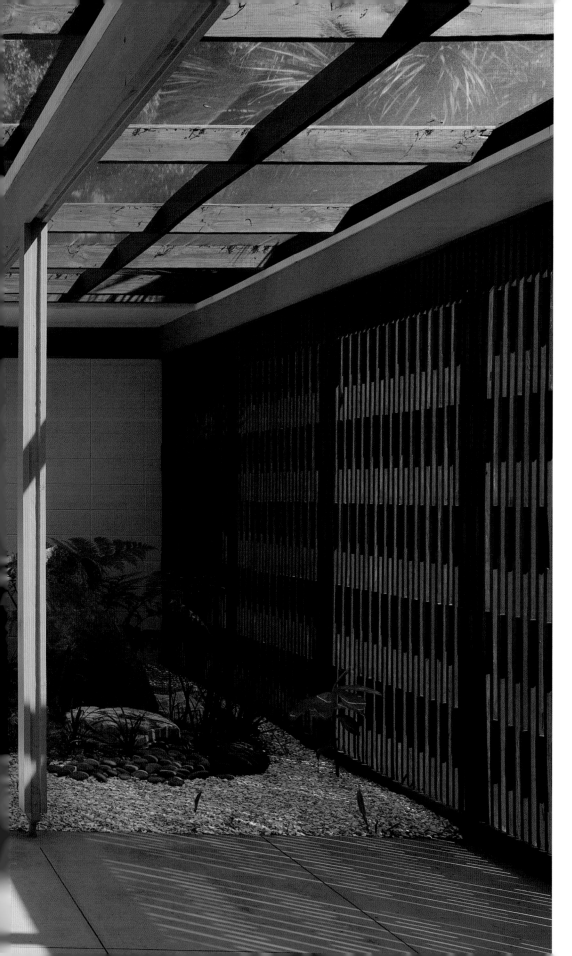

Mr. and Mrs. Tex Mitchell wanted a place in the sun to get away from the winter in hometown Toronto, where Tex Mitchell was a well-known economist and writer as well as an aviator. The couple was in search of something quite specific. The new house, which they'd use for up to six months a year, had to be built for the future, equipped with up-to-date technology. The Mitchells also required ample space for themselves and frequent visitors. As they were also keen golfers and swimmers, access to a good health club was a must and as there would be no staff. "The house must be easy to maintain and the landscaping must be of low maintenance," the client directed.

Instead of going the traditional route of finding a lot, an architect, and a contractor, the Mitchells discovered a "builder" house that, in their case, simplified the process. Purchasing a house they could already see, and whose price was fixed, was preferable to a house design on paper whose eventual cost would likely exceed any initial estimate.

Tim Seibert, with the builder Frank Thyne, worked on this house, one of about twenty-five built as

stock for contractors to sell as finished products. In this case, though, Seibert added "a little romance in the way of a redwood lattice over the entrance court, refined some details, and worked to improve the mechanical systems." Some drawings show even more ideas that could have been included, but on whole the house was built according to its original plan and layout.

Typical of Seibert's work, the house is constructed of concrete block with timber beams spaced on a six-foot module, with terrazzo floors, full-height aluminum sliding glass doors, and plywood-faced internal walls.

In 1961, the same year the house was recognized as one of the top twenty contemporary house designs in the United States, the Mitchells moved in. In the *Sarasota News,* a full-page article entitled "Sarasota Home one of Nation's Top Designs" praised the house, citing its appearance, structural design, interior and exterior spatial organization, and the ingenuity of its electrical and mechanical systems design.

Lucky for the Mitchells, the house backs onto the Sarasota Bay County Golf Club. Great views of the golfing green close by could be enjoyed from the from the large living area. Also, in the rear, is a forty-five-foot-long pool that allowed Mrs. Mitchell to practice building speed with her favorite strokes. Originally enclosed within a cage that towered over the house and took up most of the backyard, this very large pool had a very simple and elegant cross-bracing that kept it rigid and intact for many years. While it restricted views to the golf course , it did of course stop the biting bugs.

Besides her swimming, Mrs. Mitchell was a gourmet cook. Her kitchen, open planned with the living and dining area, is within view at all times. An island holds all the appliances out of view while the large exhaust hood absorbs all cooking fumes. Mrs. Mitchell, who was partially blind, had cooktops placed far enough away from each other so that no two pots would be close together. The dishwasher, with one cycle one for "daily use" and another for "party," sums up the lifestyle the household encouraged. The mahogany-faced units of the kitchen and beige laminate worktops follow the color scheme through out the house, with the only real color on the bright orange front doors to the courtyard area and the redwood latticework used for screening. Above the cooking island is a large extractor hood. How modern is this house?

The two bedrooms and several bathrooms were furnished with new Scandinavian pieces, a refreshing look that distinguished the house from its somewhat uniformly furnished contemporaries. A study with built-in fixtures and fittings overlooks an internal courtyard situated between the front door, garage, and main house. The courtyard's screened roof was typical of Seibert's works of the period. The master bedroom has a series of full-height, thirty-inch-wide doors that open as desired to capture a cross breeze that runs through the house from the street side to the golf course beyond.

Michael Cichon, the most recent owner, bought the house from the second owners, George Consantin and his wife Jean Roubadoux, who had lived there since 1967.After careful restoration and reassessment, the house is now back to its former glory, showcasing exposed terrazzo floors, redwood screens, and more sympathetic furnishings. A little bit of persuasion has insured that the house will keep its original kitchen for some time to come. With everything intact, it is hard to imagine anything else in its place. Luckily the house had not been altered or added to significantly prior to restoration, so reaching this end result was a lot easier.

Right
Here, the simple construction of the screens is apparent. A series of slats applied at regular intervals give privacy and shelter from the sun.

Page 162-163
The sliding glass doors run in various tracks to enable as much open area as possible. The beams spread the load throughout the house, from front to back, supporting the roof slab. The original photo shows nothing has really changed.

Page 164-165
The pool screen, as seen from the golf green just after construction, dominated the house and yet allowed for comfortable bug-free bathing.

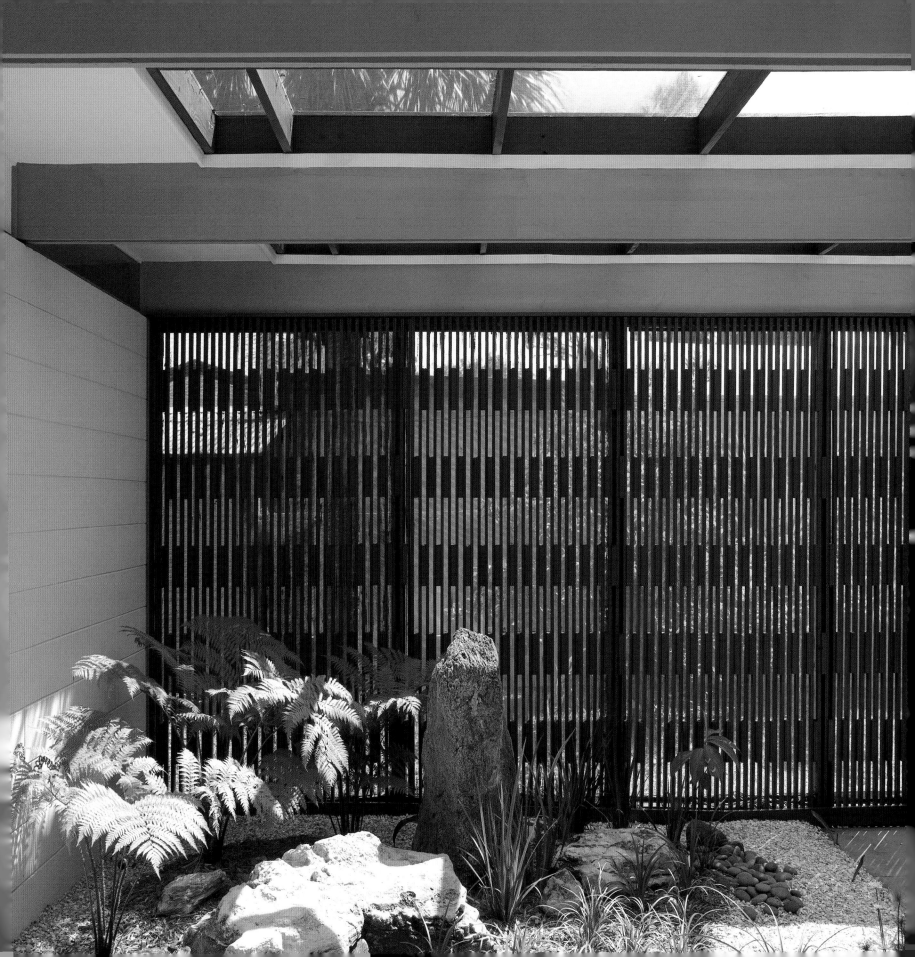

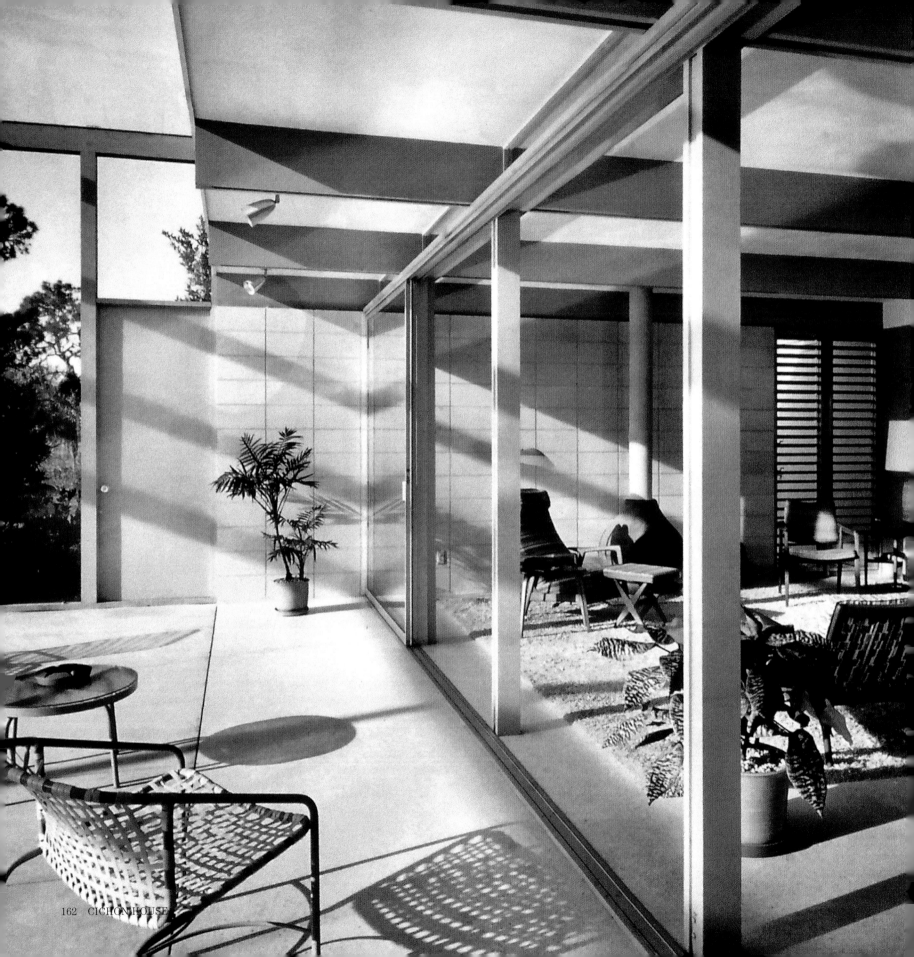

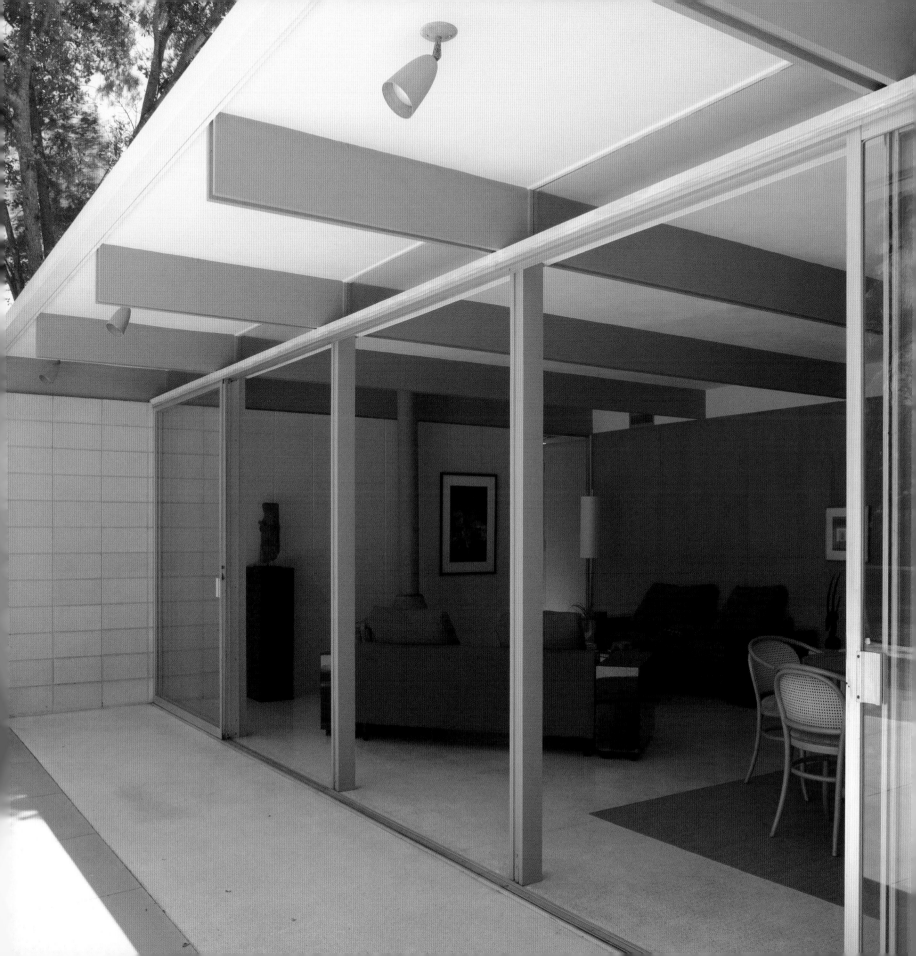

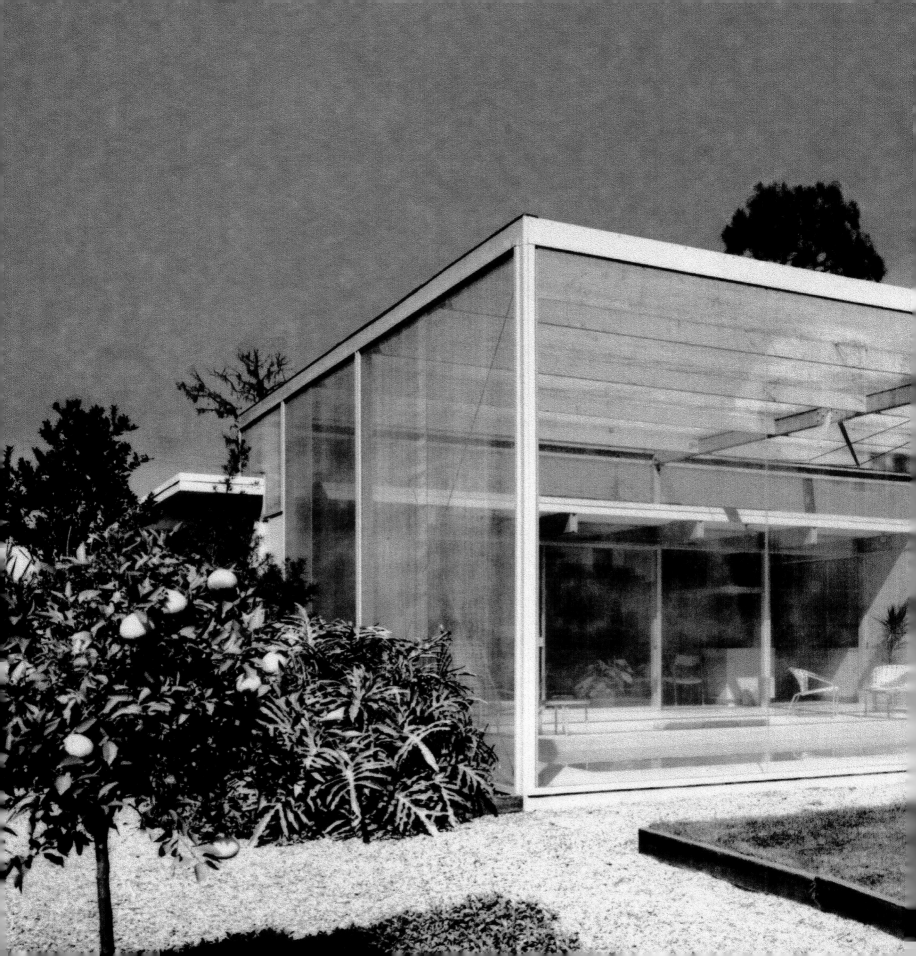

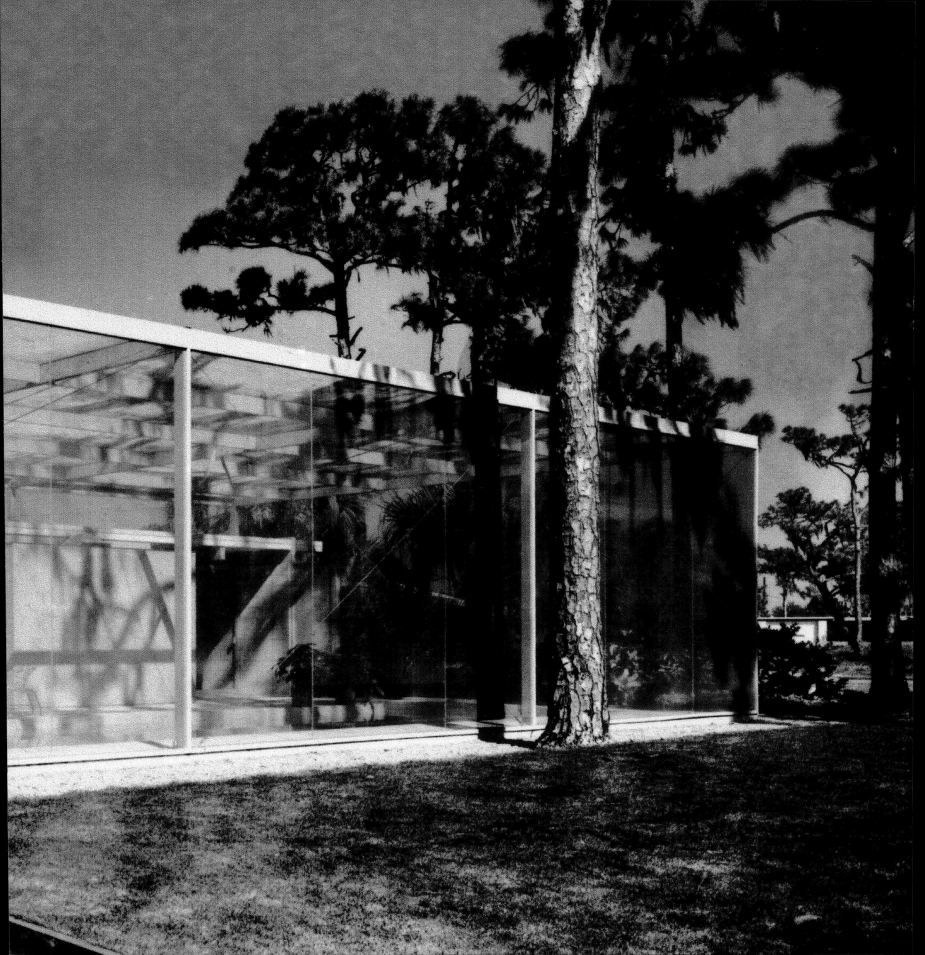

Twitchell Hutchins House

Casey Key

Ralph Twitchell, 1956

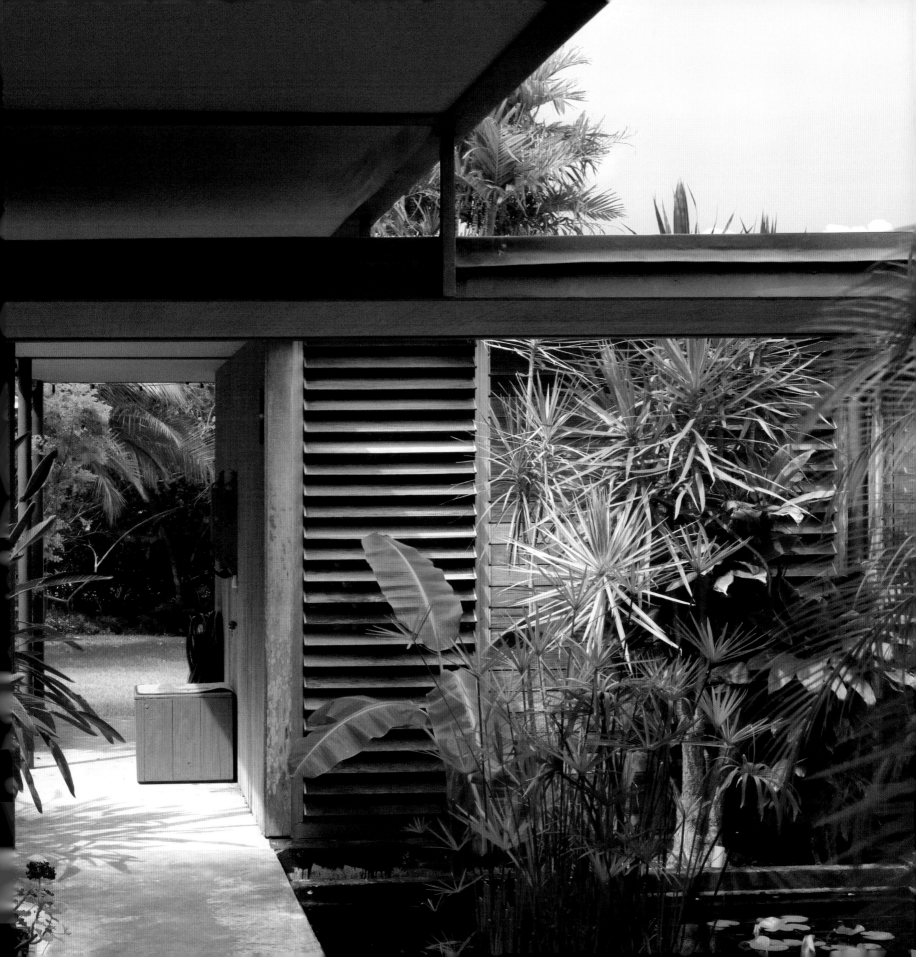

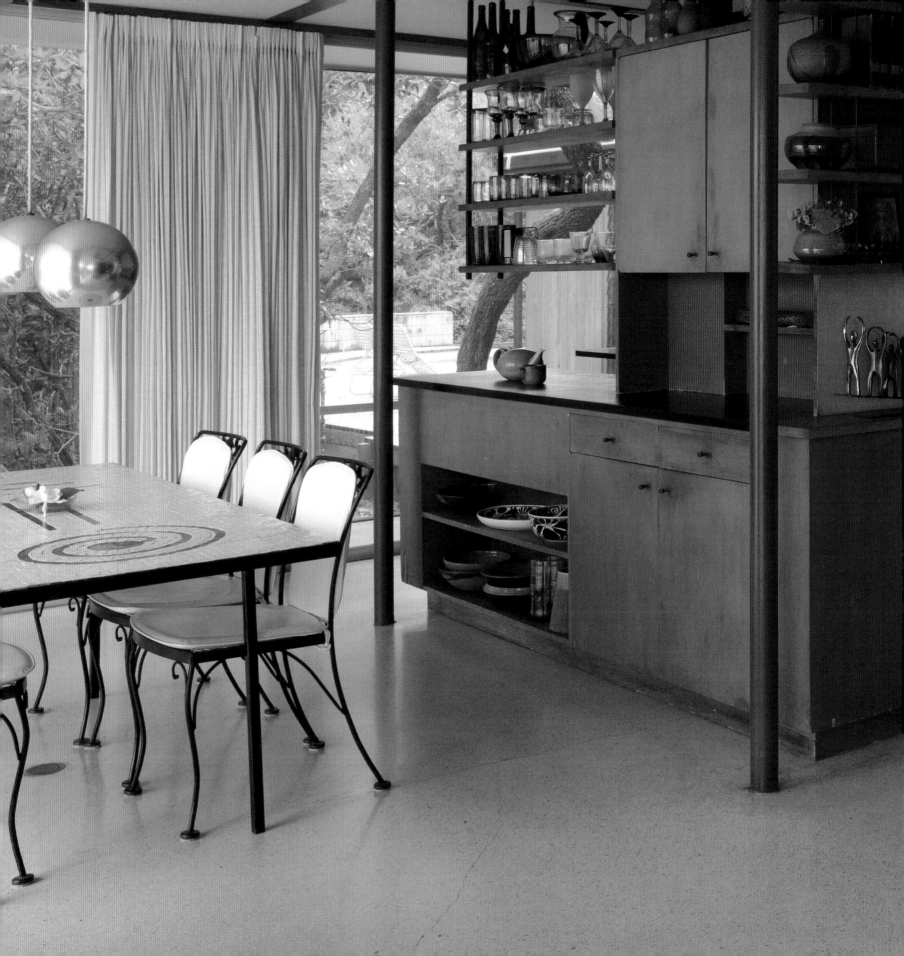

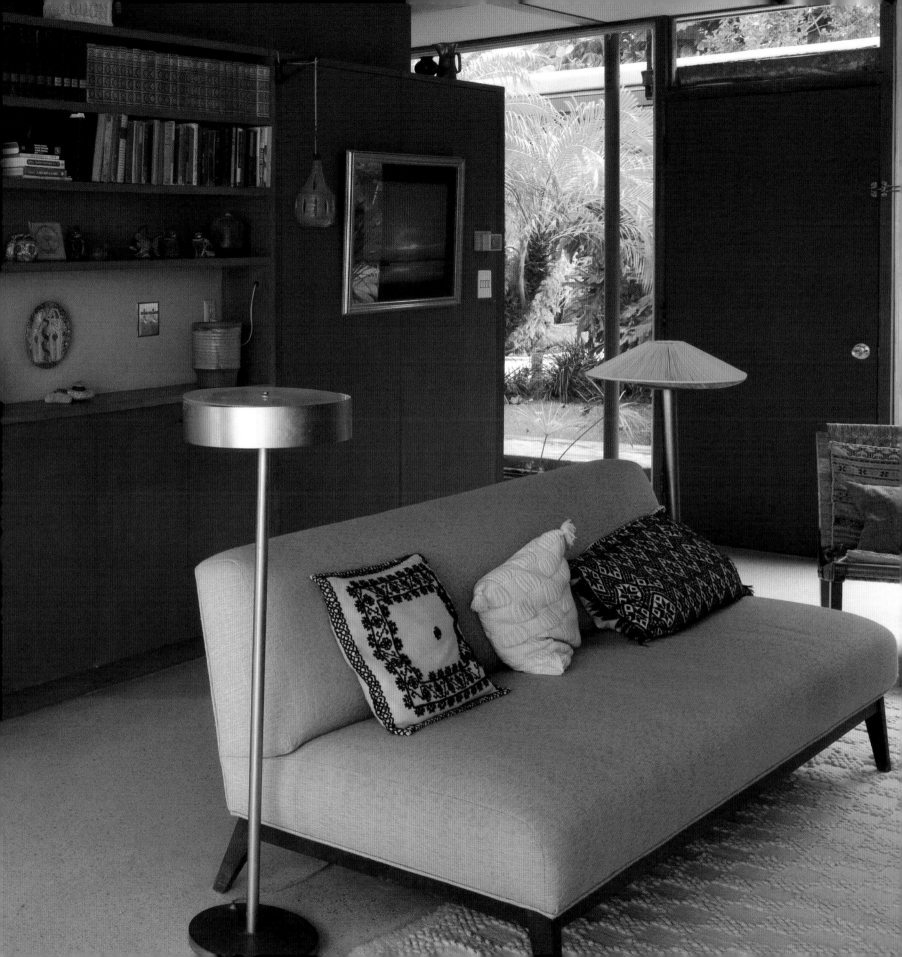

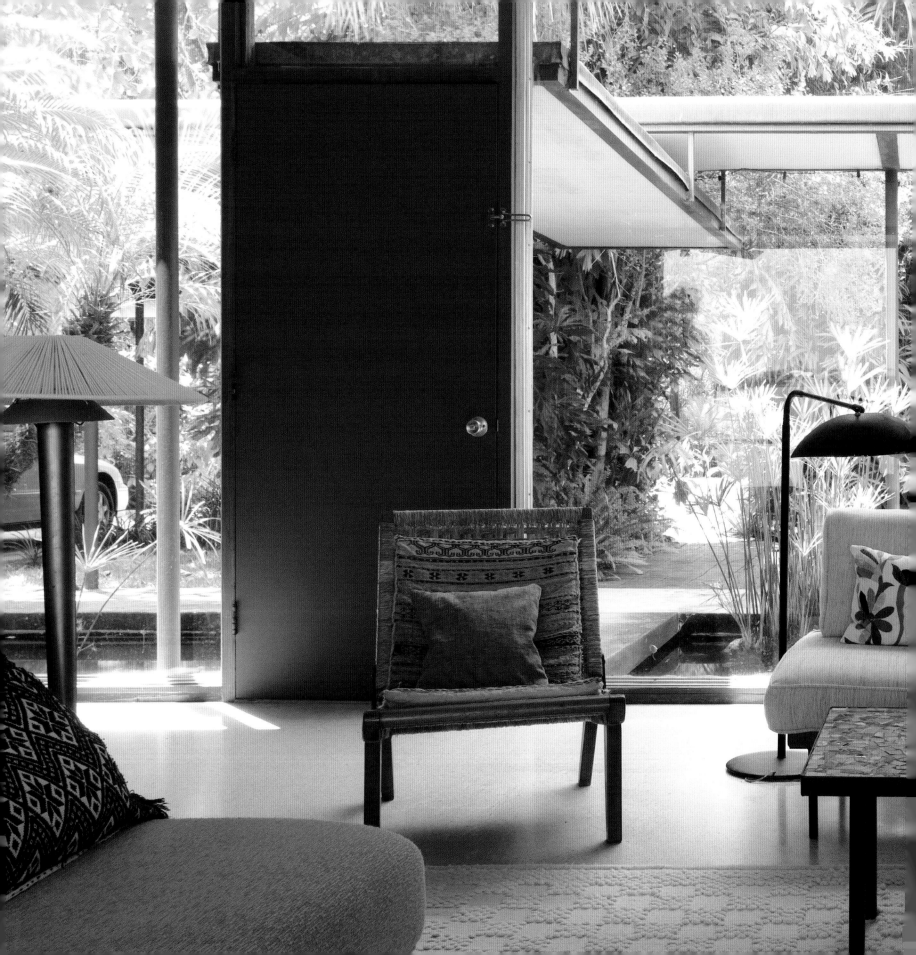

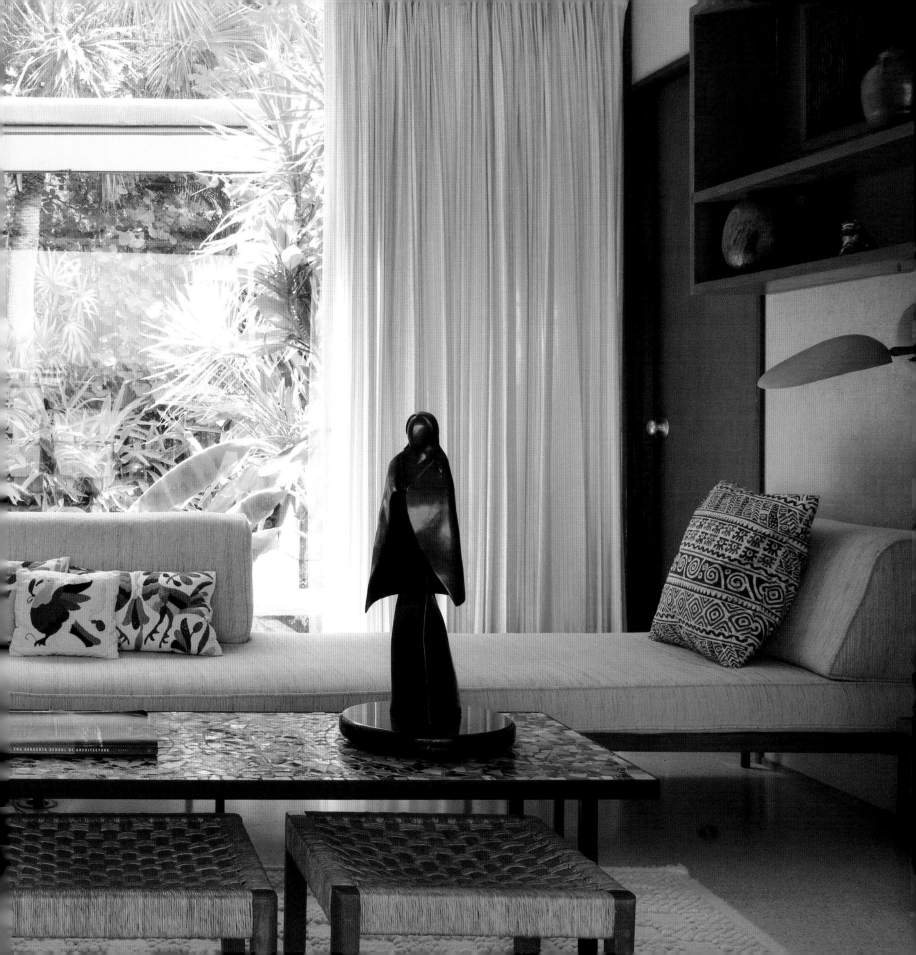

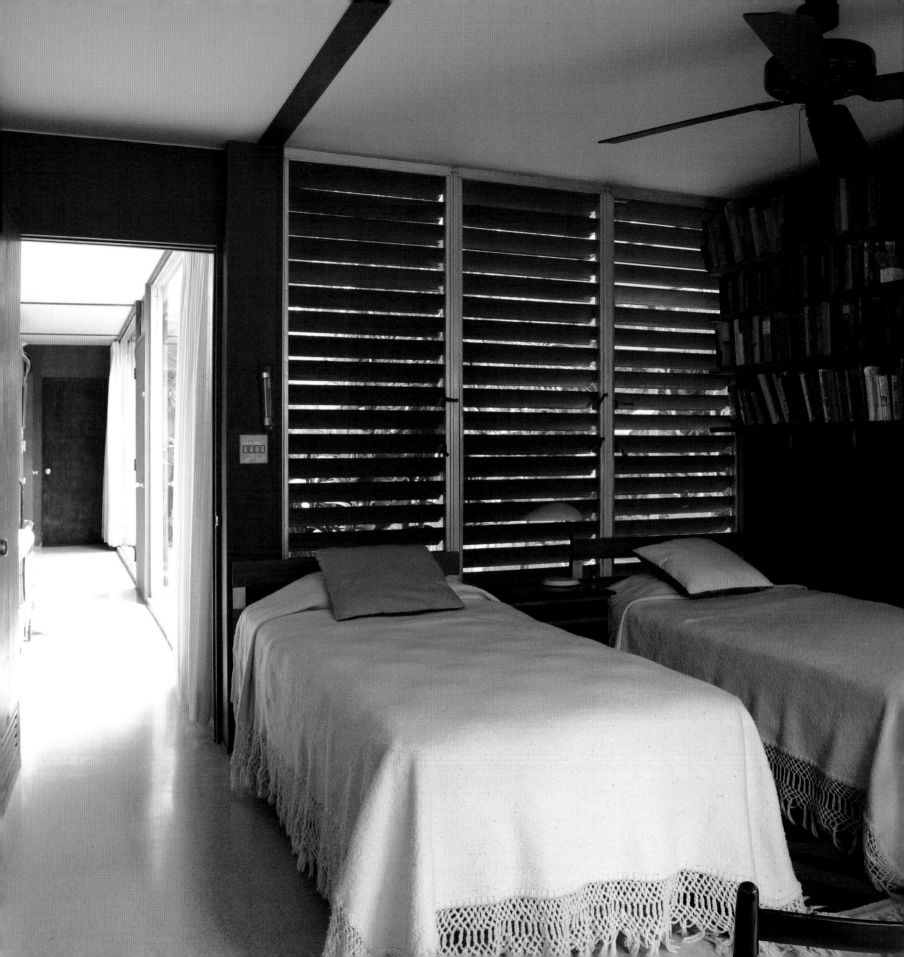

Left
A small bedroom looks out onto the large waterside lot on one side while the other includes a wall of timber jalousies. The steel structure is on show here running across the ceiling.

Tollyn Twitchell went into partnership with his father Ralph in 1956 after receiving his bachelor of architecture degree from M.I.T. and a stint in the U.S. Air Force as a pilot. Since he did not obtain his architectural registration in Florida until 1965, his earlier work is credited to his father Ralph. Soon after, his father retired from the architectural scene, leaving his example of practice for younger architects to emulate.

The Twitchell Hutchins residence on Casey Key was built for Lucienne Neilsen, Tollyn's mother and ex-wife of Ralph Twitchell. Built in 1956 on a waterfront lot overlooking Sarasota Bay, it is an outstanding example of the Sarasota School of Architecture. It was originally intended to be built further into the water but due to planning it was built where it is now, on the very edge of the key. The house, steel-framed with walls of glass, fixed and sliding wooden jalousies, and the typical screened-in areas, is built on a continuous slab foundation with a flat roof. The use of glass for most of the exterior walls allows for extensive views of the bay from most rooms.

In the National Register of Historic Places proposal documents, the house is described as "an international style building which incorporates the tenets of the Sarasota School of Architecture in its design, siting, materials and adaptations to the area's natural climate." Entry is from the west. The walkway, lowered roof above, passes over a small decorative reflecting pool, planted with luxurious foliage. The eastern exposure is open the length of the living and dining areas, with full-height glass and aluminum fixed and sliding doors that take advantage of the bay view. Windows in both bedrooms and bath also offer views across to the mainland. A single-space carport, screened off with blue painted textured timber fencing, is located at the southwest corner of the home; additional parking can be found along a driveway of marl. The

roof overhangs, some extending more than three feet and painted Twitchell blue, are common Sarasota School designs, which give necessary shade to the rooms within. As is common with Sarasota School homes, exterior cladding is a mix of glass and indigenous materials—in this case cedar, well weathered now. The use of ocala block is limited to the swimming pool area (a later addition) and the interior wall containing the typical Twitchell fireplace. The chimney is of stacked block with a copper-faced firehood. The color of the house's terrazzo floors recall the crushed-shell marl of the driveway.

Many original pieces of furniture and fittings designed especially for the house are still in place, including the couch in the living area and the fitted furniture on the fireplace wall. In the bedroom are various fitted units designed to work within the house, while a sliding pocket door closes the bedroom areas to the living space. The kitchen area acts as the central hub of the house; accessible from both sides, it works as both a physical and visual division of the space. The kitchen is built within the lally columns of the steel structure. Brown-painted wooden fittings create a wall of storage either open or closed, and there are ample work surfaces. Various open display areas are painted within for visual impact. A table with a mosaic top in the dining area was also an original furnishing. Other areas in the house are divided with sliding full-height doors and wooden jalousies open up and close off the areas where they are still intact. Without central air-conditioning, the house relies on the cross breezes via the opening jalousies on the gulf side and the sliding doors on the bay side.

Sylva Twitchell, daughter of Ralph and Lucienne, lives in the house with her husband, James Huthchins, a golf pro. They are the caring stewards of this family heirloom, enabling this Sarasota School gem to retain its importance in its idyllic setting.

Left
At the carport, a simple, slatted,
wooden screen gives some privacy
to the pool area; it retains some
Twitchell blue coloration.

Right
Twitchell's son added the circular
pool at a later date to the house.
Beyond is a small workshop studio.

Page 176-177
The house is built right on the
edge of Sarasota Bay, and thus a
boat is a necessity rather than a
luxury. In this location, the house
is at risk not only to the elements
but also to the developers.

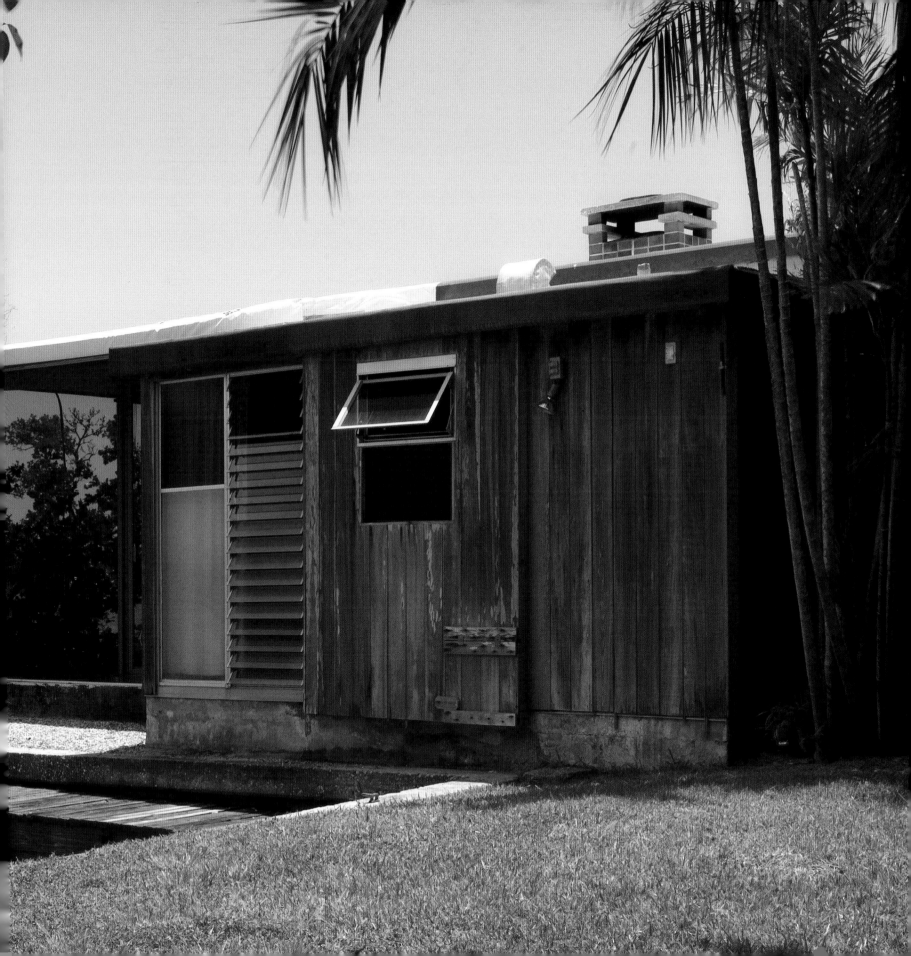

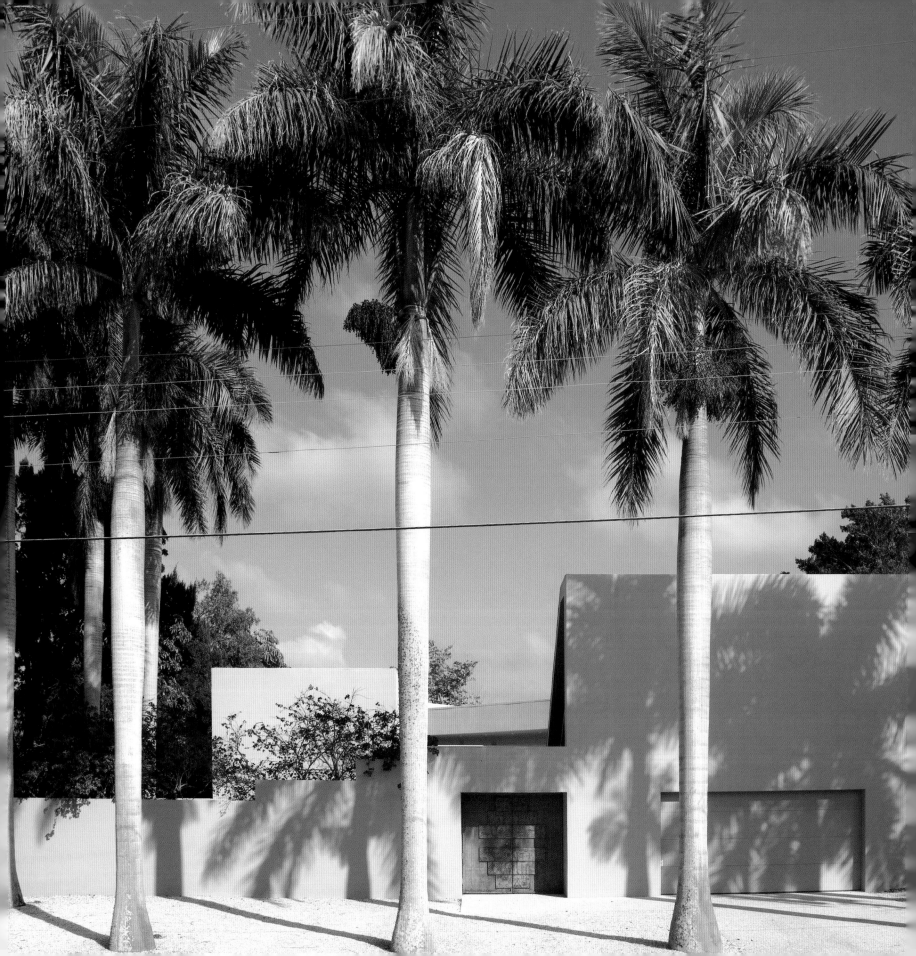

Putterman House and

other Abbott work

Carl Abbott, 1980–1

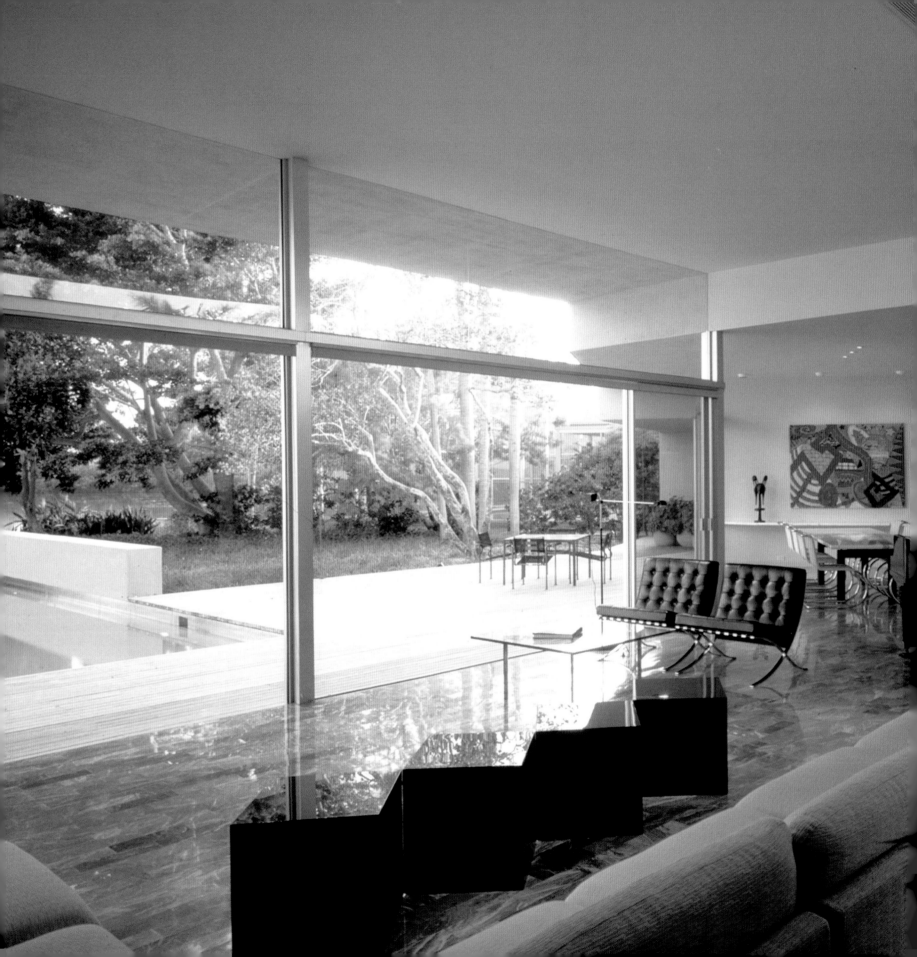

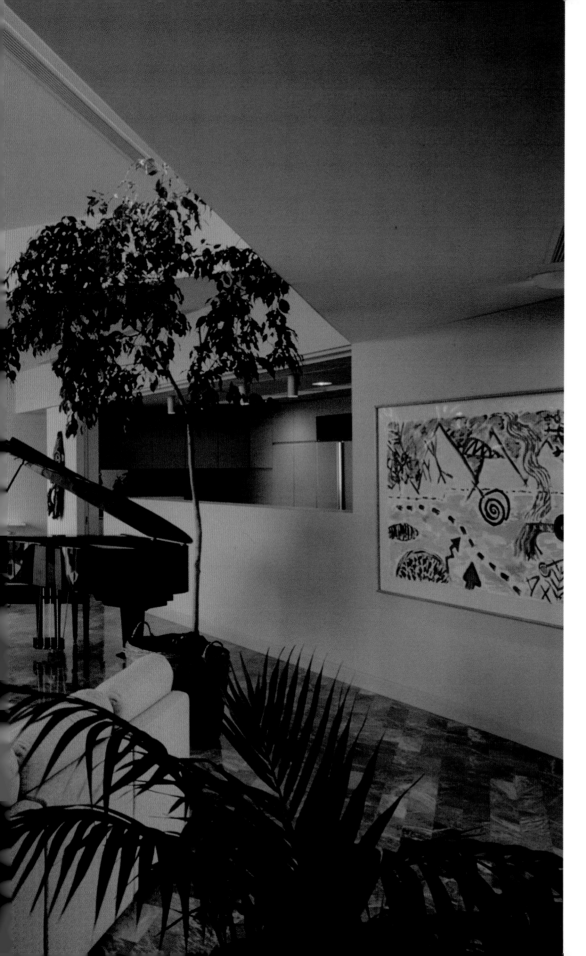

Carl Abbott set up his office in Sarasota in 1966 having previously worked for I. M. Pei in New York and with Richard Rogers and Norman Foster at Team Four in Britain.

His introduction to the Sarasota School of Architecture came while he worked for Bert Brosmith, after receiving his bachelor's degree in architecture from the University of Florida and before attending Yale, where he received his master's degree in 1962. (Paul Rudolph was the chair there at this time.)

Given that Pei was commissioned to build New College but was based in New York, while Brosmith was based in Sarasota, Brosmith was chosen to be the architect at hand. Abbott had worked for both men's firms, and the New College project in Sarasota added to his experiences there. During the time he was working in Brosmith's office the addition to the Hiss Studio for Philip Hiss was being constructed. Carl Abbott was given the job of designing the walnut doors and frames throughout the addition.

In his own practice the first house he built was the Weld Beach House in Boca Grande. The house's geometry—right angles and triangles—and its situation on the lot benefiting from the cross breezes and commanding views made it the basis of many houses to follow.

The Lido Bayfront house was built in 1980. The owners required a home with a strong architectural appearance that would function as a private home as well as a place for business entertainment. The lot, next to a house also by Abbott, stretches from the Bay to the Gulf of Mexico, being heavily treed its informal garden is an extension of the junglelike wildlife preserve to the south. Abbott describes the house, "The entrance is formed by the large north wall and a low wall leading into the informal garden—a flowering extension of the jungle. The feeling of the house changes abruptly on this living side of the site, the light wood planes visually float from the heavy stuccoed north wall. The long, straight dock, which projects out from the house,

further emphasizes the sense of reach and lightness. The house is divided into public and private areas: the public areas are in the tall volume near the bay, with views to the water and to the jungle. The private areas are in the long run of the building with views to the garden and jungle. Acting as a visual anchor for the structure, the three-story-tall entry hall opens to a suspended upper level den and then to the high rooftop deck." Abbott adds, "This private hideaway is a voluminous pavilion of platforms and terraces that open on every level to the Gulf of Mexico. High ceilings and walls of glass in multiple planes amplify the panorama of the beach and water. Terraces offer extended living areas beyond the interior, reinforcing the relationship between living space and environment."

On an island near Sarasota, Abbott built the Gulf-front Beach House in 1981. The clients wanted "a winter beach house with a feeling of lightness and uplift, expressing the joy of living: spaces that are exhilarating to live in—either alone or with guests." The dominant view of the beach and the gulf have created the plan. One terrace juts out to the west to the winter sunsets while the other terrace faces southwest out towards the crescent shaped beach. The materials used in the house, the silver gray wood, the Mexican tile, and the clear glass all add to the overall concept, uniting with the beach, the water, and the sky. Supported on tall concrete columns the house has a sense that it is an extension of the narrow wooded site. This house has received many design awards, Paul Rudolph, Chairman of the Florida AIA Awards Jury, described the house as, "three raised horizontal planes, which do not follow each other in plan, but interpenetrate one with the other—all raised above ground in a tropical climate . . . developed are the thrusting and counter thrusting and balancing of solids and voids and the flow of space horizontally and vertically."

Artist Florence Putterman commissioned Abbott to build a house for her and her husband that was completed in 1986. Carl Abbott visited their country house in Selingsgrove, Pennsylvania, built by Hugh Newell Jacobsen where, as Florence explains, "we are used to living in a Zenlike atmosphere," adding that to "see how we lived made it so it was easy for him to understand what we wanted for our house in Sarasota. We worked very well together as we were explicit on exactly what we wanted and he was able to carry it out."

According to Ms. Putterman, one of the most enjoyable parts of this house is showing it to others. "They approach the outside, with its colonnade of towering Royal palms," she says. "With the carved doors [designed by Florence Putterman] there is no indication of what lurks inside. Once inside the courtyard they are able to see the glass door which leads into the house and also provides a view to the outside. The bay is visible then and when they enter I usually hear 'Wow!' The view is breathtaking and Carl has taken full advantage of it with a beautiful deck cascading down to the water."

The landscape was created by the Puttermans' son, Joel, a landscape architect. This house is also the artists studio, where, now retired her husband, Saul, is her assistant. Easy to maintain and suitable for entertaining the owners have had sit-down dinners for up to seventy-five people, just by rearranging the furniture. In Abbott's words, "as with a seashell, the heavy outer walls are in sharp contrast to the inner side with its total openness to the bay. The monolithic facade has doors leading to a private entry court. In the main house, the spaces fan out and open wide to the bay. Across the entire water frontage are the walls of glass, angled in plan, allowing each room to have a different focus. The large ceiling planes step upwards creating a sweeping flow of interior space. In plan, the house is wrapped tight to the front and sides of the site, leaving the large central open space from which the terraces reach out into the bay. Dominant force lines—the central axis of the main entry and the axis of the long swimming pool—are not parallel but slip past each other, emphasizing the sense of movement. Natural

Page 178-179
The street presence of the Putterman house is breathtaking. The towering palms dwarf the main structure of the house.

Page 180-181
Across from the terrace, the sweeping design of the house invites you in. The kitchen area has concealed screens to close it off, similar to those in the Umbrella House. The furniture includes Barcelona chairs by Mies. The paintings are by Florence Putterman.

Right
Once into the courtyard of the house, a staircase rises to the guest suite

Page 184-185
On Lido Bay every level opens to the Gulf of Mexico. The terraces invite the inside out, bringing together the interior and the environment.

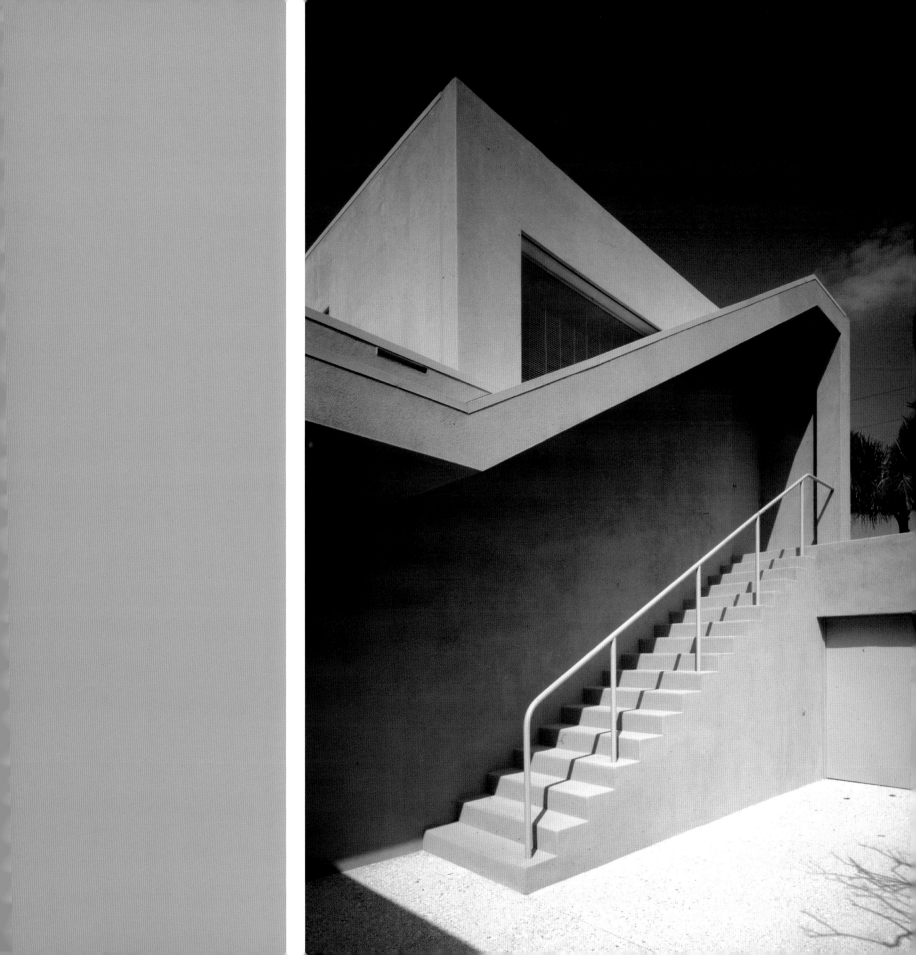

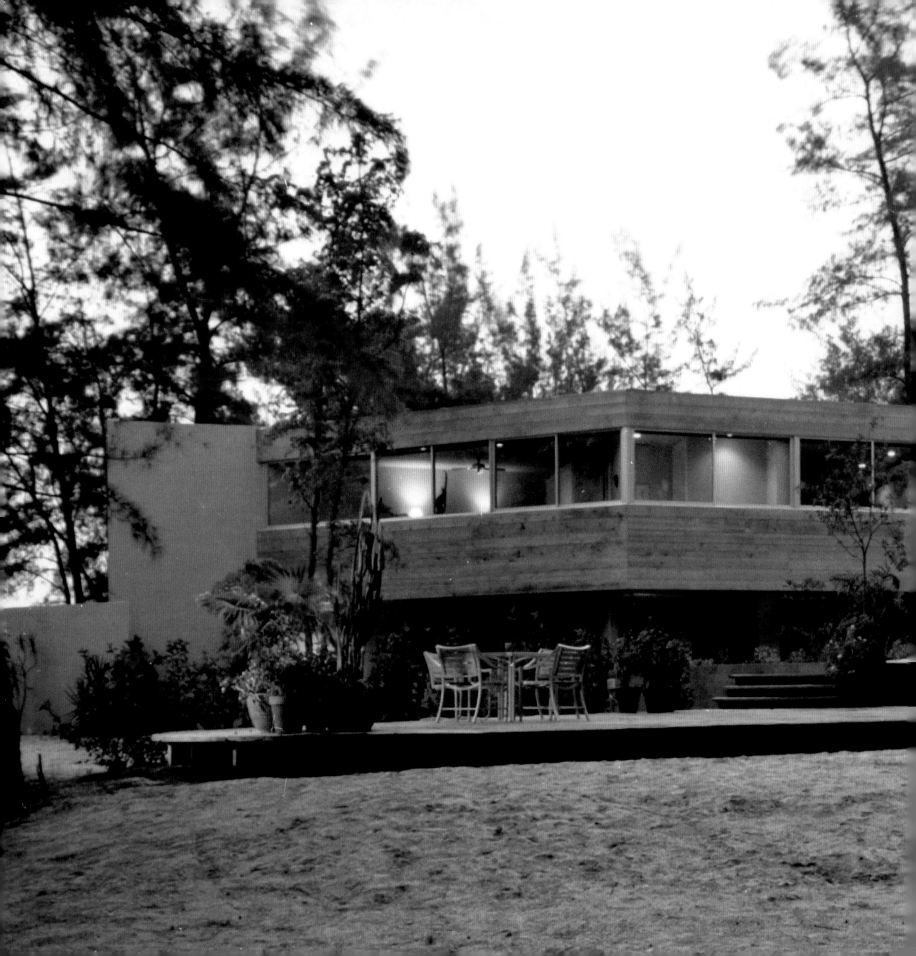

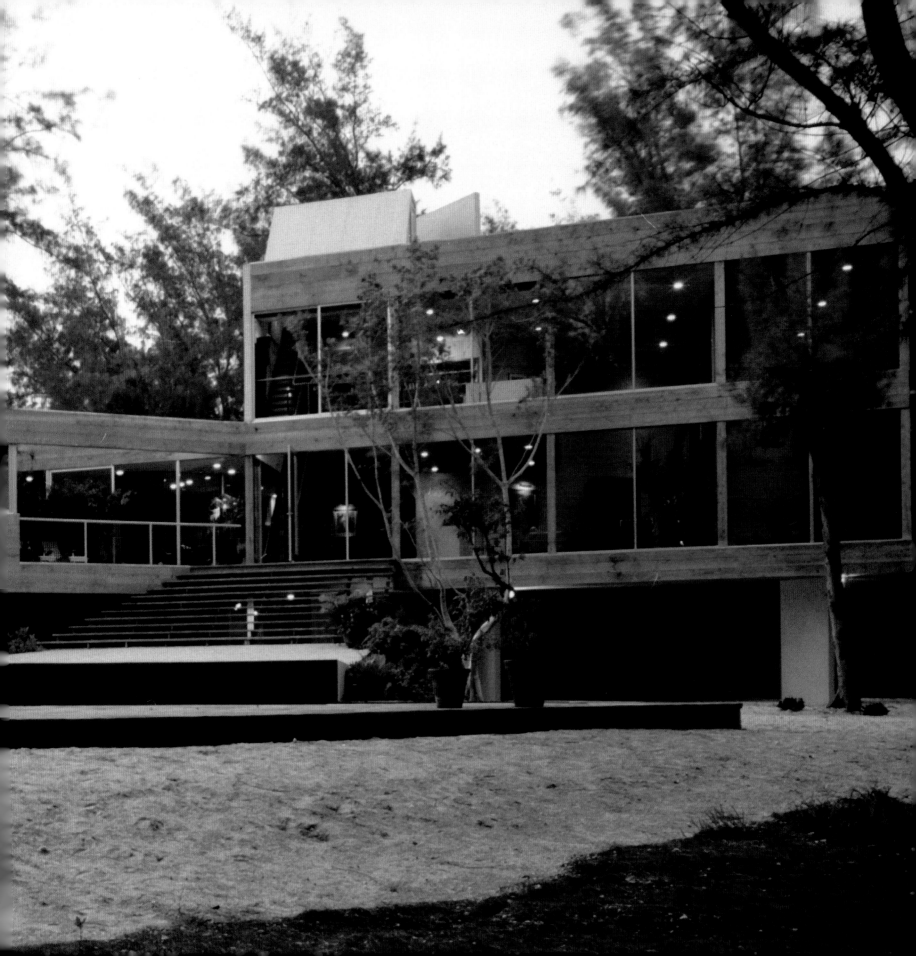

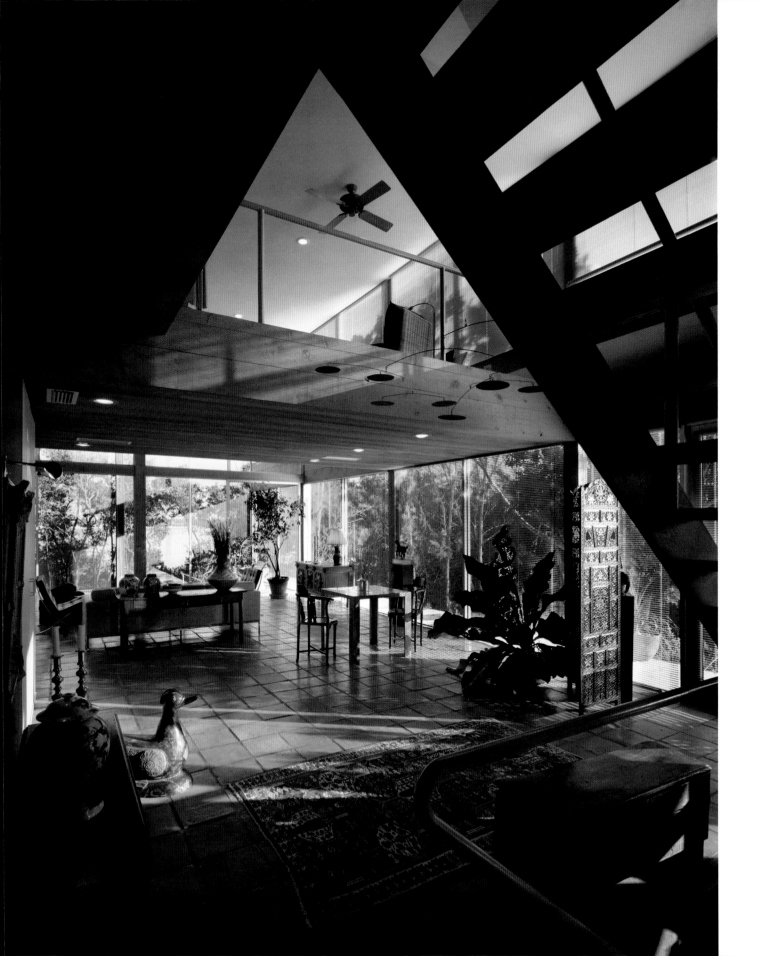

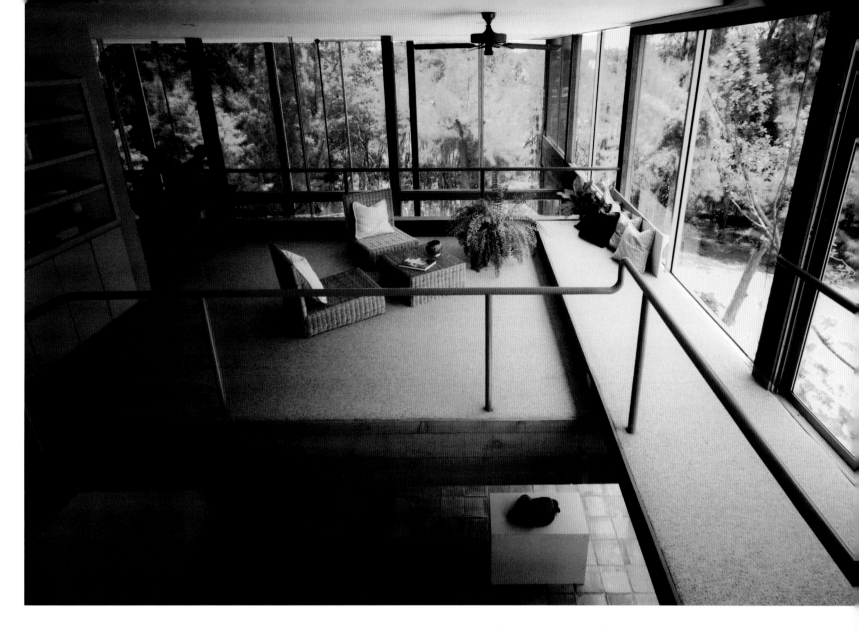

Above
An upper level sitting area appears to float above the jungle like the landscape outside.

Left
Vast expanses of glass, and open balustrades and staircases complete the sense of openness that pervades the house.

materials and neutral colors based on seashells are used throughout, acting as a backdrop for the vibrant colors of the owners' artwork."

Sarasota is renowned as the cultural center of Florida but the art scene is not as it was, although there are a few galleries showing interesting art and The Ringling Museum has had a few important exhibitions of contemporary art. Florence sums up her point of view: "I think the interior decorators have taken over and are influencing their clients not so much to choose good art but instead to choose works that fit above the sofa," she quips.

Abbott's work is a continuation of the Sarasota School's principles. He is always working on several projects, ranging from residential estates, an apartment building in downtown Sarasota, to private houses, a new public library in Venice, and the final building in the St. Thomas More complex. Adding to his already renowned reputation, his Summerhouse restaurant, built in 1976 in a jungle setting on Siesta Key, has recently been saved from demolition by positive action from the Sarasota Architectural Foundation and the local community.

Left
The Gulf-front Beach House at night.
A series of light floating terraces are
supported by tall concrete columns.

Right
Cutouts from each terrace reveal
varying levels below.

Burkhardt / Cohen House

Casey Key

Paul Rudolph, 1956–57

addition by Toshiko Mori, 1999

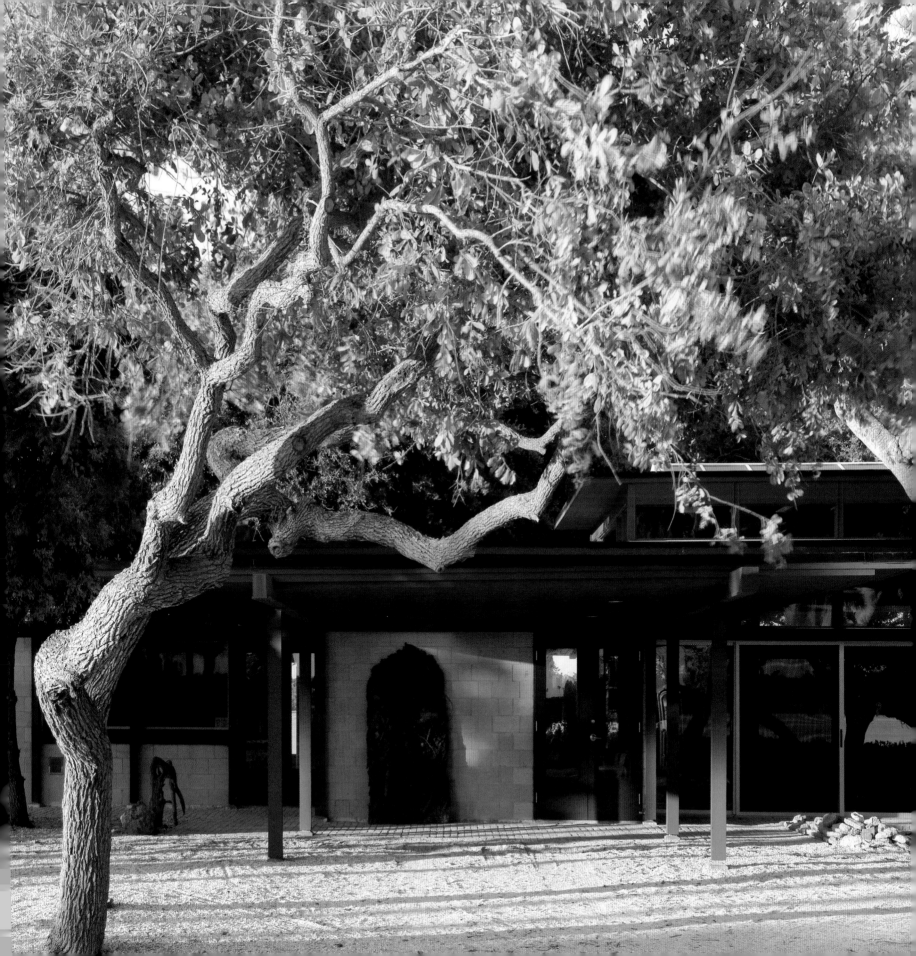

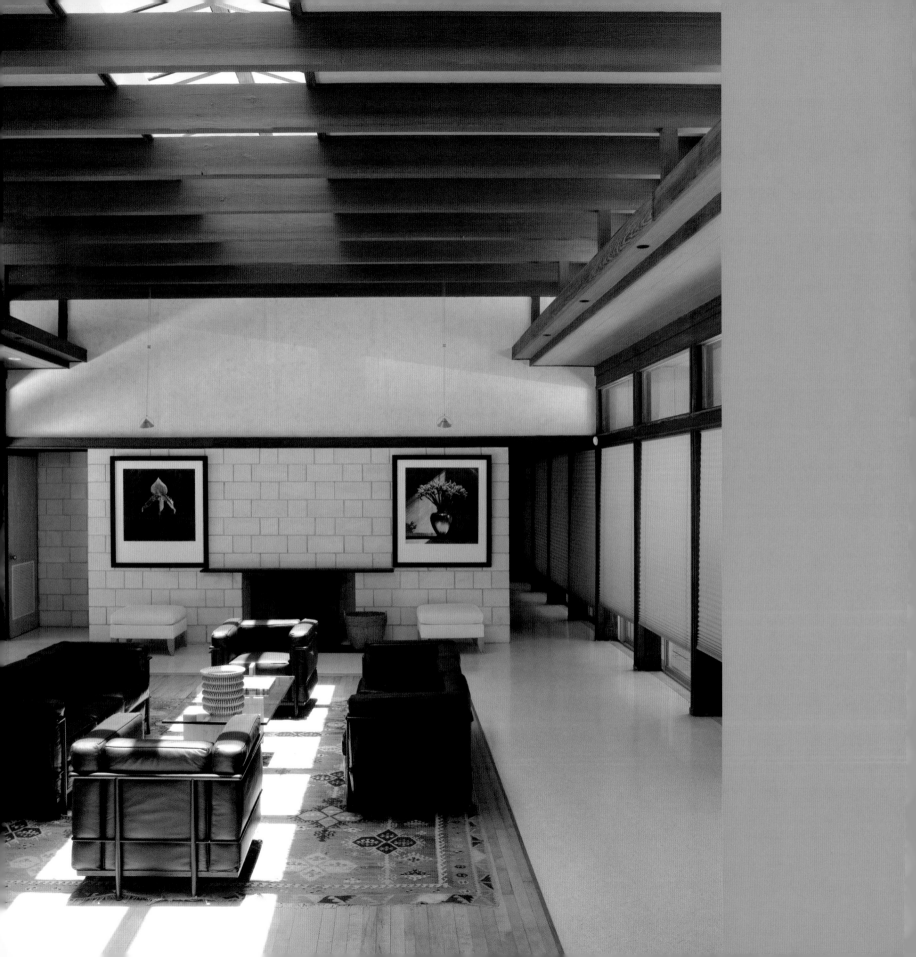

On Casey Key, a subtropical island just south of Sarasota, Rudolph built a house predominately of wood on a lot that spreads from the Gulf of Mexico to the Bay of Little Sarasota.

The Burkhardts, of European descent, wintered in Sarasota until the mid-1970s. Their lot, on a more remote and naturalized barrier island, drew Rudolph away from Sarasota's typical surroundings and allowed him to look again at the heavy post-and-beam structures he'd constructed with Ralph Twitchell.

The Burkhardt/Cohen house's simple horizontal planes stagger across the elevation and rise up toward the center of the house, creating voluminous clerestory skylights while carrying the post-and-beam structure. The builders used Ocala block to define the public and private areas, which are separated by a breezeway screened with timber. A wall of glass closes off the living area, while a block wall that leads off from the open living space fronts the bedrooms. The house's double-height areas and second story (unusual in Rudolph's work) house a small office and include elements from projects Rudolph had conceived earlier. The deep cantilevered roof overhangs to protect from the sun, while the deep joists, as in the Cohen house, break up the sun's bright light. This house was finely crafted by Jack Twitchell, Ralph's nephew, who built most of the early Rudolph/Twitchell houses.

The present owners, Bebe and Edward Cohen, rescued the house after years of neglect by its second owners. Some updates were predictable and necessary. For instance, the open living area had to be glazed-in and central air-conditioning was installed. The previous owners had also closed up the skylight area and blocked up the rear wall of the living area. The terrazzo floors were covered with shag pile carpeting and a kidney-shaped pool now occupied the rear of the building.

Built beneath live oaks, with a huge graveled front yard and rear garden that rambled down to the bay, the original house offered an excellent family environment for the winter. For many years, the Cohens used the house for the winter season away from their home in the north and did no major work until the early 1990s, when they removed the inappropriate additions and restored what Rudolph intended.

As she updated the house, Betsey Cohen installed a more sympathetic pool and new lighting. The public space also underwent a complete reorganization and the conversation pit was filled in with furniture classics of the twentieth century. While perhaps going against Rudolph's minimalist furniture tendencies, the reorganization added visually exciting pieces to the overall concept of the open-plan areas.

As time passed, the Cohen children had children and the new families required space of their own. In 2000 the Cohens commissioned Toshiko Mori, whom they met when she was the appointed architect of the Farnsworth Museum in Rockland, Massachusetts, where the Cohens served on the board of trustees. The Cohens soon realized that Mori shared their avid interest in the Sarasota School and invited her down to see the property and discuss ideas for a planned guesthouse on the recently acquired adjacent lot.

Toshiko Mori created a T-shaped plan of some 2,800 square feet, raised seventeen feet off the ground, well above the necessary height restrictions in an area threatened by floods and hurricanes. The structure was built on piloti (in Le Corbusier's five points of architecture, the piloti would support the mass of the building off the ground, thus creating a building raised on columns). The mass of the building resembles a treehouse set into a canopy of live oaks. The challenge was to create a space for the three grown-up children when they visited their parents while allowing for privacy when they are all in residence. Thus, the intention was to provide both private and communal space in a flexible arrangement. Mori's idea was to create a new building that would gel with the existing house and sit naturally in the surrounding landscape.

There once stood on the site of the addition a 3,000-square-foot house that was destroyed in a storm.

To get through the permit process, the new house had to be approximately as large as the previous building, durable materials like concrete and steel (which are somewhat resistant to the action of weather and mellow) were required. The interior of the building includes floors of terrazzo in the main communal areas and bamboo in the bedrooms, with an exposed concrete block wall relating it to the construction of the original Rudolph house. Sliding glass windows and louvered screens tie the whole scheme together.

Side by side, the two buildings stand together as examples of modern architecture—separated by almost fifty years yet equally up to date in both use and appearance. The Cohens are in the process of adding another building by Mori to the site, welcoming yet another addition to this landmark group of architectural works.

Below
Furniture by Scandinavians Kjaerholm and Jacobsen gives a contemporary feel to the guesthouse addition.

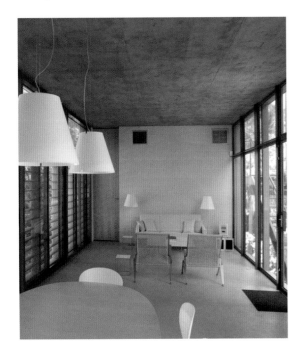

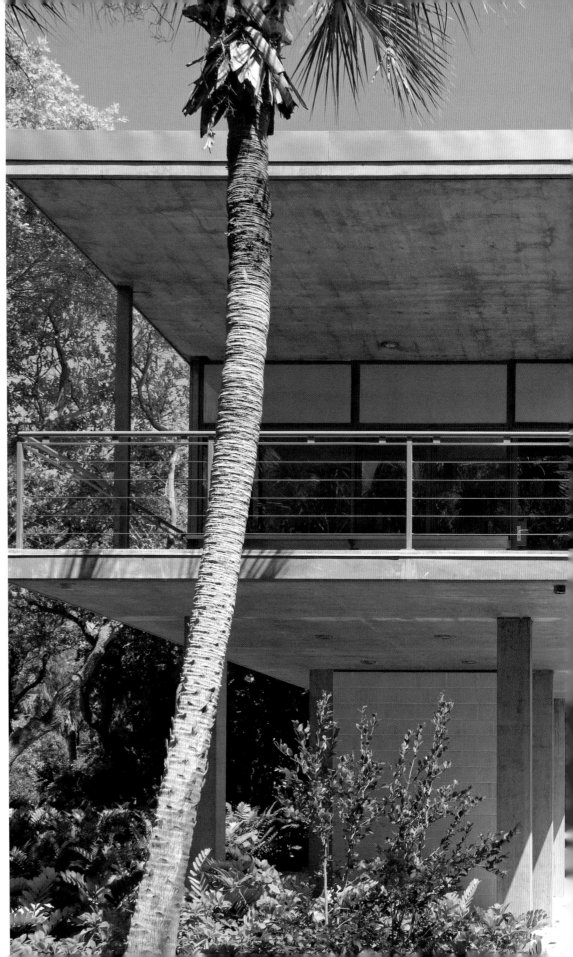

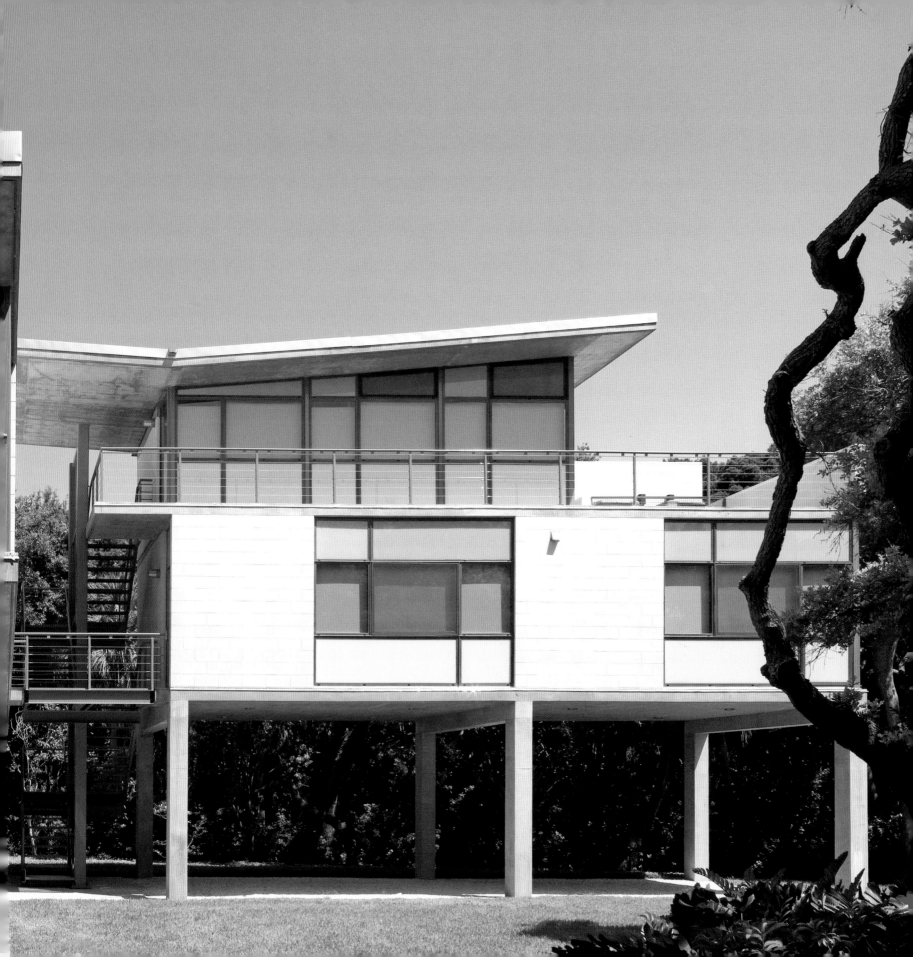

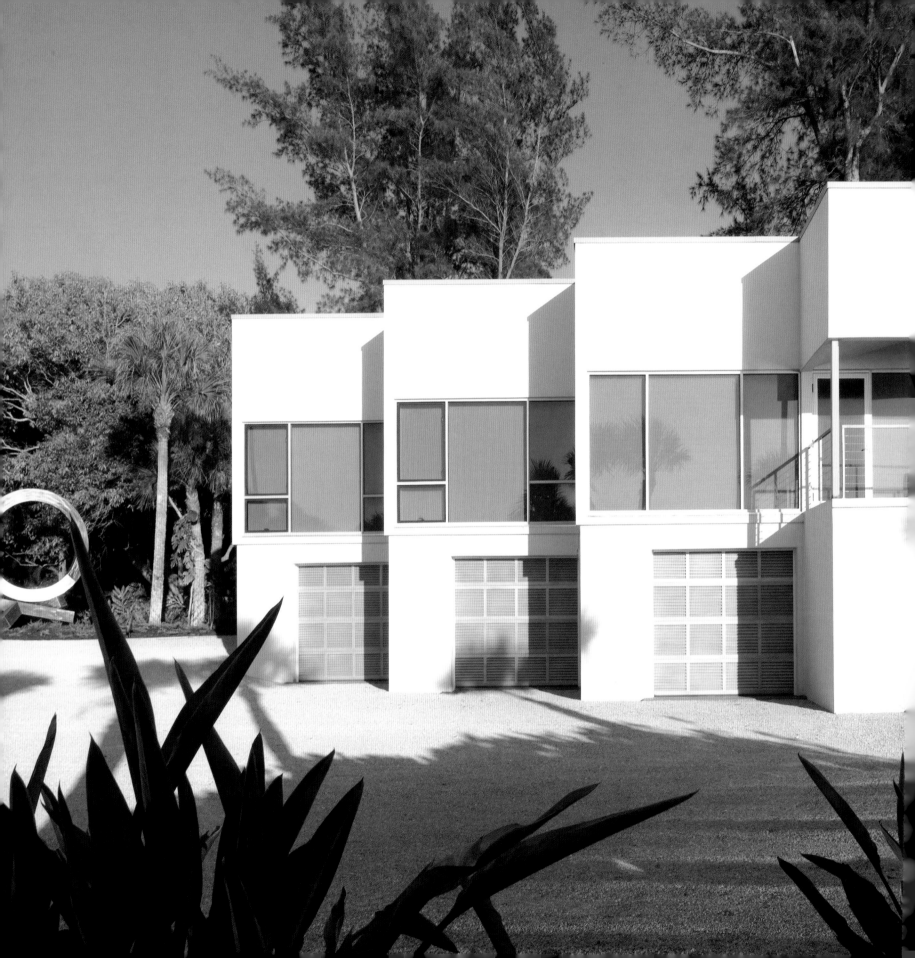

Silverstein Residence

Casey Key

Toshiko Mori, 2002–3

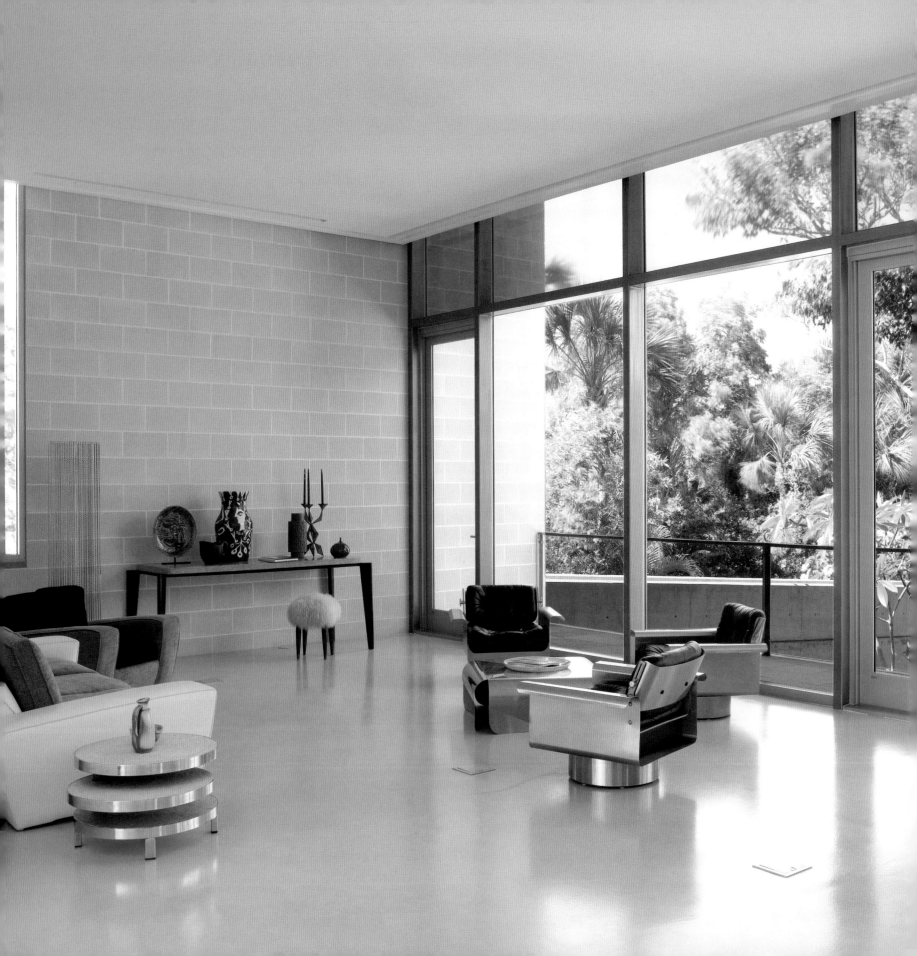

Page 198-189
The guesthouse at the
Silverstein residence takes
the place of the original lifeboat
house that stood on this lot.

Left
In the main living area with
its full-height windows
and concrete-block walls,
the mid-century furniture
is well displayed. The long
strip window to the left echoes
examples seen in earlier
Sarasota School buildings.
The furniture and accessories
include works by Frankl,
Pergay, Charpentier, Prouvé,
and Bertoia.

Right
An installation by James
Carpenter, Mori's husband,
sits above the glass and steel
staircase. Carpenter also
designed the massive dining
table in collaboration with
Renee Silverstein.

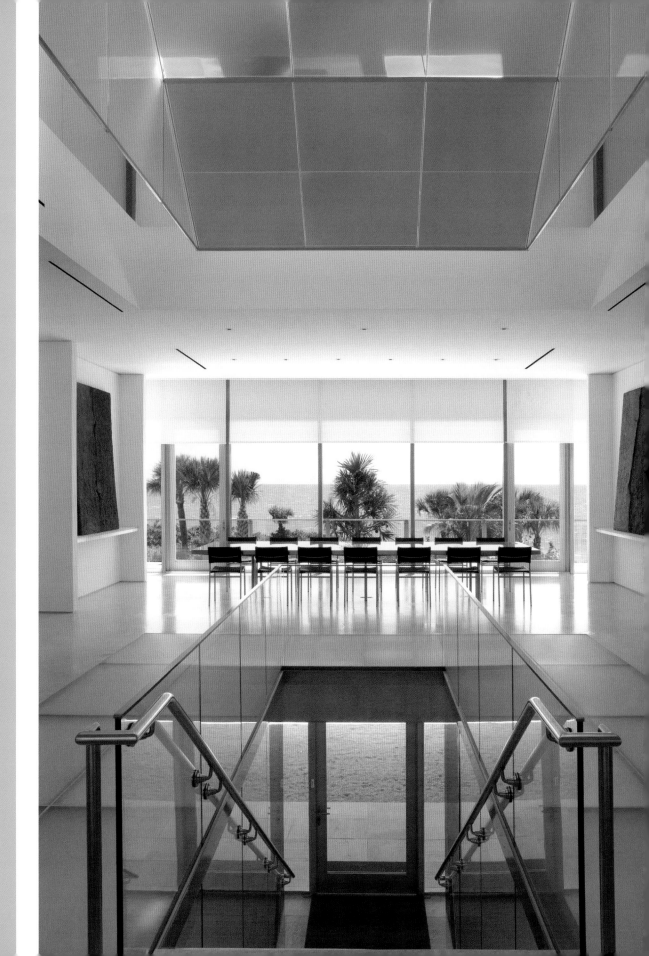

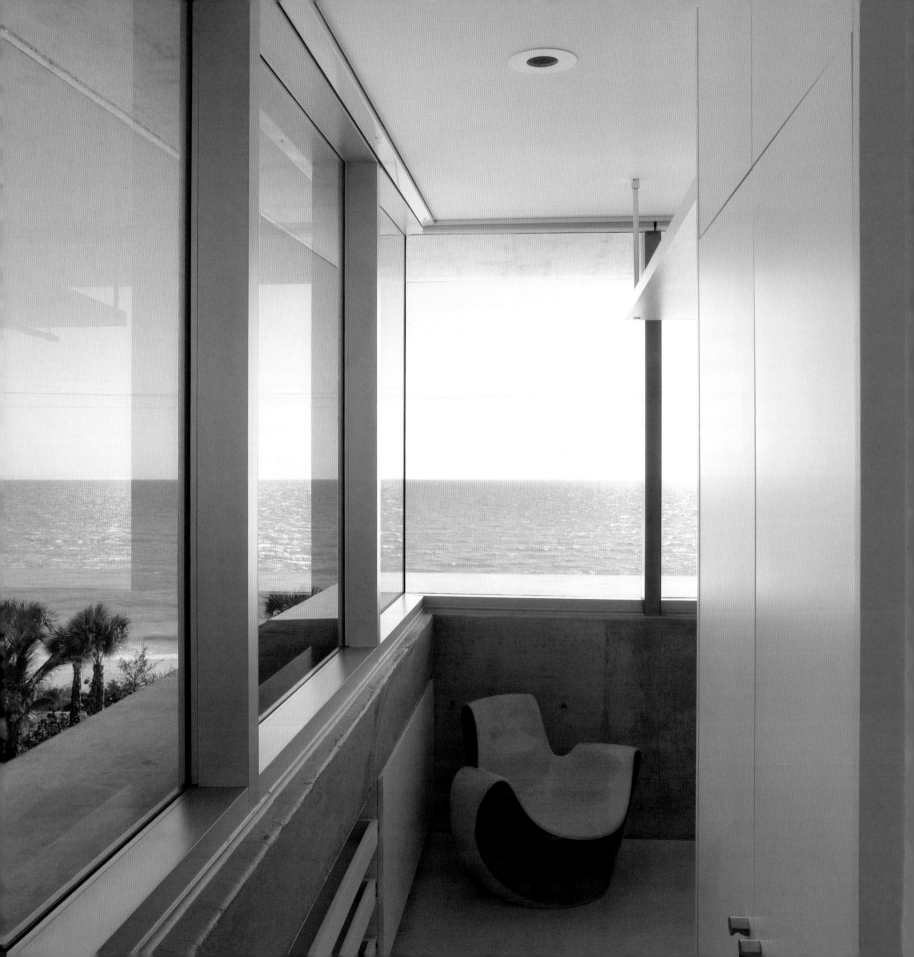

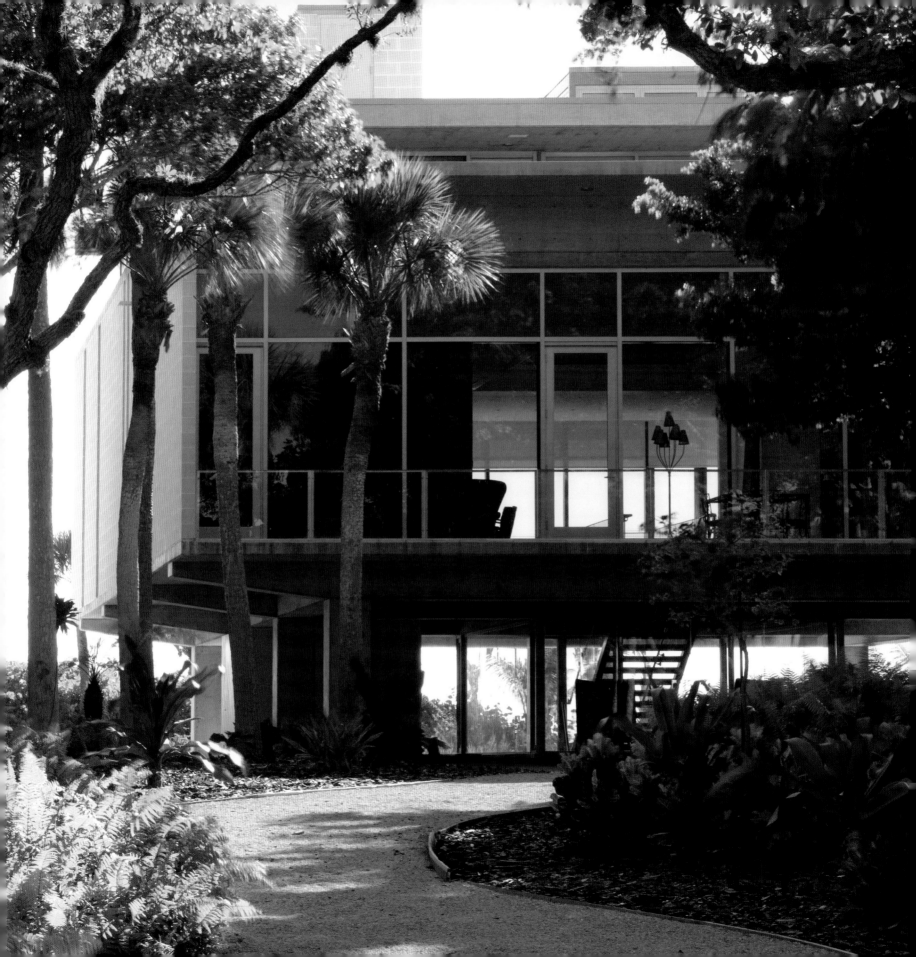

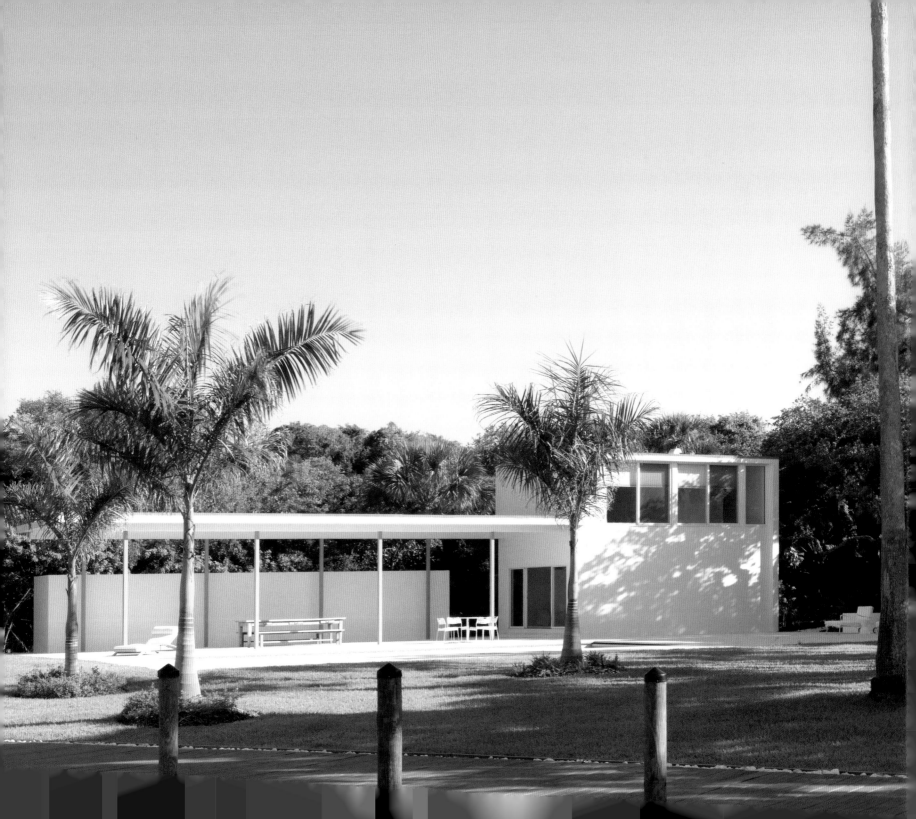

Page 202
The dressing room at the top of the house has unobstructed views of the gulf.

Page 203
The transparent house stands on massive concrete supports among lush tropical landscaping.

Left
The recently added pool house stands almost at the water's edge. Its simple construction reflects ideas of times past. The house includes ample accommodation for guests.

Having already designed a guesthouse on Casey Key, Toshiko Mori had quite an understanding of this island location. Indeed, while working on the Burkhardt house addition nearby, she spent time at the Sarasota Marie Selby Botanical Gardens, researching native plants and studying the local landscape and the weather cycles of the coastal communities on the barrier islands.

Here Mori designed and built a monolithic house for Renee and Michael Silverstein, avid collectors of twentieth-century furniture, design, and art, who lived in New York and wintered here in Sarasota.

Having spent a great deal of time already on Casey Key, the Silversteins knew this was the place for them. The lot spreads from the Gulf of Mexico on one side to Sarasota Bay on the other. Since the site was the originally a lifeboat station it has the largest boat dock in the area.

Mori built a poured concrete house that rises above the landscape, floating above its see-through entrance. It rests on eight pillars that lift the house safely above the flood plain and its construction will combat any storm.

The Silverstein house expresses a devotion to the ideals of the Sarasota School of Architecture: clarity of construction, maximum economy of means, simple overall volumes penetrating vertically and horizontally, clear geometry floating above the Florida landscape, and honesty in details and in structural connections

Comparing it to the Hiss Studio by Tim Seibert, one can see the similarities—the mass of the building raised off the ground on pillars and full-length and full-height front elevations of glass.

While from the outside, the glazed areas appear blue, from inside this is not so apparent. The incoming light is ever changing; it creates playful shadows with the furniture and projects silhouettes across the concrete floors.

In the center of the house, above the welcoming staircase of glass, is an installation by Mori's husband, James Carpenter. This prism of dichroic glass breaks the light up into a spectrum—throughout the day the light coming through the prisms of glass diffracts and creates color-changing rainbows. As the sun moves across the sky, the colors change within from hour to hour, day to day.

The Silversteins are avid collectors and this space acts as an excellent showcase for their obsession. Decorated with works by Royere, Giacometti, Prouvé, Frankl, and Charpentier, the house thrives. The architecture allows the outside in but protects the Silversteins' valuables from the elements.

Among the collection from the mid-twentieth century are new furnishings made especially for the house. The long dining table by James Carpenter, for example, was created in collaboration with the Silversteins and is titled "Renee." The paintings above the seating areas are by Nancy Lorenz and reflect the colors and materials used throughout the house.

It is not a house so much as an installation, a masterpiece of architecture on the Florida landscape that holds inside it a timeless collection of international masterpieces.

Photo Credits

Index